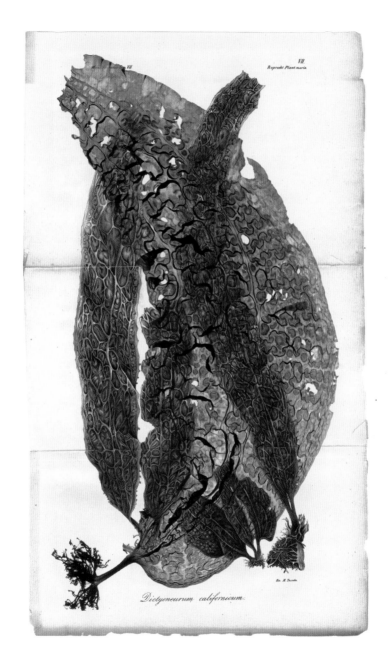

Costaria costata with *Dictyoneurum californicum*. Image by author, incorporating foldout plate from Ruprecht (1852, pl. VI).

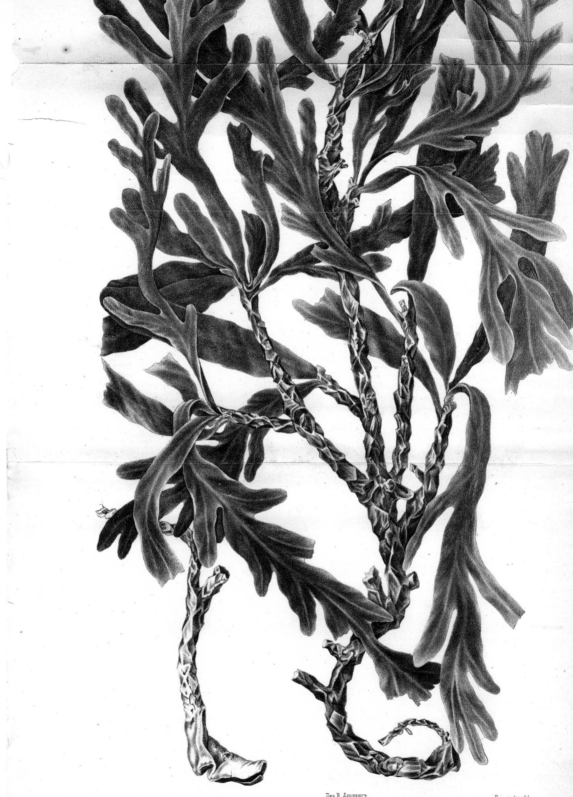

Präss. ad nat. del. Печ. В. Дарленгъ Pape in lap. del.

Stephanocystis osmundacea.

THE CURIOUS WORLD OF SEAWEED

JOSIE ISELIN

Heyday, Berkeley, California

Opposite: Stephanocystis osmundacea.
Foldout plate from Ruprecht (1852, pl. III).

To K. A. P.

The publisher is grateful to the following supporters of this project:

Moore
Family
Foundation

Library of Congress Cataloging-in-Publication Data

Names: Iselin, Josie, author.
Title: The curious world of seaweed / Josie Iselin.
Description: Berkeley, California : Heyday, [2019] | Includes bibliographical
 references.
Identifiers: LCCN 2019001110 | ISBN 9781597144827 (hardcover : alk. paper)
Subjects: LCSH: Marine algae--Pacific Coast (North America)
Classification: LCC QK570.5 .I84 2019 | DDC 579.8/1770979--dc23
LC record available at https://lccn.loc.gov/2019001110

Cover Image: *Stephanocystis osmundacea* (formerly *Cystoseira osmundacea*) with same. Image by author, incorporating foldout plate from Ruprecht (1852, pl. III).

Cover Design: Ashley Ingram
Interior Design/Typesetting: Ashley Ingram with Josie Iselin
Cartography by David Deis

Published by Heyday
P.O. Box 9145, Berkeley, CA 94709
(510) 549-3564
www.heydaybooks.com

Printed in China by Regent Publishing Services, Hong Kong

10 9 8 7 6 5 4 3 2

CONTENTS

Note on Illustrations...*vi*

Introduction...*1*

Egregia menziesii Feather Boa Kelp...*18*

Nereocystis luetkeana Bull Kelp...*32*

Stephanocystis osmundacea Bladder Chain Wrack...*50*

Mazzaella splendens Rainbow Leaf...*66*

Corallina vancouveriensis Red Coralline Algae...*78*

Agarum spp. Colander Kelp...*90*

Pyropia spp. Nori...*104*

Postelsia palmaeformis Sea Palm...*116*

Macrocystis pyrifera Giant Kelp...*128*

Codium fragile Dead Man's Fingers...*140*

Ulva spp. Sea Lettuce...*152*

Phyllospadix scouleri and *Zostera marina* Surfgrass and Eelgrass...*164*

Desmarestia herbacea Acid Kelp...*180*

Halosaccion glandiforme and *Botryocladia pseudodichotoma*
 Sea Sacs and Sea Grapes...*192*

Weeksia reticulata...*200*

Pterygophora californica Walking Kelp...*212*

Afterword...*224*

Acknowledgments...*234*

Bibliography and Sources...*236*

Index...*248*

About the Author...*253*

NOTE ON ILLUSTRATIONS

As artist and designer, I worked with every image to create the best visual narrative for each seaweed story. The simple scans of marine algae were made in my studio between 2007 and 2018. Identified by species, these seaweeds were collected on walks on the beaches of California and on field trips and excursions up and down the Pacific Coast. The illustrations on pages i, 18–19, 54–55, 102–103, 150–151, and 232–233 are part of my photographic series, *Algal Dreams: Contemporary Scans on Historical Seaweed Descriptions*. There are also a few cyanotype prints made in my studio using my own seaweed specimens. These can be recognized by their Prussian-blue color. On two of them I have filled the white seaweed shadow with the colorful seaweed scan: a true combination of new and old photographic nature-printing techniques.

Herbarium specimens are courtesy of the University and Jepson Herbaria at the University of California, Berkeley. These I downloaded from the university's digitized collection and reworked to erase the color and scale bar reference and barcode. They are captioned by species and with their catalog ID numbers. The collection data is not repeated in the caption if it is clearly visible with the specimen pressing.

The older lithographs and historical book pages are from Franz Josef Ruprecht's report "New or incompletely known plants from the northern part of the Pacific Ocean" (1852), Alexander Postels and Franz Josef Ruprecht's *Illustrationes algarum* (1840), S. G. Gmelin's *Historia fucorum* (1768), William Henry Harvey's *Nereis Boreali-Americana* (1852, 1853), and Dawson Turner's *Fuci* (1808). Ruprecht's 1852 plates and those by William Henry Harvey and Dawson Turner were scanned in my studio. The Postels lithographs from *Illustrationes algarum* are courtesy of the University of Southern California, on behalf of the USC libraries. S. G. Gmelin's plates from *Historia fucorum* were digitized by the Marian Koshland Bioscience, Natural Resources, and Public Health Library at UC Berkeley. Exceptions are noted in the captions.

Drawings on pages 149 and 221 were originally printed in *Marine Algae of the Monterey Peninsula* (1944) by Gilbert M. Smith and are used with the permission of Stanford University Press. Drawings on pages 27 and 83 by Ernani G. Meñez are courtesy of

the Royal BC Museum and Archives. Drawings by E. Yale Dawson on pages 15, 142, 167, and 204 are republished with permission conveyed through Copyright Clearance Center, Inc. The drawing by Paul C. Silva on page 145 is reproduced with permission provided by Cambridge University Press.

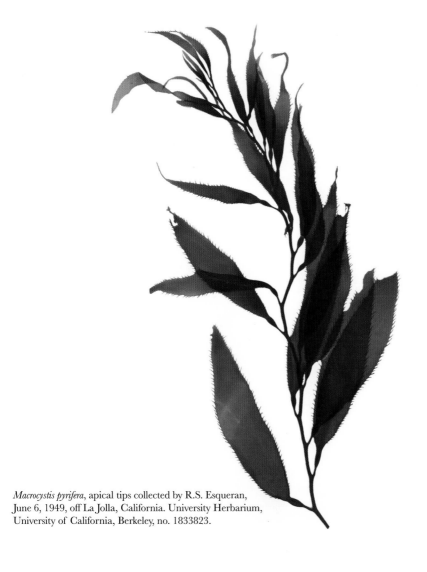

Macrocystis pyrifera, apical tips collected by R.S. Esqueran, June 6, 1949, off La Jolla, California. University Herbarium, University of California, Berkeley, no. 1833823.

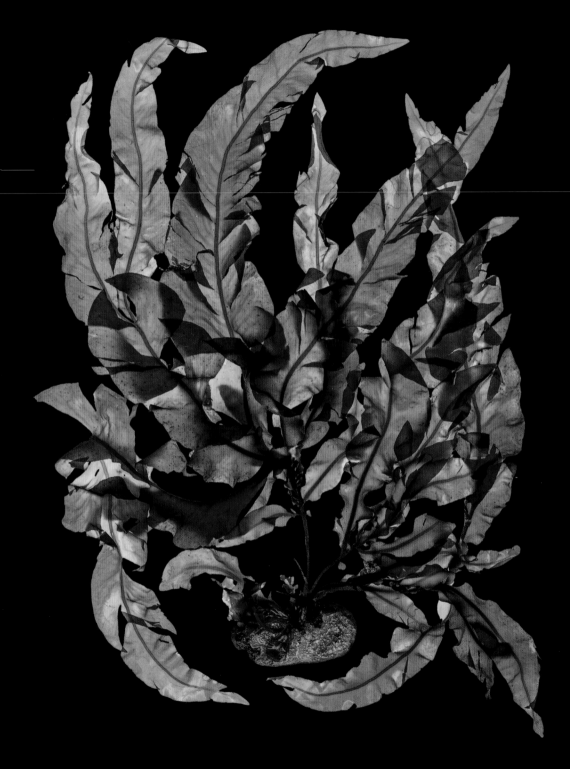

This page: *Erythrophyllum delesserioides*. *Opposite*: *Microcladia coulteri*.
University Herbarium, University of California, Berkeley, no. 1107686.

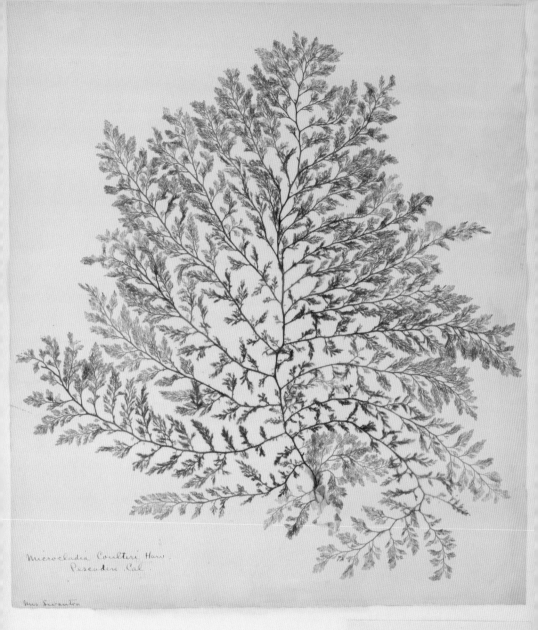

Microcladia Coulteri Harv.
Pescadero Cal.

Mrs Swanton

INTRODUCTION

The thin region where the sea meets the land is unlike either land or sea. It is betwixt and between, a threshold from one state to another. It is a linear point or a coastal ribbon, a place of dramatic change and remarkable abundance—abundance of life and also of possibility. The regions where continents meet the great oceans of our planet are long stretches of liminal space.

From the continent's point of view the approach to an ocean is usually through dunes or over a cliff to a sandy beach, a rocky coast, or a cobbled shore. The littoral region extends from the terrestrial land to the edge of the water at the lowest tides, where it gets swallowed by the marine world. From the ocean's perspective, the approach to the world's great landmasses is from the deep and dark pelagic up over a continental shelf into a dim region where light barely penetrates the waters and on up into a brighter photic zone, what might be called the subtidal, and continues into the low intertidal where the extreme full-moon tides pull away the water once or twice a month, up towards the beach or rocky reef where the ocean swells in and out in six-hour cycles, up finally to the highest tide mark, the wrack line, where the ocean leaves its debris to mark a final encroachment towards dry land.

This sliver of ocean, where sunlight penetrates enough to allow photosynthesis to work its magic and where the benthos, or ocean bottom, provides something to hold onto, is the home of the seaweeds, or marine algae. Seaweeds have three requirements

for survival: a substrate to hold onto to keep them in one place, sunlight to provide the energy for primary production of biomass, and nutrients to fuel growth. The thin section of ocean from the intertidal zone to about three hundred feet deep is where the ocean flora find these three elements for success and where they reside. This is a miniscule sliver of ocean area, less than 2 percent of the entire sea floor, and yet it is a zone of incomparable richness, where marine algae are the supreme eco-engineers. They oxygenate the waters, create three-dimensional habitat for countless other organisms, and form the base of a food chain that keeps our planet unique in the universe as we know it—opulently rich in life.

The Pacific Ocean's edge where it encounters the North American continent is considered one of the richest of these rich zones. The continental shelf is abrupt and close to the coastline, often less than a mile from shore. The steep transition from deep to shallow and prevailing winds that push surface waters away, letting the cold deeper waters well up with their vast nutrient stores, allow for exuberant algal growth. This slice of ocean from Alaska to Baja California in Mexico has some of the most diverse and abundant seaweeds and kelps on Earth. The rocky, fog-shrouded coast sports a spectacular number of seaweed species, from enormous kelps to tiny corallines.

I usually approach the ocean from the land, from cliffs down to a sandy beach where along the water's edge or along the wrack line I encounter cast-ashore seaweeds from this terrestrial vantage point. Or with rubber boots on, I venture out on a rocky reef, timing my excursion carefully with the low tide, to inspect the exposed seaweeds during the brief interval before the tide comes in and covers the rock.

Recently I had the chance to approach the land from the sea, when I was snorkeling along the Mendocino coast. I felt the distinct difference of moving from the dynamic ocean towards the stationary land. Being underwater amidst the undulating kelps and seaweeds is a healthy switch of frame of reference. Everything, myself included, is in motion, in flux. It is a gestural world. The water is milky with detritus, mostly bits of seaweed or kelp worn or ripped from their origins and floating suspended in the near-shore currents. A flash of chartreuse floats in front of my mask and I cannot help but grab the bright bit of algae to add to the bouquet I am gathering in my neoprened fist. After a couple of hours in the murky ocean, captivated by the eerie forms and constant motion of the giant kelps and leafy seaweeds, I am just cold enough to need to come

ashore but disappointed to leave the misty, oversized world of the kelp forest so soon. I crawl back onto the rock-strewn pocket of a beach between the rocky cliffs of this spectacular coast, and kick off my flippers and peel off my wetsuit.

Seaweed seems to be on the tip of many people's tongues these days. While only yesterday seaweed was considered slimy and undistinguished by most Americans, it is now regarded as an answer to many of our oceans' ills. Seaweed farms have the potential to become an aquaculture that will help working waterfronts maintain an ocean-oriented way of life beyond fishing, since the fish themselves have been fished out. Marine algae can be the indicator for radiation in our waters after poisoning catastrophes. It can be a sustainable food source when corn, beef, and almonds have sucked our lands dry. Algae can be the next biofuel, taking advantage of its remarkable ability to turn sunlight into chemical energy five times more efficiently than land plants. Seaweed can be a beacon, lighting our way towards ocean awareness. Only last week I drank a cup of a seaweed broth in a trendy East Village restaurant. It was savory and spectacularly delicious—a culinary delight.

All these wonderful things about seaweed are true, and many people are passionate about realizing seaweed's potential. The long and culturally rich history of seaweed foraging is being rediscovered and can be sustainable if done thoughtfully and correctly. Seaweed cookbooks are springing to life, and edible seaweed is becoming more widely available in health food stores. It *can* be the next superfood.

But this is not why I love seaweed. I love seaweed because it is gaspingly beautiful. My photographer's eye is in love with its palette of colors, from olive green to golden brown to deep purple. I am turned on by its crazy shapes and forms, some reminding me of the mid-century look of my youth—think Marimekko—but many without any comparable translation in our terrestrial world. Seaweed can be smooth or bumpy, complexly delicate or magnificent in its simple architecture. My designer's sensibility revels in the gradient of color from rose to olive in the lovely sea sacs, or the fabulously holey, fresh kelp tissue of *Agarum*, or colander kelp. I love seaweed because it has a visceral quality when in the hand. It is smooth and slimy and tough and stretchy. I love seaweed because it is passionately of its world, the marginal world of the intertidal zone, the edge of the sea, which, as Rachel Carson describes it, "remains an elusive and indefinable boundary."

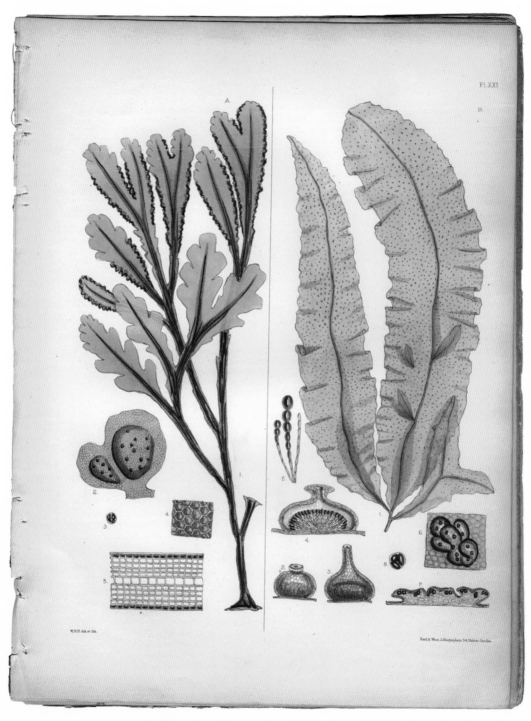

A: "*Botryoglossum platycarpum,*" actually *Cryptopleura* and B: *Grinnellia americana.* Illustration by William Henry Harvey from *Nereis Boreali-Americana, Part II—Rhodospermeae* (1853, pl. XXI).

It is hard for us as humans to imagine such an existence. We cannot begin to place ourselves in such a dualistic, changing world where the basic fabric of life, the ocean, is pulled away and floods back in twice each day. It is beyond our comprehension. And this, to me, is exhilarating. It is my meaning of wild: a state our human intellect cannot quite comprehend.

And yet a select few have chosen to delve deep into understanding the grammar and lexicon of the seaweeds of our western seaboard, not to take advantage of them, but simply to understand their world and their strategies for survival. This lineage of learning about macroalgae, the field of phycology, is a fascinating line of scientists and explorers who individually have built empathy with some favorites in the world of Pacific Coast marine flora and collectively have handed down their knowledge from mentor to mentee. Many of these scientists are women who provide great inspiration with their intense intellectual and intuitive curiosity. These men and women have taken on the task of assigning genus and species names to specific algae. Phycologists revisit these names again and again in an effort to understand the evolutionary relationships between the seaweeds under the tides.

The field is not crowded. It is in fact a thin line, perhaps better described as a linked chain of marine scientists. And while taxonomy (the classification of living things by name) can appear dry and beside the point in our changing world, where ecological connectedness is paramount and the health of our oceans is of primary concern, the process of learning about and understanding a particular algal species brings us closer to life-forms different from ourselves. Appreciating a particular kelp or seaweed as an original explorer did, or a specialized phycologist might, can reveal an algal-centric perspective that will be helpful as we pick our way through the weeds of climate change, warming oceans, and depleted fisheries. Marine algae's obscure corner of our natural world, with all its unseen forces and extraordinary forms and processes, expands our notions of what life is and adds new dimension to the notion of coastal living. As we grapple with concepts such as carbon sinks and ocean acidification, it is imperative that we recognize the role kelps and seaweeds play in complex nearshore ocean systems.

———

Each of the world's continental coastlines has its individual flora of seaweeds. There is some crossover—sea lettuce (*Ulva*), nori (*Pyropia*), and the coralline algae (*Calliarthron* and others), for example, can be found in all of the world's oceans—but each littoral region has its distinct flavor. The cold waters of coastal California are one of the richest zones for marine algae in the world, with over 750 species listed to date. The variety of the reds, the majesty of the many browns, and the lusciousness of the greens make for a rich floral brew with variations that extend upward through Oregon, Washington, and British Columbia into Alaska and southward past San Diego into Mexico. This algal flora is a cornucopia to learn about and learn from.

Seaweeds have been used by the indigenous peoples of California and the Pacific Northwest for thousands of years. The first specimens of algae collected by Europeans from the Pacific west coast were plucked from the rocky shores by naturalists aboard some of the exploratory expeditions of the late 1700s, such as those led by Vancouver and Malaspina. In the late 1800s, women living in Pacific Grove, California, sent fresh specimens collected around the Monterey Peninsula up to William Albert Setchell, head of the botany department at the University of California at Berkeley, and they made meticulous pressings of their algal finds. Setchell initiated concerted study of marine algae of the Pacific west coast, and a lineage of phycologists continues from there. In 1944, Gilbert M. Smith published *Marine Algae of the Monterey Peninsula*, and in 1976, Isabella Abbott and George Hollenberg continued this work with the massive *Marine Algae of California*. George Papenfuss, one of the great mentors in phycology at UC Berkeley, contributed to this volume with the introductory "Landmarks in Pacific North American Phycology," describing the history of who had learned from whom in our pursuit of knowledge of Pacific Coast seaweeds. I come back repeatedly to his essay and to Big MAC (as the blue brick of a book is affectionately called by those who have worn *Marine Algae of California* to tatters with use). Papenfuss's history comes to completion with Abbott and Hollenberg and the 1976 volume.

Since 1976, exploration and study in the intertidal zone—with the attendant seaweed specimens pressed, labeled, and cataloged—has led to more species being identified and more knowledge accrued. The passion and interest in marine algae continues to be passed down from mentor to mentee. From 1976 until his death in 2014, Paul Silva was a leading figure in phycology at UC Berkeley who mentored the current cura-

tor of marine algae there, Kathy Ann Miller. Dr. Miller is currently working to update *Marine Algae of California* with added species, corrections, and new names. Every year, phycologists and their graduate students gather at a nationwide conference to exchange papers, compare notes, and learn from each other. It is a warm and generous event.

I wrote a first book about seaweed a few years ago. It is a primer of sorts, based on the act of looking closely. I made portraits of the algae I collected at the beach and those species I learned about in workshops given by Kathy Ann Miller. I used (and still do use) my flatbed scanner to create algal portraits, to capture the luminous qualities, the color and shape of a particular algal specimen. I learned the basic science of seaweed and wrote about it so that someone like me, a nonscientist, could become infatuated as I had.

Callophyllis flabellulata.

I wrote about the workings of the tide and the piles of seaweed wrack, as well as the role of color and the mysteries of reproduction. But that book was just a start.

Here, I have chosen to continue the journey with sixteen seaweeds or kelps and two seagrasses. They are iconic examples from our California coast, findable by most any walker of the beach or tide pool explorer. They represent each algal category of green, brown, and red and grow in a variety of habitats, from subtidal kelp forests to atop the rocky reef. They offer a chance to take a deeper dive into the science of seaweed and the history of that science. My hope is that the coastal explorer can develop more than a passing connection to the weeds and can nurture a deep and abiding empathy for this remarkable family of wild organisms. There is something astounding about the story of each one. Each story is important to tell.

The visual component of this storytelling is as important as the narrative. The historical pressings illustrate the intriguing beauty of a particular species and offer a trove of hints into its taxonomic history—who collected it, where, and when. The herbarium specimens remind us that a seaweed scientist's real love is being out on the foggy coast, usually very early in the morning, at low tide. Collections made up and down the West Coast at an assortment of marine labs and other locations have been consolidated at the University Herbarium at the University of California, Berkeley, which houses an astounding fifty thousand algal specimens from California alone. It has taken in orphaned and historically relevant collections as well, making it an extraordinary resource for the study and teaching of seaweeds of the Pacific Coast of North America. Alongside the pressings are the historical lithographs that were the visual accompaniment to the original published descriptions of a seaweed's form and aspect—all part of the naming process. One does not think of taxonomy as a visual discipline, and yet it is spectacularly so.

These essays, arranged for visual dynamism and roughly by chronological theme, do not create a linear narrative but will build upon each other so that a sensibility about the seaweeds might emerge, much as algal detritus and drift can, given the conspiracy of tide, current, and coastline, accumulate in a particular cove or beach into a remarkable mass of scraps of shape and color. There is much left to be discovered about marine algae. The scientific and ecological waters are still murky in places, but I would never desire a picture cleansed of mystery and the unknown. I am tickled every time I

Cyanotype print of *Scytosiphon lomentaria*.

ask a scientist a seaweed-related question and get a shrug of the shoulders and "Well, we just don't know" in response.

The process of visual scrutiny and close observation continue to guide me into the natural history of how these marine flora find their way in the intertidal zone. I am confident that the poet and artist can reap from the science and from the scientists, to learn not only about the seaweeds of our region, but also from them—from their resilience and toughness, their resourcefulness and efficiency, their deep and abiding connection to the ocean, their poetry and magic.

Seaweed Basics

The common name "seaweed" implies a kinship to plants that is misleading. Algae of all sorts were established in the oceans well before the arrival of vascular plants on land, and most seaweeds have no genetic connection to terrestrial plants at all. "Algae" is a broad term and covers the domains of both microalgae and macroalgae. Microalgae are the invisible, single-celled organisms that populate our oceans and waterways. Diatoms and other phytoplankton are the oceanic microalgae that produce more than half the oxygen in our atmosphere, but they are too small to see so their stories are told elsewhere. "Algae" can also refer to toxic algal blooms and epiphytic muck clogging estuaries. Freshwater algae grow in ponds and lakes, streams, rivers, and reservoirs.

"Macroalgae" is a term used to describe multicellular marine algae or seaweeds. "Kelp" is an informal word for the largest, fleshy brown seaweeds that tend to grow in offshore "forests." Macroalgae produce another 20 percent of the oxygen in our atmosphere. The process making all this oxygen is photosynthesis, and seaweeds and kelps are astoundingly good at it. Both land-based plants and oceanic flora use sunlight as the fuel needed to peel electrons off of water (H_2O) and use their energy to transform carbon dioxide (CO_2) into organic compounds (growth), releasing oxygen (O_2) as a byproduct. Seaweeds are hugely efficient at transforming light energy into chemical energy and then metabolic energy. *Macrocystis*, or giant kelp, can fix from 1 to 4.8 kilograms of carbon per square meter of plant per year, growing almost two feet a day, and

other species display even higher productivities. The kelp forests of the oceans rival the rain forests of the continents in terms of oxygen production and their prodigious biodiversity.

The importance of the planet's kelp forests cannot be overstated. Kelp forests increase productivity of nearshore ecosystems. They are a food source to many invertebrate herbivores—who become food for others up the food chain—not only directly as they grow but also with an immense amount of castoff algal detritus that floats throughout the water column. That murky water is productive ocean. The kelp forests slow down the movement of water, protecting smaller organisms, larvae, and young from being washed away. They create natural breakwaters, slowing erosion and creating calm bays. They are essential for healthy, robust life in the seas. Seaweeds of all sorts are place builders. Their world includes animals big and small, from apex predators like sea otters to innumerable fish taking shelter to tiny kelp flies decomposing tangled wrack on the beach. Algal existence is grounded in countless interactions: a web between snail and seaweed, sandstone and wave action, ocean chemistry and invertebrate activity. The complexity of this world is beyond the understanding of even the most respected ecologists. This infinitude of interactions within a buoyant ocean world has shifted my perceptual lens many times over.

In 1841, the Irishman William Henry Harvey shifted the perceptual lens of all those studying seaweed at the time by sorting the marine algae of the oceans into three basic categories related to their color: the browns (division Phaeophyta), the greens (division Chlorophyta), and the reds (division Rhodophyta). In his flora of North American seaweeds, *Nereis Boreali-Americana or Contributions to a History of the Marine Algae of North America*, published by the Smithsonian from 1852 to 1858, each color group warranted its own volume, each with a set of colored plates illustrating the various seaweeds and their details, done by Harvey himself. Several of these luscious and subtly colored pages are included here. Genus and species groupings of the seaweeds continue to shift and change as deeper understanding of the seaweeds is achieved—seaweed names change vexingly often—but these three color groups continue to provide a basic taxonomic foundation for approaching the flora of the oceans.

Seaweeds are not plants but, along with ferns and mosses are often referred to as cryptogams, or that which hides its source of reproduction. The cryptogams do not

DIVISION INTO GROUPS OR SERIES.

For purposes of classification the Algæ may be conveniently grouped under three principal heads or sub-classes, which are, for the most part, readily distinguishable by the colour of the frond. They are named and defined as follows, viz.

1. MELANOSPERMEÆ. *Plants* of an olive-green or olive-brown colour. *Fructification* monœcious or diœcious. *Spores* olive-coloured, either external, or contained, singly, or in groups, in proper conceptacles; each spore enveloped in a pellucid skin (*perispore*), simple, or finally separating into two, four, or eight *sporules*. *Antheridia*, or transparent cells filled with orange-coloured, vivacious corpuscles, moving by means of vibratile cilia. *Marine.*

2. RHODOSPERMEÆ. *Plants* rosy-red or purple, rarely brown-red, or greenish-red. *Fructification* of two kinds, diœcious :—1, *Spores* (*gemmules*, Ag.) contained either in external or immersed conceptacles, or densely aggregated together and dispersed in masses throughout the substance of the frond : 2, *Spores,* commonly called *tetraspores* (*gemmules*, Thw.), red or purple, either external or immersed in the frond, rarely contained in proper conceptacles ; each spore enveloped in a pellucid skin (*perispore*), and at maturity separating into four *sporules*. *Antheridia* (not observed in all) filled with yellow corpuscles. *Marine, with one or two exceptions.*

3. CHLOROSPERMEÆ. *Plants* grass-green, rarely a livid purple. *Fructification* dispersed through all parts of the frond ; every cell being capable of having its contents converted into spores. *Spores* (*Sporidia*, Ag.) green or purple, formed within the cells, often (always ?) at maturity vivacious, moving by means of vibratile cilia. *Gemmules* (*Coniocystæ*, Ag.) or external vesicular cells, containing a dense, dark-coloured, granular mass, and finally separating from the frond. *Marine, or, more frequently, living in fresh-water streams, ponds, and ditches, or in damp situations.*

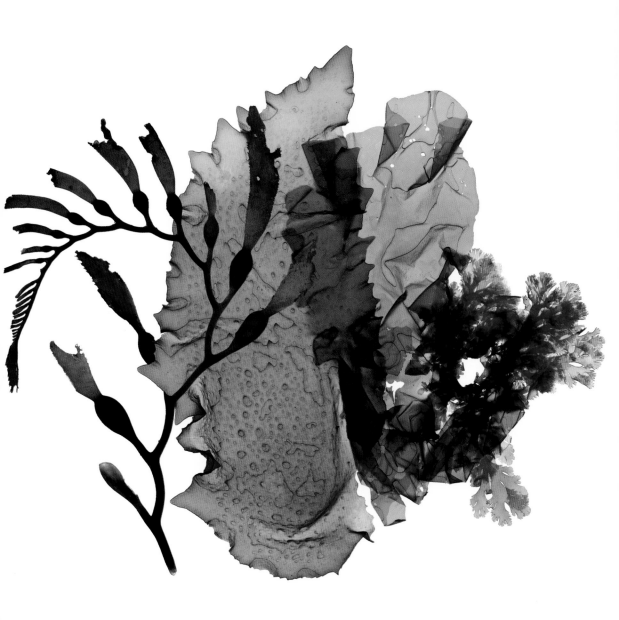

This page: Examples of brown (division Phaeophyta), red (division Rhodophyta), and green (division Chlorophyta) seaweeds. *Opposite*: William Henry Harvey's grouping of seaweeds by color in *Nereis Boreali-Americana* (1852). His terms were Melanospermeae (the browns), Rhodospermeae (the reds), and Chlorospermeae (the greens). Although the terminology has changed, the same color groups are used today.

produce seeds. Marine algae reproduction is most often a complex cycle of alternating generations that produce spores in one generation and egg and sperm, or gametes, in another. The specific terminology around reproduction and reproductive bodies in the algae is full of the jargon that made me tune out in biology class early on. In response, I have attempted to explain clearly with words that I find familiar.

I have used the simpler terms of seaweed architecture. These terms are learnable and, over time, become sensible descriptors of the seaweeds we will consider. From tiny and intricate to enormous and singular, the diverse shapes found among the tangle of seaweeds at the ocean shore are all strategies to confront the three tasks essential for success in the intertidal zone: holding on, gathering light and nutrients, and defense against predators. A scientist would refer to a seaweed's morphology while a designer would describe its form, but in either case, the complex and varied shapes that exist across all seaweeds derive from some basic building blocks. The overall body of a seaweed is the thallus. What glues the thallus to the benthos, or sea bottom—usually a rocky substrate—is a rootlike amalgam, the holdfast. Some holdfasts become large and persistent structures in and of themselves. Others are round and flat and remarkably small given their critical task.

Emerging above the holdfast is the stipe, a stemlike structure that supports branches and the blades or fronds. A blade might be as thin as a single cell or as stretchy and tough as contemporary denim, and closer inspection may offer additional information. There might be a distinct midrib, or a network of slender veins. The branching patterns can be as simple as a single stipe reaching to a single blade, a bifurcation (splitting in two), or an enormously complex system that is a lifeless tangle when draped over a rock at low tide but reveals specific and identifiable growth patterns when floating in water. The repetition of branching can result in self-similar fractal patterns, amazing to see under a magnifying lens. Gas-filled bladders or pneumatocysts are found only on that subset of brown seaweeds, the kelps. These bladders float the kelp blades upward, towards the ocean surface and light.

Given the range of environments the intertidal and subtidal zones offer—more protected or less protected, rocky or sandy, windblown or not, near a freshwater outlet or in a salty evaporating tide pool—the look of a particular algal species can vary tremendously, making identification a tricky business. But when familiarity with a few seaweeds

grows, appreciating these differences only builds respect and awe for the resiliency and power of that given algal strategy. Learning the names of seaweeds, common names or Latin binomials, though challenging for many of us, brings them into the realm of family. When out on the reef, algal encounters become as those among old friends.

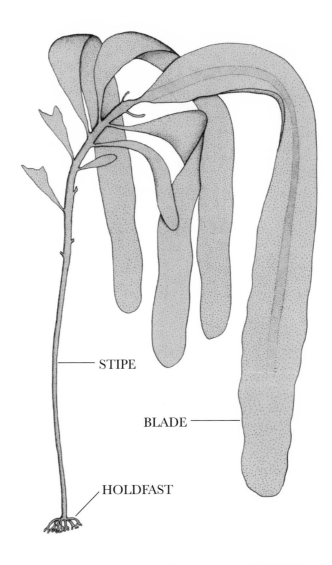

STIPE

BLADE

HOLDFAST

Pterygophora californica, a dark brown kelp. Illustration by E. Yale Dawson from ZoBell and Dawson, *The Seaweed Story* (1954).

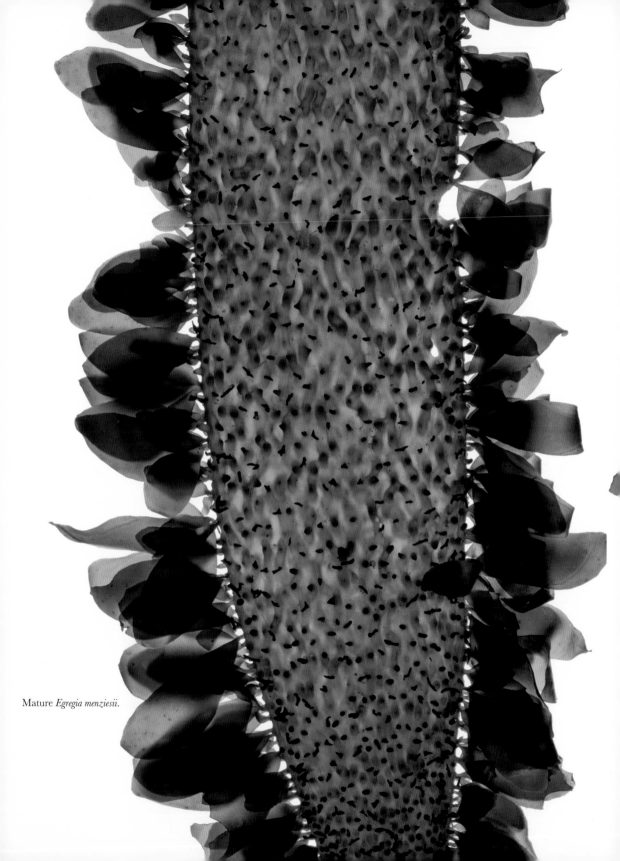

Mature *Egregia menziesii*.

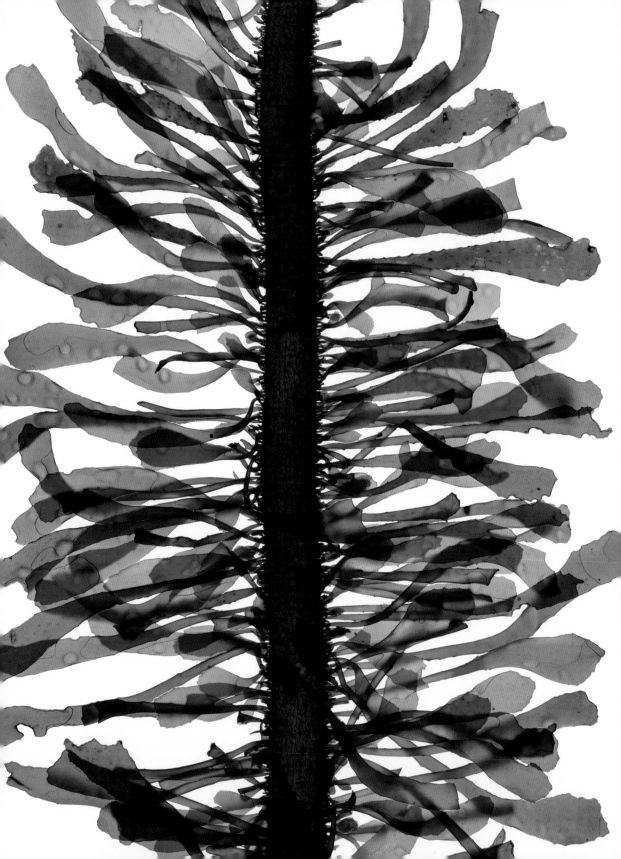

Feather Boa Kelp

Egregia menziesii is better known as the feather boa kelp. It grows where the tide exposes rocks only at the lowest tides or, deeper yet, where it is always submerged, the subtidal zone. *Egregia menziesii* ranges widely along the west edge of North America, found from the most southerly Alaskan waters continuously south to Baja California in Mexico. It is a bizarre-looking organism, growing long, twenty-to-forty-foot straps of flattened kelp tissue speckled with tiny spikes. This textured leash is edged by a profusion of lateral paddle-shaped blades that glow olive green if the sun comes through them. *Egregia* can vary widely in the relative proportions of its strap and blades, but most often it really does look like a feather boa. Whimsical gas-filled bladders punctuate the length of the kelp, like oversized beads. These beads hold the entire snakelike affair aloft towards the ocean surface. In my quest to make a visual record of the seaweeds of the Northern California coast, I found that *Egregia* is one that must be captured quickly in the studio before it loses its luster and fabulousness. It cannot be dried and pressed. It has to keep a bit of the ocean with it to display its luminous olive hue and unique and astonishing profile. Nothing in the plant kingdom of our terrestrial world, no tree shapes or branching patterns, ready us for *Egregia*. It is purely a concoction of its ocean environment.

But *Egregia* can be enormously different from one algal plant to another. Its components are all variable—thick strap with short oar-ended blades versus thinner strap with a profusion of thin, needlelike blades. The wide range of shapes is testament to the variations in nearshore ocean habitat where *Egregia* grows as well as to how much it can change with age. A small section of coastline might diverge from a wave-crashed energy zone to a quieter strip of reef. The temperature and salinity of the water can also fluctuate in that same locale. All these factors affect *Egregia*'s outward presentation. Many seaweeds exhibit a broad morphological range within one species, but *Egregia* might take the prize for this variability. Early botanists were confused by the differences from specimen to specimen. The air vesicles or bladders alone were described variously as globose, ellipsoid, or ovoid. Different species were suspected. In the end, however, *Egregia menziesii* is the only one of its genus on the west coast of North America.

When submerged in this subtidal range, with sunlight seeping through a few feet of ocean water, *Egregia* hangs like an extended nest of serpents suspended in the current, waving with the constant ocean flux. A bit farther up towards shore, in the low intertidal, *Egregia* splays along the surf channels or drapes down a boulder's face, devoted

Egregia pneumatocysts with *Egregia menziesii*. Image by author, incorporating foldout plate from Ruprecht (1852, pl. IV).

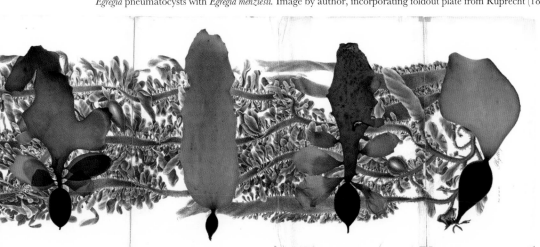

to the rocks for a few hours before floating aloft with the rising tide. Often found along the tough, straplike midrib of the *Egregia* is a particular limpet, *Discurria incessa*, which lives and dines exclusively on this kelp, leaving a series of ovoid divots along its length.

Like other large kelps, *Egregia* is a prolific grower. It is also a perennial—its holdfast remains attached to its rock through the seasons and can grow into a substantial knob of worn haptera over many years. The stipes are beaten back to blackened stalks by the winter storms. In spring the ocean cycles begin again. The surface layers of the northeastern Pacific Ocean are blown offshore, allowing for the bottom layers of ocean water to rise to the surface. The deeper waters hold the residue of all the organic matter that continually sinks towards the bottom and thus are rich in nutrients and minerals—sodium, calcium, potassium, magnesium, phosphorus, iodine, iron, and zinc—that fuel life in our oceans. This springtime upwelling combines with the extended hours of sunshine to reignite the engine of photosynthesis. New juvenile fronds of *Egregia* emerge from the darkened anchor. These young *Egregia* are round-faced and goofy, mostly frilled blade, but within months they become long, tape measure–worthy adults stretching for yards from the matured holdfast. The magic partnership of sunshine and rich ocean waters stretches before us with each feather boa blade discovered on a full-moon tide.

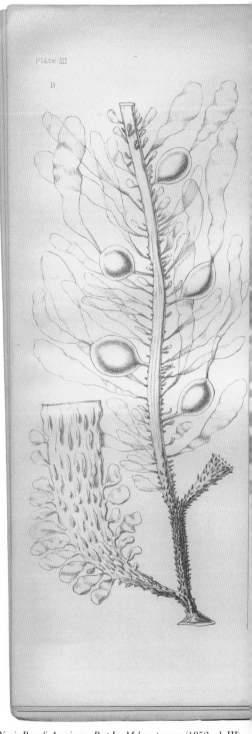

Phyllospora menziesii, now *Egregia menziesii*. Illustration by Harvey from *Nereis Boreali-Americana, Part I—Melanospermeae* (1852, pl. III).

The California Current runs down the west coast of North America, bringing the cold waters of the North Pacific to most of the California coastline. Until you reach Point Conception just north of Santa Barbara, your toes will tense when dipped into the waves, summer or winter. These cold waters are not inviting to swimmers, but they are perfect for the abundant growth of the spectacular array of California's seaweeds. At Point Conception, the coastline abruptly turns eastward and the current is spun off to the west. To the south, the ocean is warmer. Point Conception marks the northern range of many seaweeds that are abundant in Mexico and southern climates. *Egregia* seems to be comfortable in a broad range of ocean temperatures and is found both above and below Point Conception. Its resilience in our time of shifting ocean temperatures is evident in its increased abundance on the north coast of California and on up into Canada. While other kelps struggle to maintain their natural profusion during years of warmer waters, whether because of El Niño, a warm-water "blob," or warming oceans, *Egregia* seems to be doing fine.

It is of particular note that *Egregia* is currently thriving along the west coast of Vancouver Island, where the first specimen of *Egregia* to be named by Western science was collected in 1787 by Archibald Menzies. Most well known as the naturalist and surgeon on board George Vancouver's notoriously contentious 1790–1794 expedition to the Pacific Northwest, Menzies was also on board as naturalist to an earlier expedition to the same region commanded by James Colnett. While Vancouver's crew of the ship *Discovery* was tasked with surveying the coastline for the English Crown, the prior 1786 voyage of the *Prince of Wales* was a trade expedition intent on collecting as many sea otter, seal, and fox pelts as possible. Menzies was appointed the surgeon-naturalist for both expeditions by the powerful patron of science Joseph Banks of Kew Gardens in London, and Menzies collected *Egregia* on both occasions. Banks insisted that a glass enclosure be built on the deck of the *Discovery* to house live plant specimens to be brought back to England. This contraption infuriated Vancouver, and he and Menzies were at odds throughout the voyage. Accounts of the expedition are full of descriptions of Vancouver's violent temper and bouts of depression. Menzies, on the other hand, was insatiably curious. Despite the constant fog and nearly impenetrable forests, he projected a positive attitude towards the unfamiliar landscapes, flora, and fauna. As surgeon, Menzies kept everyone on both expeditions alive. As naturalist, Menzies

returned a treasure trove of natural specimens to England, many of which were sea-weeds and kelps.

In 1787 the *Prince of Wales* made it to Nootka Sound, halfway up the west coast of Vancouver Island. The ship remained there for a month and while his compatriots were hunting the rafts of sea otter for their fur, Menzies would explore the complex coastline and, when the fog cleared, the daunting terrain typical of the Pacific North-west. The seaweeds and kelps, like the otter, were like nothing Menzies had experi-enced despite his worldly travels around the Atlantic Ocean. We can only imagine how he collected the *Egregia*. He might have been in a dory balanced by the oarsmen on the opposite gunwale as he leaned into the cold waters and pulled a long strand of feather boa up from the shallows, or perhaps he scrambled on rocks at the lowest tide. Know-ing how poorly *Egregia* dries, I wonder whether Menzies sketched the fresh feather boa showing the funny paddles and whimsical bladders and flat, spiked central stipe. We know he wrote extensive notes that accompanied this and the many other specimens that returned with both expeditions and that made up the initial collection of seaweeds and kelps from the Pacific shores of North America.

The feather boa specimens survived both trips back to England and were presented to Joseph Banks, who was given all of Menzies's botanical specimens from the Pacific Northwest. Banks handed over the new-to-science seaweeds to Dawson Turner, one of the very few English botanists of the late eighteenth and early nineteenth centuries to take an interest in the flora of the oceans, an altogether different enterprise than the botanical investigations flourishing in England at that time. These assorted seaweed samples collected by Menzies from the cold waters of California, Oregon, Washington, and British Columbia were scrutinized and named first by Dawson Turner and then by a succession of other botanists, algologists, and phycologists. They created a foundation upon which our knowledge of the marine algae of the Pacific Coast was built.

In 1808 Dawson Turner published four volumes of illustrated seaweed descriptions under the single title *Fuci, or Colored figures and descriptions of the plants referred by botanists to the genus Fucus*. The volumes included some of the first Latin names and scientific descriptions of North American Pacific Coast seaweeds. Turner segregated the fleshy seaweeds from filamentous or stringy seaweeds, which he labeled *Conferva*, and the membranous or sheer seaweeds, which he labeled *Ulva*. The large group labeled *Fucus*

includes the more robust seaweeds with bladders (rockweeds and kelps). Menzies's feather boa specimen from Nootka Sound, as well as some others from Monterey and Trinidad in California, are described in the first volume in Latin and English. Turner describes the dilemma facing the illustrator when confronted with such a large original organism: Does one shrink the whole to fit on the page or does one choose a section at life-size? His conclusion: "I prefer the figuring of a portion, only, and leave it to the imagination of the reader to supply the remainder from the description." The lush and gloriously olive-colored lithograph on the page opposite the written description presents a five-inch clipping of a feather boa kelp complete with details and cross sections. Dawson Turner's wife, Mary Turner, an accomplished botanical watercolorist, oversaw the printing of the lithographs for the enormous *Fuci* project. This particular plate (seen on the follwing page) captures the feather boa exactly as we might encounter a scrap of it tossed into the wrack line on the rocky coast today.

In the tradition of honoring the explorers and naturalists who collected the specimens, Turner named this species *Fucus menziesii*. Turner writes:

> For many of the particulars in the account of the present Fucus, as well as for the specimens from which the drawing is made, I am entirely indebted to Mr. Menzies, who brought it home with him in his first expedition round the world, and after whose name I have had a particular pleasure in calling it, being convinced that no man better deserves to be enumerated among the promoters of botanical science, from the zeal with which he has prosecuted it, and the liberality which he has shewn [*sic*] in dispersing his treasures. *F. Menziesii* is a very singular and elegant species, so much removed from every other hitherto described, that there is not only no fear of confounding it, but that it would even be difficult to say to which it is most akin. (*Fuci*, vol. 1)

Menzies's specimen of feather boa kelp was thus established by Turner as the type specimen—the one against which all other specimens are then compared—and Nootka Sound recorded as the type locality—that particular place where the type specimen was found. In field guides or reference books there is often a string of names after the

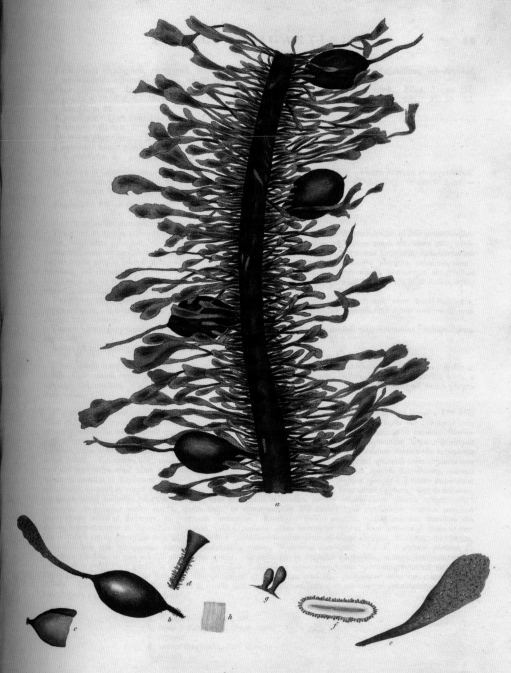

Fucus menziesii.

species name of a particular seaweed. This is the list of phycologists who have focused their considered regard on this particular creature or organism of our natural world and proceeded to place it or rearrange it within the Linnaean taxonomic system of naming. *Egregia*'s list begins with Turner and continues with Areshoug, the Swedish kelp specialist of the day, who erected the genus name *Egregia* in 1876, then Setchell and Gardner, Smith, and Silva. These are just some of the scientists who took an interest in *Egregia* and confirmed or changed its name.

After Dawson Turner, two other important phycologists of the mid-nineteenth century paid attention to this odd kelp from the Pacific Coast of North America. Franz Josef Ruprecht was in Russia in St. Petersburg and had received specimens collected during a Russian expedition to their outpost at Fort Ross on the Sonoma coast in 1839. He published a folio in 1852 describing five California kelps brought back from that expedition. Ruprecht encountered the same dilemma as Turner when considering how to illustrate these large and magnificent organisms—scaled down or in sections? Ruprecht chose to publish lithographs of the entire organism, but not scaled to a single page. The plates of his 1852 folio are a magical unfolding of panels. The lithograph of an *Egregia* specimen (named at the time *Phyllospora menziesii*) is so large and complex as to defy imagining how it was accomplished. As the nine panels unfold, a minutely detailed rendering illustrates a complex and almost life-size *Egregia* folded over on itself, dense with blades and bladders. The first time I saw this lithograph, I swooned. It is still unknown who deserves credit for these illustrations.

At about the same time, the Irish botanist and phycologist of Quaker background named William Henry Harvey was accumulating specimens from all parts of North America, collected by an assortment of naturalists in the field. From 1852 to 1858, after a trip to the United States, Harvey published his monumental *Nereis Boreali-Americana or Contributions to a History of the Marine Algae of North America* with the support of the Smithsonian Institution. Harvey was a gentle, brilliant soul whose commitment to the kingdom of nonflowering (cryptically reproductive) plants, including algae, was pronounced by the age of fifteen when he wrote: "I intend to study my favourite and useless class, Cryptogamia. I think I hear thee say, Tut-tut! But no matter. To be useless, various, and abstruse, is a sufficient recommendation of a science to make it pleasing to me." He traveled the globe collecting seaweeds, and while his specimens

Opposite: *Fucus menziesii*. From Turner, *Fuci* (1808, vol. 1, pl. 27). Now *Egregia menziesii*.

had infinite variations of color, their spores, clearly visible under his microscope, were definitive circles of super-color: vibrantly "grass-green," intensely "olivaceous" or olive brown, and vividly red. In 1841 Harvey established the taxonomic groupings of brown, red, and green that are still used to group the seaweeds, and he organized the volumes of his North American algal descriptions accordingly.

On page 62 of his first volume—focusing on the brown, or olive-colored, algae—Harvey describes the *Egregia* and acknowledges Menzies as the collector of the type specimen at Nootka Sound. He emphasizes throughout his description how variable this kelp can be in its appearances, its fringe made of "leaves" that "are of various sizes; some reduced almost to bristles, and others being from two to three inches in length. The shape is also subject to great irregularity…the leaf in some cases is narrowly spathulate at others obovate: in all it tapers greatly to the base and ends in a blunt point." Harvey concludes, however, that despite all the differences from one sample to the next, they are all one species, *P. menziesii* (using the name *Phyllospora menziesii*). Even today, despite a remarkable range in appearances, there is only the one species of *Egregia* along the western coast of North America: *Egregia menziesii*.

Today Harvey would be considered both an artist and a scientist, a polymath. He created the splendid watercolor drawings for all of his various algal publications and he wrote poignantly about the seaweeds as unrecognized yet essential organisms of our planet. How I wish we still considered Harvey's organizational chart of the natural world with "man's minor economy" on the sidelines relative to the great "economy of nature." He perceptively, unerringly describes the "household of nature" in which the algae, "though humble when we regard them as the lowest organic members in that great family, are not only highly important to the general welfare of the organic world, but, indeed, indispensable." He explains how the algae "fix carbon in an organized form, in extending their bodies by the growth of cells," and exhale oxygen gas in a free state. "By this action they tend to keep pure the water in which they vegetate, and yield oxygen gas to the atmosphere."

Both Menzies's and Harvey's profound humanity and humility towards the "abstruse and useless" seaweeds is in contrast to the mercantile economic missions of most exploratory ships plying the waters of the Pacific Northwest coast and farther south during the eighteenth and nineteenth centuries. The efforts to create navigational charts and

discover new plant and animal resources were all in the service of increased trade and wealth for colonizing powers. None of the indigenous uses of algae, either in North America or Asia, caught the attention of the seafaring traders. The timber from the great forests and the fur of the sea otter, fox, and seal were shiny objects of clear value, while the seaweeds remained beneath the waves. In contrast, the intense investigations of Menzies, Turner, Ruprecht, and Harvey into life forms different from our own and secreted under the ocean are still inspiring today. As we chew through resources on our planet and frame most notions about the natural world in terms of entrepreneurship and business models, it is refreshing to be in the company of scientists who are trying to understand, to build empathy for an organism as interesting and wondrous as the feather boa kelp, which, as far as I know, has no monetary economic importance whatsoever, but, as one of the algae, plays a part in life-sustaining oceanic-atmospheric interrelationships that affect us all.

William Henry Harvey acknowledged all the explorers and collectors who sent him specimens to describe in *Nereis Boreali-Americana*, but he held a special place for Menzies and his collections from the Pacific Northwest, "that interesting botanical region." Harvey had met the older naturalist before he died in 1842 and remembered him as "one of the finest specimens of green old age that it has been my lot to meet. He was the first naturalist to explore the cryptogamic treasures of the Northwest, and to the last could recall with vividness the scenes he had witnessed, and loved to speak of the plants he had discovered. His plants, the

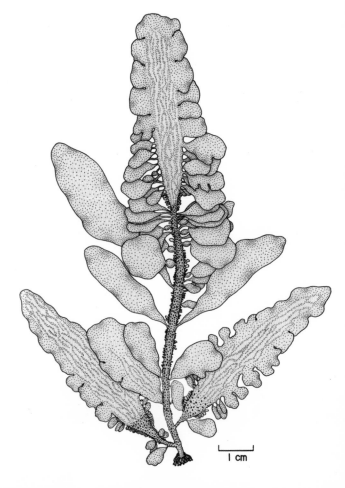

Juvenile *Egregia menziesii*.
Illustration by Ernani Meñez from R. F. Scagel,
Guide to Common Seaweeds of British Columbia (1972).

| cm

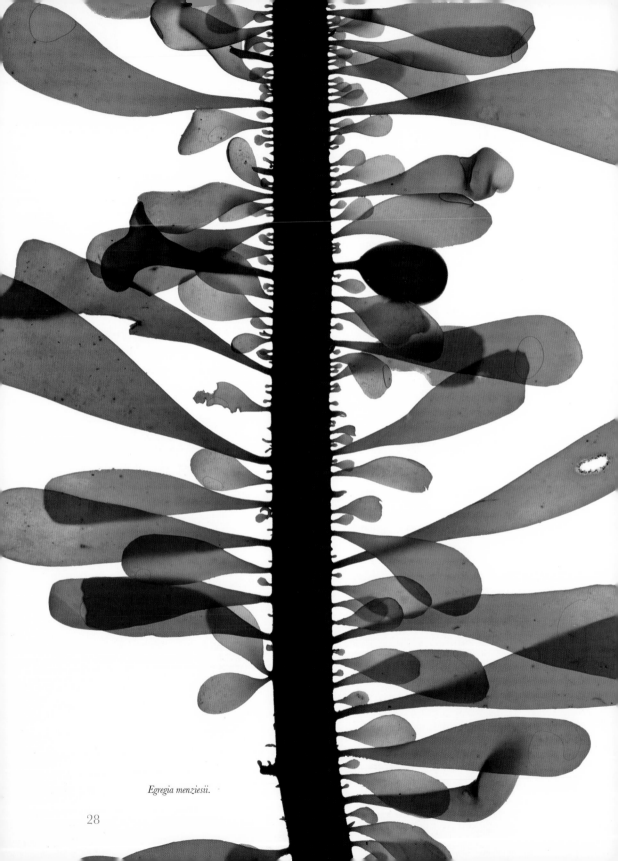

Egregia menziesii.

companions of his early hardships, seemed to stir up recollections of every circumstance that had attended their collection, at a distance of more than half a century back. He it was who first possessed me with a desire to explore the American shores, a desire which has followed me through life."

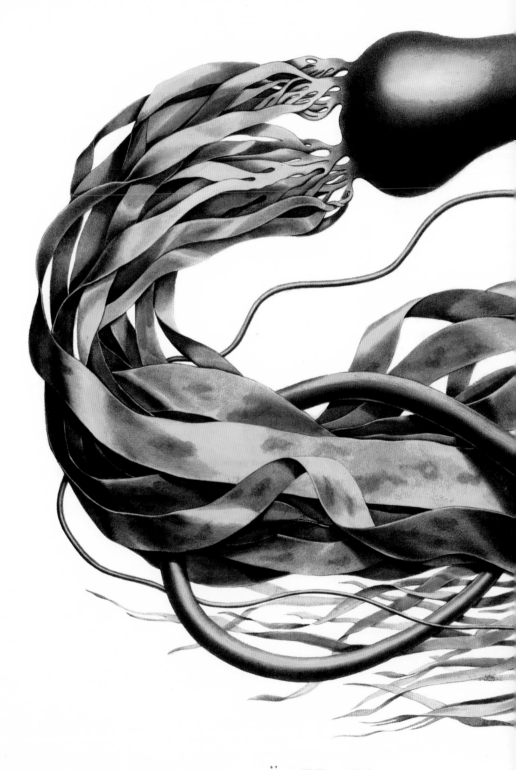

TAB: IX. **NEREOCYSTIS LÜTKEANA** *adulta.*

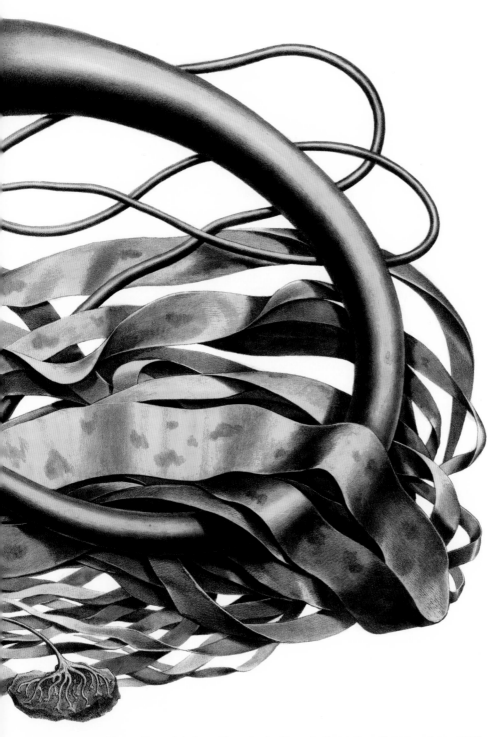

Mature *Nereocystis luetkeana*. Illustration by Alexander Postels from *Illustrationes algarum* (1840).

Nereocystis luetkeana

Bull Kelp

For many years I have been walking the tideline looking for wrack. I wander the same San Francisco beach twice each week, expecting enormous piles of seaweed to appear, but during the drought years they did not come. Normally, winter storms wash up great quantities of kelp that dislodge from the subtidal forests farther north up the coast. These untethered algae drift south, gathered by the waves into great aggregates of twisted stipes and matted blades, a remarkable amount of biomass. These piles of seaweed are stinky and unruly, not your picturesque beach treasure, but for me they are a fascination. They signal the health of the kelp forests just beyond the lowest tides—kelp forests, otherwise invisible to us beachcombers, stretching along the coast of California, north to Oregon and Washington, and through British Columbia and Alaska.

The kelp we expect to see the most on this San Francisco beach is the bull kelp or *Nereocystis luetkeana*. Bull kelp dominates the subtidal canopy forests of the Pacific coastline from Santa Cruz north to Vancouver Island. There are other large kelps of course. *Macrocystis pyrifera*, or giant kelp, dominates the kelp forests south of Monterey clear to Mexico. There should be mounds of *Egregia* (feather boa kelp) and *Stephanocystis* (bladder chain wrack) washing ashore. Bull kelp, however, is typically the major player in these parts, massive and hefty, thriving in the nutrient-rich, cold waters of the North Pacific. The stalks—or stipes—are long ropes of tough, cortical material it takes a pocket knife to cut through, ending in a single bulb, or bladder, as big as the lemons on my no-good lemon tree. The blades, streaming out from the bladder—or pneumatocyst—multiply from four source points into sixty or more ribbons of thin golden fronds. The piles of wrack are sometimes a combination of kelps—the green, paddle-fringed straps of *Egregia* intertwined with the golden tips of *Stephanocystis* or the chain of ovoid bladders of the *Macrocystis*. But I have found from many years of walking on this particular beach that the seaweeds tend to come in by type, with one species dominating the wrack line on any given day.

Opposite: Nereocystis blade with sori patches, collected by K. Kikuchi, Santa Catalina Island, California, 1979. University Herbarium, University of California, Berkeley, no. 1834035.

On a typical "*Nereo* day," the huge, mature kelps tumble together, their long "bull-whip" stipes—which can stretch up to 38 percent to give and take with the ocean currents—entwined with one another, the blades more or less intact. If it is springtime there might also be baby or juvenile kelps, on their own, close to the water's edge, their golden bladders no bigger than my thumbnail, their four golden blades catching the sunlight, radiating wonder in their molten translucence. While the baby *Nereocystis* found on the shore is no longer viable, it indicates that other youngsters still grounded to the ocean bottom below the lowest tides are thriving, using the power of sunlight and the nutrients of the ocean to perform one of the greatest feats of metabolic growth on our planet.

Nereocystis luetkeana is an annual. The entire organism grows anew each season, typically starting in late winter or early spring. For six months that growth is astounding. The long, singular stipe grows in a reverse taper, from thin at the bottom, where a modest holdfast secures it to the rocky bottom, to thick towards the top. It can grow six to ten inches a day and reach heights of fifty to sixty feet in a matter of months, slowing once the bladder—containing 10 percent carbon monoxide—senses a proximity to the surface. This stupendous growth is all in the service of efficient photosynthesis. The long stipe and gas-filled bladder allow the blades to spread along the surface waters catching as much summer sunlight as possible. After about two hundred days, the entire organism dislodges from the ocean floor, holdfast and all, and washes away, settling in ocean canyons or tumbling onto sandy beaches. This

bull kelp detritus fuels other food webs: beach hoppers and kelp flies consume the wrack piles, in turn delicious food for shorebirds.

But the mighty bull kelp must reproduce each year if the kelp forest is to persist. It must disperse its spores before it is pulled off the ocean floor. Like most kelps, the life cycle of *Nereocystis* is a complex cycle involving both an asexual phase producing spores and a sexual phase with egg and sperm. This alternation of generations with two radically different physical manifestations—one macro and one micro—must all work in concert with the tides and currents. Despite what seems like desperate reproductive odds, *Nereocystis* has been in the subtidal mix for hundreds of millennia. It must have a recipe for success.

In spring the ribbonlike blades of mature bull kelp emanate from the bladder in four olive-brown clusters, luminous when the sun shines through them. Extended daylight of summer and upwelling of nutrients accelerate bull kelp growth, and by the end of summer a dark-brown patch, two to seven inches long, emerges on each blade. Called "sori," these fertile patches are bundles of spores. As growth continues, the maturing sori gravitate to the outer ends of the blades, while new ones emerge closer to the bladder. At some point, coordinated with the light of dawn, a whole sorus abscises from its blade—the connecting cells at the edge of the elongated blotch become structurally weak and the patch falls away to settle near the base of the parent alga. Within one to four hours of this falling away, millions of photosynthetic spores are released into the water column to disperse. The majority settle on the rocky bottom, the habitat that was favorable to the adult from which they came. With forty to sixty blades each, an adult *Nereocystis* can produce over three trillion spores—it is a sporophyte with two copies of nuclear DNA in each cell. As the spore patches fall away, only the edges of the blades remain, ragged, hanging like stencil edges or the leftover dough after cookies have been cut out. A few of these mature bull kelp will overwinter, but the winter storms will wash most of the massive organisms away from their kelp forest home.

The tiny spores that successfully settle on the rocky bottom germinate via meiosis into the alternate phase of the *Nereocystis* life cycle: microscopic, threadlike sexual organisms, males and females, gametophytes that sport only a single set of nuclear DNA. These tiny organisms lodge in the cracks and

crevices of the ocean bottom to wait out the rough weather and dim light of winter. Studying this cryptic sexual phase is understandably hard, and questions abound. It is not clear, for instance, how long these filamentous microorganisms wait until they release their egg and sperm. Can they persist for years and create a seed bank of sorts? Do they photosynthesize to survive down on the ocean floor? Do they have a cue, more sunlight perhaps, to start the sexual process? How do they keep from being washed away into different territory by the ocean currents? We do know that when the time comes, the sessile, or fixed-in-place, female releases a powerful pheromone that attracts the nearby roving sperm. Fertilization initiates the development of a baby sporophyte that grows into the massive bull kelp we recognize. This new growth begins in late winter or early spring. There should be a regular rotation of wrack on the beaches each year, indicating the rhythms of robust growth out under the waves.

But these typical cycles can get alarmingly out of whack. In 2016, early summer aerial surveys of the Sonoma and Mendocino coasts showed a dramatic decrease in kelp coverage. At one point the decrease was as high as 93 percent. Like so much of our natural world, stressors on the kelp forest can accumulate to become overwhelming.

One overriding factor affecting all seaweeds is ocean temperature. From 2013 to 2016 an ocean heat wave, known as "the Blob," parked a large mass of warm water offshore. The warm water on the surface did not allow the deeper, colder waters to rise

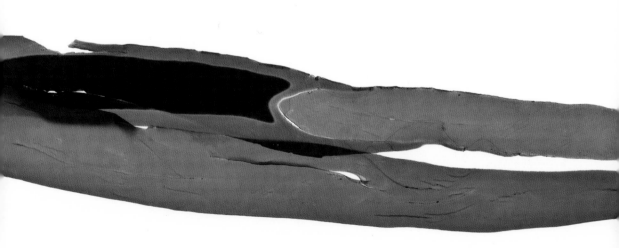

Nereocystis blade with sori patches.

up, effectively putting a lid on the upwelling of critical nutrients. Without vital cold temperatures and the nitrates, silicates, phosphates, and other nutrients at the base of the food web, the whole ecosystem suffers. The Blob gave way and in 2017 there was healthy upwelling, to the delight of marine biologists, whale watchers, and tide-poolers alike. The creeping rise in general ocean temperatures, however, will provoke substantial changes in algal populations such as shifts in range or smaller growth patterns. Warmer oceans will also increase an organism's susceptibility to other stressors.

Urchin herbivory is perhaps the most obvious stress factor to affect the bull kelp forest. These kelp forests of the northern coast of California are ecosystem drivers, creating food and habitat for countless fish and invertebrates. They offer shade and cover, a nursery to lay eggs and allow larvae and young fish—especially rockfish—to grow and hide from predators. The kelp, the source of so much richness in nearshore ocean ecologies, is also delicious to eat. Bull kelp is susceptible to predation by a number of hardcore herbivores, most notably sea urchins and abalone. These voracious kelp foragers are, in turn, typically kept under control by a couple of their own predators, starfish and sea otter. This web of predator (starfish or otter), prey (urchin), and primary producer (kelp) is known as a trophic cascade. It is in constant flux, and the balance can easily be upset when numerous factors come into play at once.

Abalone and red sea urchins eat some of the kelp, but the most aggressive grazer along the California coast is the purple sea urchin. *Strongylocentrotus purpuratus* is one of those surprising organisms for which humans have not found a use. The larger red urchin is fished by divers and sold as a source of the delicacy uni, but the purple are left to munch unchallenged. When snorkeling recently I happened upon a single bull kelp, attached by its holdfast to the bottom, whose bladder and blades were pinned to a vertical rock face by a group of devouring purple urchins. It was a remarkable scene—the bull kelp was defenseless against the attack. I also saw numerous urchin barrens, those areas where thousands of urchins have cleared away any sign of the kelp forest whatsoever, leaving the bare rock covered by a barbed carpet of urchins. It is as devastating a sight as hiking across a clear-cut mountainside. To save the bull kelp, we humans should come up with some reason to love and harvest the purple urchin, because its two natural predators, sunflower starfish and sea otters, have vanished from California waters north of the Golden Gate.

From 2013 to 2016 a widespread starfish wasting disease killed off most of the orange or purple starfish (ochre stars) one would normally find when tidepooling along the California, Oregon, or Washington coast. Ochre stars (*Pisaster ochracea*) keep mussel populations in check and also prey on sea urchins. More significantly, the wasting disease has devastated the deeper water populations of *Pycnopodia helianthoides*, or sunflower star, one of the largest starfish in the Pacific. *Pycnopodia's* flexible body with up to twenty arms and tens of thousands of tube feet make it a formidable hunter and a remarkably effective predator of the sea urchin. It has been called the wolf of the subtidal oceans. The sunflower star can sense light and dark and move quickly to get its arms around an urchin. While ochre stars are making a comeback in shallower waters, divers are looking urgently for signs of a rebound in populations of sunflower stars, but none has been observed. The species has pretty much disappeared. As a result, urchin populations have exploded.

The demise of the hunter starfish has highlighted their importance as a keystone predator that kept the trophic systems in balance by keeping urchin populations in check. This would not be overwhelming to the kelp forest if it were not for the overriding context that another effective top predator, the sea otter, was hunted to near extinction.

By 1900, the fur trade had decimated the once robust populations of the northern and southern sea otter, who ranged from the Aleutians down the coast of Alaska, through Canada and southward all the way to Southern California. Sea otters can clear an area of sea urchins in no time. They must eat about a quarter of their body weight each day to maintain their hypercharged metabolism, and while the sunflower stars will eat the smaller urchins, the otter can eat fifteen to twenty pounds of large urchins in a day. They eat a range of invertebrates—mussels, snails, abalone, crab—but if the urchins are healthy, they are a favorite. An otter dives to the ocean floor and carries an urchin and a stone to the surface in a pouch of loose flesh under its forelegs. It places the stone on its belly and smashes the hard and spiny outer test, or shell, of the urchin to get at the nutritious food within. The otter's capacity to hunt and eat urchins is a crucial dynamic for healthy kelp forest habitat.

Sea otters have the thickest fur of all mammals, luxuriously soft and warm. To make up for their lack of blubber, otters have a million hairs per square inch of coat, allowing

them to thrive in cold Pacific waters. Sea otter pelts were considered "soft gold" by the mid-eighteenth century when Russian traders were expanding their routes from the Aleutian Islands to Alaska and south past Vancouver Island to the California coast. In 1778 Captain James Cook introduced sea otter pelts to the Chinese and European markets. Menzies's expedition of 1786, captained by James Colnett, was driven by the fur trade between the Pacific Northwest and China. By 1800 the Northwest maritime fur trade was in full swing when other British and American outfits joined the Russian enterprise, commandeering and enslaving expert Aleut hunters to do the killing. Although it took a century to complete the slaughter, the sea otter along the California coast had little hope. One tiny colony of sea otters survived, hidden at Point Sur on the central coast, and these fifty otters, discovered in the 1930s, are the source of the rebounded population around the Monterey Peninsula and south to Morro Bay. But further north in California, no sea otters have lived amongst the bull kelp for 150 years. We have almost forgotten their place at the top of this particular kelp forest's food chain. Their story needs to be told.

Amidst the exploitive ventures of the fur trade, a Russian expeditionary force, sponsored by Tsar Nicholas I, was the first to collect samples of the great *Nereocystis* along with other seaweeds from the Pacific coast of North America. From 1826 to 1829 the corvette *Seniavin*, under the command of Captain Friedrich Benjamin von Lütke, plied the

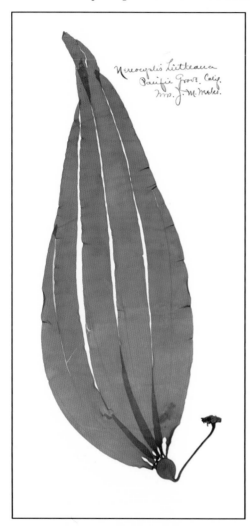

Nereocystis luetkeana, collected by J. M. Weeks, Pacific Grove, California, no date. University Herbarium, University of California, Berkeley, no. 97153.

shores of present-day Alaska surveying and collecting specimens. Although two official naturalists were aboard, the lead being Dr. Henry Mertens, it was a third, Alexander Postels, a professor of geology, who demonstrated a genius for sketching and an affinity for the enormous and extraordinary seaweeds found along the Alaskan coast. In 1840, in partnership with the botanist Franz Joseph Ruprecht, Postels created one of the most extraordinary folios of marine algae of all time, *Illustrationes algarum*. Ruprecht's descriptions are accompanied by Postels's dynamic, oversized lithographs of each species rendered in full color.

Postels imbues the lithographs of the seaweeds and kelps with all the grandeur they deserve. But even the enormous page size could not contain the mature *Nereocystis*, which he depicts wrapped around itself. The profusion of blades emanating from the large bladder swaddle the circling stipe, which reduces through fold and squiggle to a diminutive holdfast on a tiny rock. The entire organism creates a regal crown announcing itself as the influential player in the hierarchy of marine organisms.

The mighty bull kelp was officially described for the first time in the Postels and Ruprecht publication and was given the species name *Nereocystis luetkeana* by Mertens, commemorating the leadership and scientific zeal of their commander, whose portrait reveals a mustache as grand as the expedition itself. Mertens notes with delight the astonishing bull kelp as seen for the first time in Norfolk Sound, as Alaska's Sitka Harbor was then called: "Norfolk Sound is equally rich in beautiful Fuci as in rare and remarkable marine animals; and I doubt if a more delightful strand for sea-weeds is to be found…one, was too remarkable to be passed over in silence. The more so, as it is quite a feature of Norfolk Sound."

Mertens describes in detail the bull kelp, noting that the lower stipe is as thin as "packthread" and used locally and throughout the Aleutians as fishing line, and the great upper cylinder of the stipe is used as a container or a siphon to bail water out of a kayak or *baidarka*. He notes that the Russians call this seaweed "sea otter cabbage," remarking in his account how otters make "particular choice of this seaweed, as its favourite refuge and residence; delighting to rock and sleep on the long cylindrical bladders, which, like enormous sea-serpents, float on the surface of the water and individually sweep between the little islands, rendering the channels impassable for boats."

Mertens and Postels also might have seen a mother otter wrap her young pup in bull

kelp blades to keep it from floating off as she dives for food. The intertwined relationship between the otters and the kelp forest was manifested literally. Mertens and, most likely, Postels sketching beside him, were seeing the outward beneficence of the otter-urchin-kelp trophic cascade in working order, whereby otter keep urchin populations in check so that the kelp forest can grow abundantly and in turn provide food and shelter not only for the otter but for its food source as well.

The intimate relationship between otter and bull kelp was also recorded by a pioneering zoologist named Edna Fisher (1897–1954). Fisher received her bachelor's and master's degrees in zoology from the University of California at Berkeley and began teaching biology at San Francisco State College (now San Francisco State University) in 1930. Within a month of the discovery of *Enhydra lutris nereis* (southern sea otter) in March 1938 in a remote cove fifteen miles south of Carmel, Edna Fisher was on the bluffs with binoculars observing and writing about sea otter behavior. She brought students down to Bixby Canyon on primitive camping trips, pioneering a style of instruction that gave students real experience in field observations. She collected carcass specimens washed ashore. She photographed and recorded the features of this marine mammal that all had thought to be extinct along the coast of California. Fisher published numerous papers from her observations and was the first biologist to describe the tool-using behavior of the sea otter. Throughout her papers she describes similar interactions between the otter and the bull kelp, as did Mertens. The *Nereocystis* is clearly observed and described as the otter's nursery. Fisher's charming drawings of the otter, always surrounded by the large "tubular kelp," confirm the entwined reality of these two organisms, marine mammal and marine alga.

Edna Fisher was an advocate for the otter throughout her lifetime, wary that the value of its pelt might spark poaching. Like many otter scientists today, she dreamt of the mammal's return to its historical range along the entire western coastline from Mexico to Alaska and on through the Aleutian Islands. Otter populations have rebounded in parts of Alaska and along Vancouver Island and other parts of the coast of British Columbia where they have been reintroduced from remnant populations in Alaska and the Aleutian Islands. As a result, kelp forests and fish populations along those shores have rebounded as healthy, robust ecologies.

In California the otter population around the Monterey Peninsula has grown from that core group found in 1938 to about three thousand, but its range has not expanded beyond the central coast. There are no otter or sunflower stars to the north of the Golden Gate, and the subsequent surge of urchin populations has caused the steep decline in bull kelp coverage along the coast of Sonoma and Mendocino counties in California. The reduced presence of kelp forest is alarming. Some might argue that kelp is resilient and cycles or "regime shifts" are common. Perhaps with no more kelp

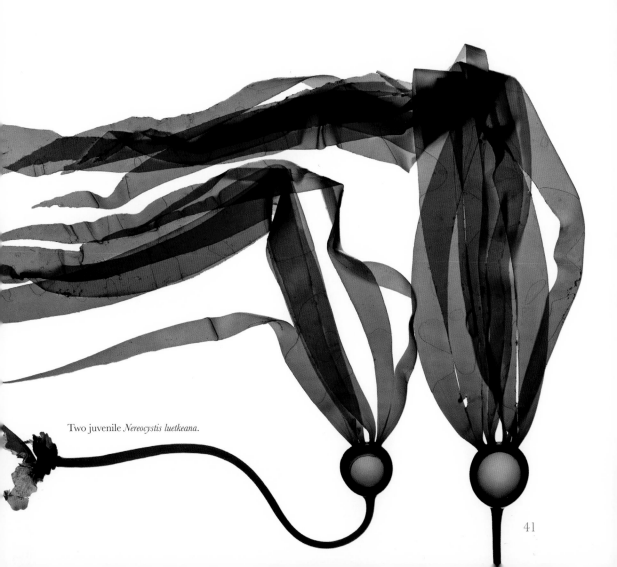

Two juvenile *Nereocystis luetkeana*.

41

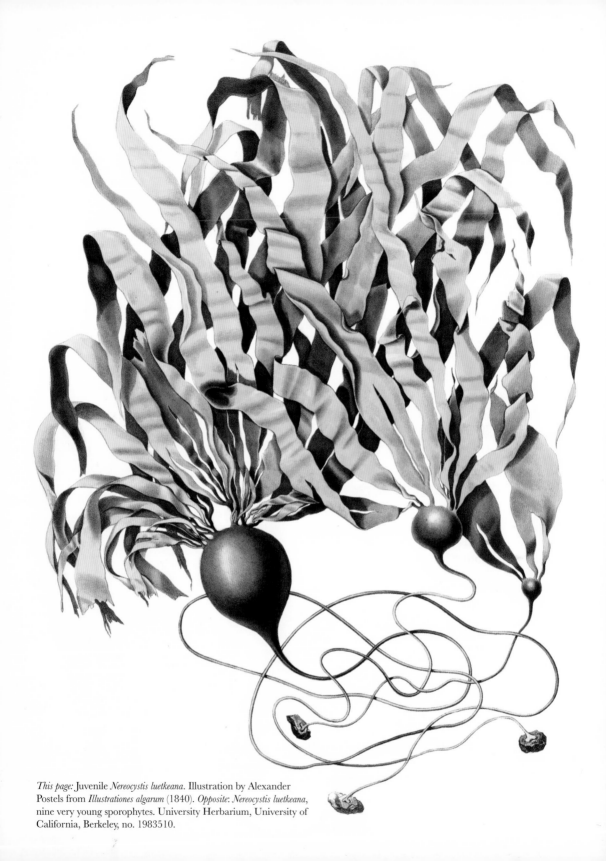

This page: Juvenile *Nereocystis luetkeana*. Illustration by Alexander
Postels from *Illustrationes algarum* (1840). *Opposite*: *Nereocystis luetkeana*,
nine very young sporophytes. University Herbarium, University of
California, Berkeley, no. 1983510.

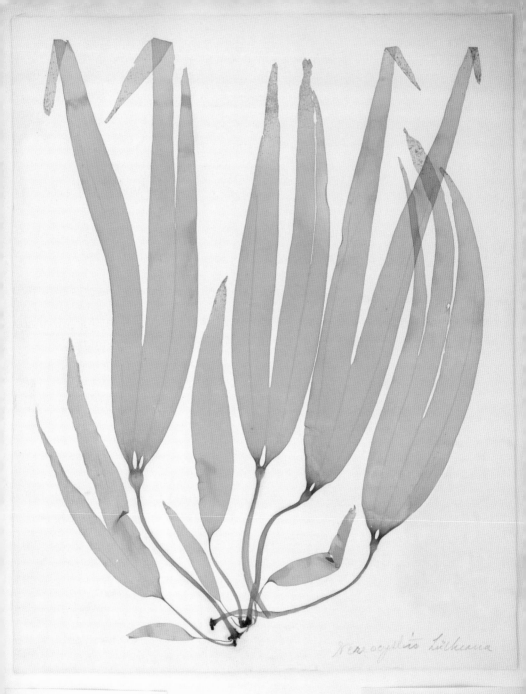

to eat, the urchins of the barrens will wither and die off from starvation, giving hope that the bull kelp forests will revive. In the beautiful book *Imam Cimiucia: Our Changing Sea* (2011), Anne Salomon, a British Columbian anthropologist-ecologist, uses the direct voices of indigenous families in Alaska to record shifts in ocean ecosystems along the Kenai Peninsula, an area that mirrors the California coast in many ways. There, notably, sea otters have returned and the resulting regeneration of the kelp forests is exhilarating. But there is a commensurate decline in shellfish and invertebrates that both human foragers and otters compete for, and ambivalence towards the otter is palpable. While a decline in purple urchins because of otters is hailed, a decline in abalone, whether in Alaska, Canada, Oregon, or California, is controversial.

The idea of a return of sea otters to the Humboldt, Sonoma, and Mendocino county coastlines in California, despite the benefit to the total kelp forest ecology, is met with resistance and ambivalence from some stakeholders. Divers for prized abalone have forgotten about otter as a natural predator of both urchin and abalone and have come to expect a size, abundance, and density of abalone only known after the fur trade hunted otter to near extinction. When otter are around, abalone hide in crevices and rarely reach the dinner-plate-size mollusks that are wrenched off the rocks and brought home for the barbecue. If otter returned to their historical habitat amidst the kelp forest of Northern California, there would be heavy impacts to the abalone fishery. There are no baselines for knowing the abalone populations counted under predation pressure from otters. If we imagine the kelp forest before Vancouver and Lütke, before the mercantile economies of the Russian, British, and Spanish empires made otter pelts an accepted and desired form of currency, those underwater worlds, flowing blades of *Nereocystis* up top and understory kelp and seaweeds below, would probably include only occasional abalone. Abalone shells were rare enough to be prized by Northern California indigenous tribes, and they were accepted as payment for otter skins in the 1830s and 1840s. Unfortunately, in 2019 the depleted kelp forest could not support otter. The impoverished urchins would not provide enough protein to keep the voracious otter satisfied and healthy.

The frontispiece of *Illustrationes algarum*—the first plate presented by Postels and Ruprecht—is titled *algarum vegetatio*, or seaweed community. It shows a pair of Russian navy sailors collecting seaweed on the rocky shore of present-day Alaska circa 1829.

The major portion of the image, clearly delineated by the surface of the water and colored in greens, golds, and reds, is the realm of the seaweeds beneath the tide. Clearly drawn with slender stipe, single bulb, and blades flowing with the current are a cluster of the unmistakable *Nereocystis luetkeana*.

Nereocystis, the largest algal organism on the California coast, is akin to the great redwoods in their scale. Both create habitat for a whole array of organisms, and both are photosynthetic machines, pumping out oxygen and sequestering carbon. Unlike the redwoods, *Nereocystis* grows to its grand height in a single season, and unlike the redwoods, I can't go buy a sapling at the nursery and watch it grow. I did this with a couple of redwoods. My neighbor and I planted two redwood saplings in a vacant lot in the neighborhood, tucked away from view under a steep hill. We have watered them through drought and clipped away the encroaching blackberry vines, hoping to give their taproots a chance to find a deep source of water and to thrive on their own. I have shared their secret with my children and hope to keep watch with a future generation as they grow. How I wish I could do this with a young bull kelp sporophyte: watch it grow from two tiny blades and a few haptera of holdfast into a juvenile with a countable four blades and finally into the mature organism with countless blades flowing off the ripened bladder. This year the massive bull kelps are again washing up on our beaches, so I make do with appreciating the end of its life cycle. I take way too many pictures of the jumbled wrack and describe its subtidal life with enthusiasm to any who walk with me. Most of my compatriots are surprised at my alarm when describing the decimated kelp beds of Northern California. They had no idea.

Despite the increased viability and proliferation of kelp farms—mariculture—*Nereocystis* is not on the list for cultivation. It is truly a wild thing; its habitat is open ocean and bays, the wave-drenched, rock- and reef-strewn, fog-enshrouded coast of the Pacific Northwest, not very hospitable farming terrain. *Nereocystis* comes to mind as an organism so of its place, of the web of its place, that it cannot be organized by humans. And yet when we remember that *Nereocystis* evolved over millennia in concert with *Enhydra lutris*, the sea otter, whom we nearly extirpated from the Pacific Coast, we realize that in fact humans have created an unnatural ecology for the bull kelp forest, an ecology with a large piece missing, making resilience and comeback so much harder.

It is disturbing when the health of the kelp forest, unseen and thought to be beyond

the economies and politics of humankind, is yet entangled in them. The challenges beyond these are already considerable. Unlike a perennial such as *Macrocystis*, *Nereocystis* cannot regenerate if the top portion of the organism is removed or harvested by human or urchin; it must grow its reproductive blades anew every year and go through the complete and complex cycle of generations. Warmer oceans hold fewer nutrients than colder oceans, so the intensification of climate change means *Nereocystis*, with its huge

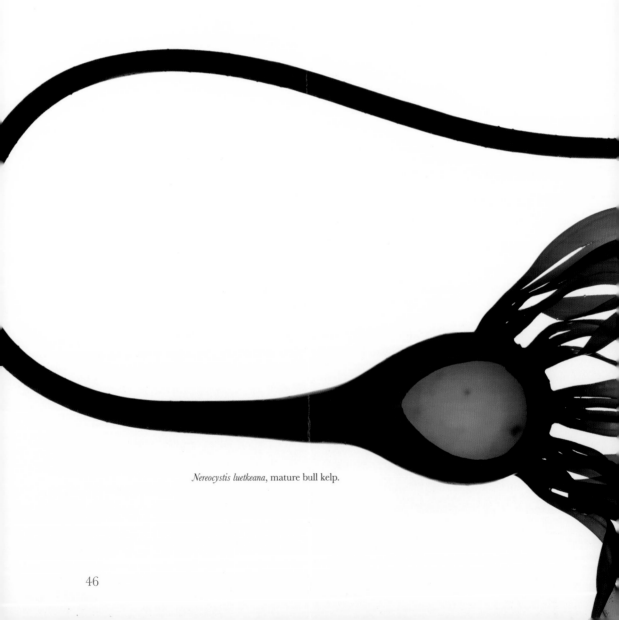

Nereocystis luetkeana, mature bull kelp.

nutrient demands to make that fabulously fleshy thallus of stipe and bulb and blade, will have a harder time regenerating. If we take a considered and thorough look at the pressures we put on the ecosystems we want to recover, and let the wild systems work their ways, I hope with all my heart that the bull kelp will flourish along our coasts again. A few sea otters amongst the Northern California bull kelp is a vision I hope I live long enough to see.

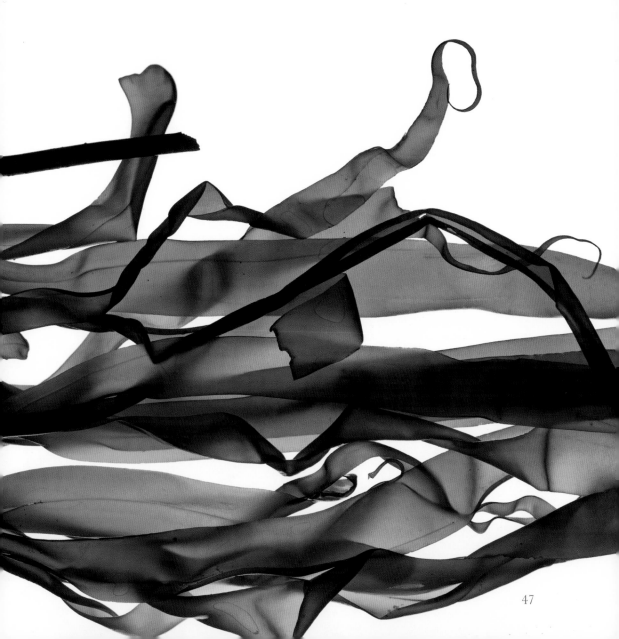

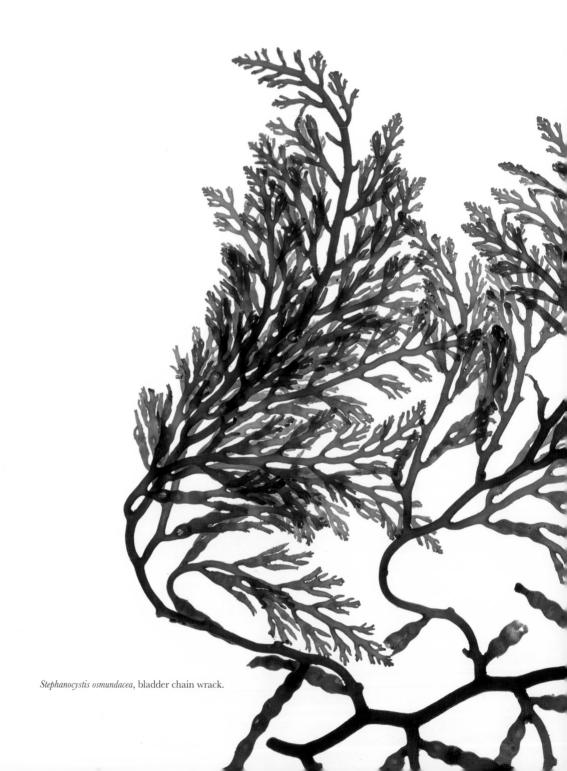

Stephanocystis osmundacea, bladder chain wrack.

Bladder Chain Wrack

Stephanocystis osmundacea is a common but elegant brown seaweed, designated a "wrack" as opposed to a kelp. It is in the order Fucales like the rockweeds, and is a close cousin to *Sargassum*, those famously floating algae. The body, or thallus, of this seaweed has two distinct sections: the tough, rounded blades at the base and the delicate bladder chains above, each rising to a pointy apex. The bulk of the algae shifts from the decidedly opaque brown blades below to a golden glow in the upper reaches as the sun pushes through each elongated figure of three to four tiny connecting beads or floats. This top portion can grow profusely in summer, creating a floating canopy of bladder chains. Then, if winter storms do their duty, great mounds of *Stephanocystis* should be heaped along the ocean edge at Stinson Beach in Marin County or the beaches around the Monterey Peninsula. The upper portion of the plant dominates these mounds of wrack. In the water, the holdfast, a triangular agglomeration of cells extending into the crevices of the rocky ocean bottom, keeps the lower portion of the organism intact to weather out the winter below the waves. I am most amazed when amidst a pile of beach detritus I can isolate a small section—a single cluster of the bejeweled chains—whose graphic shape resembles a cleverly designed corporate logo, and yet is completely algal

made. Until recently, the genus of *Stephanocystis osmundacea* was recognized as *Cystoseira*, *cysto* being Greek for bladder or pouch and *seira* meaning chain or rope.

While gas-filled bladders—pneumatocysts—are unique to the division Phaeophyta, the brown algae, *Stephanocystis* seems to have its organization backwards. Typically, the bladder's function, as seen in *Egregia* and *Nereocystis*, is to hold the flattened kelp blades—maximized arrays of photosynthesizing cells—up closer to the surface waters, where sunlight is strongest and photons can most easily ignite the pigments within the blade's cells to energize the process of photosynthesis for

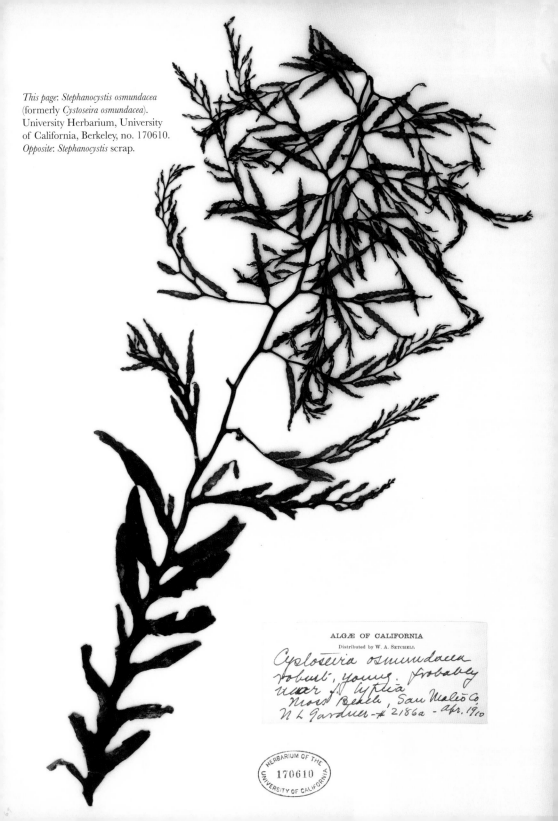

This page: *Stephanocystis osmundacea*
(formerly *Cystoseira osmundacea*).
University Herbarium, University
of California, Berkeley, no. 170610.
Opposite: *Stephanocystis* scrap.

ALGÆ OF CALIFORNIA
Distributed by W. A. SETCHELL

Cystoseira osmundacea
robust, young. Probably
near f. Lyngbia
Moss Beach, San Mateo Co.
N L Gardner - # 2186a - Apr. 1910

170610

growth. This all seems to make good evolutionary sense. The delicate bladder chains of *Stephanocystis*, however, rise towards the surface, leaving the flattened blades in the lower or basal regions towards the ocean floor.

Stephanocystis and its backward morphology is a testament to the nuances of the intertidal zone where variation and variability lead to a remarkable diversity of forms, colors, and solutions for success. *Stephanocystis* grows on the shallower edge of the subtidal kelp forests and extends its range up into the lower intertidal region, where the lowest tide will reveal it. Reaping sunlight is not a problem in this shallower zone, especially during the longer days of summer, when growth of the apical mass of bladder chains is profuse. But *Stephanocystis* is a perennial, persisting from year to year through all seasons. It must shed its bulky top regions to withstand the buffeting of winter storms and extreme wave action in this most vulnerable position. Other subtidal kelps are in deeper water below direct wave activity. Other rockweeds, such as *Fucus distichus*, claim higher regions where rocky reefs mitigate the pounding winter surf. *Stephanocystis* is right there in the middle where breakers exert enormous force. The strategy of shedding its top and leaving the blades to overwinter has proven a successful one. Adult *Stephanocystis* plants show high rates of survivorship: a mature organism can live from five to ten years. Judith Connor of the Monterey Bay Aquarium Research Institute describes the striking seasonal relationships of *Stephanocystis* growth as "an exquisite picture of complexity."

Stephanocystis scraps.

While full-grown bladder chain wrack shows resilience and pluck under extreme forces, the young recruits or germlings apparently have a hard time getting started. They need plenty of open space and sunlight and a rocky substrate to land on. To survive they must compete with larger algae for sunlight and avoid being eaten by

herbivorous snails, urchins, and fish. Their mortality rate is high when young, but the longer they can survive and grab a toehold in the sliver of the intertidal they have claimed, the greater their chances for survival. If they can make it past the first six months of life, they have a pretty good chance of persisting for years and making it

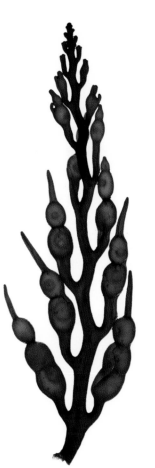

into seaweed old age. The bladder chain wrack community has a low turnover rate, and this makes it all the more vulnerable to downward pressures from ocean warming, human foraging, and other stressors to their habitat.

One of the most robust communities for *Stephanocystis osmundacea* is the Monterey Peninsula. Gilbert Smith, in his 1944 *Marine Algae of the Monterey Peninsula*, estimated that 85 percent of all California seaweeds could be found along the shoreline of the Monterey Peninsula from around Point Pinos to Point Lobos. Smith's volume became the basis for the full marine flora of California by Isabella Abbott and George Hollenberg, *Marine Algae of California*, published in 1976. Smith describes the bladder chain wrack as growing up to seven and a half meters tall (twenty-five feet), and Abbott and Hollenberg add to that, describing *Cystoseira osmundacea* as up to eight meters tall! This is an enormous seaweed.

My visits to Monterey and Pacific Grove always involve a walk at low tide along the beach around the peninsula head. On my last visit, low tide fell at sunset. The majesty of the evening—a moment when land, sky, and ocean converge—was a reminder of the poetic as well as the biological presence of this particular strip of coastline. The richness of life so different from our own is self-evident in this place where whales and otter are regularly viewed. But it is the masses of seaweed around the Monterey Peninsula, in the kelp forests and stretching up onto the shore, that help make this particular spot such a California treasure. With my rubber boots on, I clambered over slippery rocks to the edge of the incoming tide, which lapped at great swaths of green *Phyllospadix* (surfgrass) intermixed with rosy fronds of *Mazzaella* and *Chondracanthus*. Atop a boulder sitting

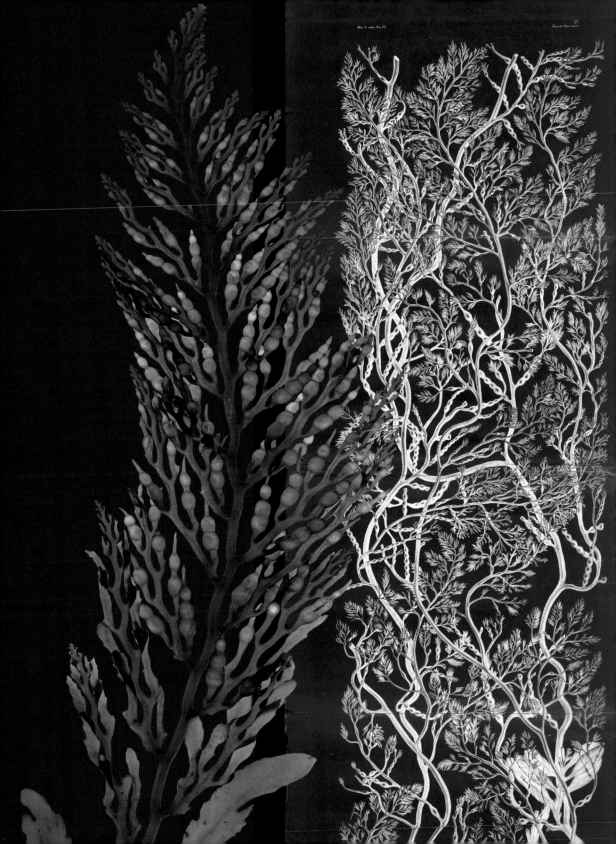

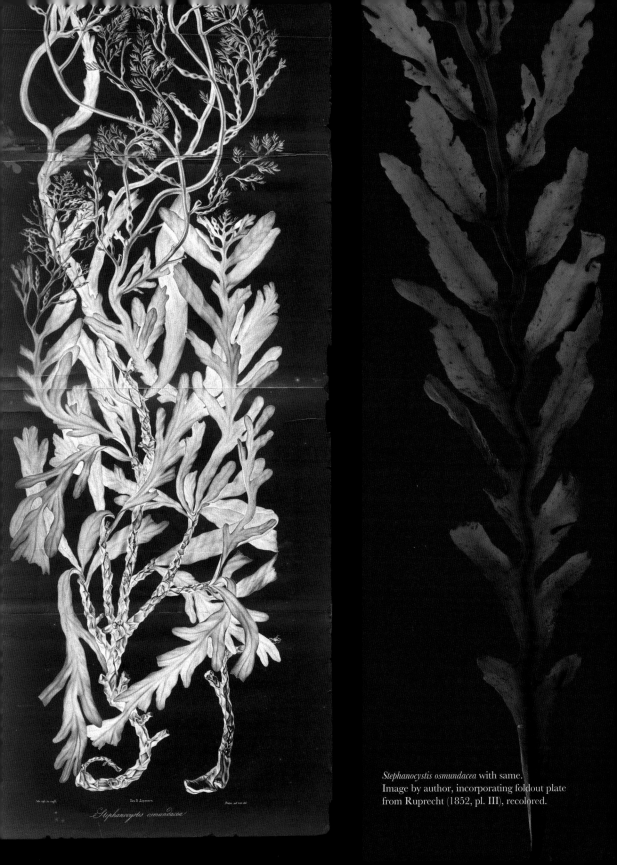

Stephanocystis osmundacea with same.
Image by author, incorporating foldout plate
from Ruprecht (1852, pl. III), recolored.

just at the waterline was a juvenile *Stephanocystis*, only about four or five inches tall, but erect and complete with both rich brown blades at the base, rounded like oak leaves, and a few apical bladder chains rising to a single triangular point, the whole forming a uniform flattened plane. Small but superb, with the low sun alight in its golden blades and bladders, it claimed its space there on top of that boulder, determined to hold on. I wish it the best of luck in today's tough ecological times—hoping it might grow into one of the seven-and-a-half-meter wonders of years past.

In *Marine Algae of California*, Abbott and Hollenberg list the type locality of *Stephanocystis osmundacea* as Trinidad, California, not Monterey. Archibald Menzies collected the specimen of record in 1792 when the Vancouver expedition was on its first circuit along the Pacific Northwest coast. This expedition of two ships, the *Discovery* and the *Chatham*, made the circuit from Hawai'i over to the west coast of North America three times in the early 1790s to survey the uncharted coast of the Pacific Northwest for the Crown of England. In spring they would set out for what Sir Frances Drake had designated Nova Albion (on the Marin coast of California), then head up towards Alaska and then back down to Monterey and San Diego, meticulously exploring and plotting the coastline from small boats, before returning to Hawai'i for the winter. Menzies collected plants and algae continually during the voyage and stored numerous plant specimens in the glass cabinet built on the deck of the ship. These important specimens—including Douglas fir (*Pseudotsuga menziesii*) and Pacific madrone (*Arbutus menziesii*)—made it through the tumult of weather around Cape Horn and back to England. The seaweeds, including *Egregia* (from his earlier expedition) and *Stephanocystis*, went to Dawson Turner, to be described in his enormous multivolume *Fuci*. The bladder chain wrack from Trinidad, California, was named *Fucus osmundacea* by Turner in 1809 because its lower blades reminded him of the royal fern, *Osmunda regalis*.

The type locality of a species is part of its taxonomic history. It is the place where the type specimen, that originally described and named organism, was collected. The collector of the type specimen usually brings or sends this "new to science" life form to an authority on the subject, in this case a phycologist or seaweed taxonomist, with the information on where and when it was collected, so that it can be named in the nomenclature of science. For California seaweeds the era of so much newness and naming was the late eighteenth century, when naturalists on exploratory expeditions

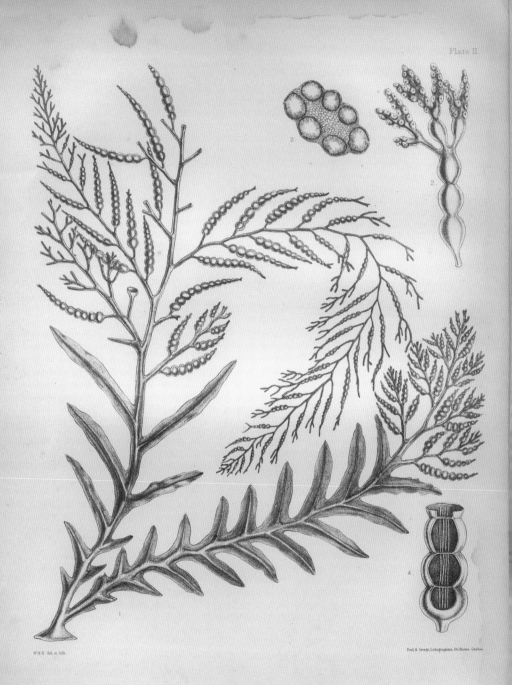

Plate II.

Halidrys osmundacea. Illustration by Harvey from *Nereis Boreali-Americana, Part I.—Melanospermeae* (1852, pl. II). The name was later changed to *Cystoseira osmundacea* and then to *Stephanocystis osmundacea*.

sent seaweed pressings along with thousands of plant and animal specimens back to be described and cataloged within the relatively new Linnaean system. Menzies was recognized as the source of the first named *Stephanocystis*.

But in 1975 Paul Silva, then curator of marine algae at the University Herbarium at the University of California at Berkeley, unraveled a mystery around specimens from an earlier expedition, one that preceded Vancouver and Menzies by about a year. The Malaspina expedition stopped in Monterey in September 1791 for twelve days to survey the harbor, draw and paint the presidio and mission and the Spanish and Ohlone people there, and enrich the expedition's botanical collections. There in Monterey, the naturalist on board, Thaddeus Haenke, collected a sample of bladder chain wrack that was sent back to Spain. It should have become the type specimen, but it did not. While Vancouver and Menzies gained great fame, few people have heard of the Malaspina expedition and Haenke. This is a shame.

The small presidio and mission of a few structures were tucked into the southern crook of the large bight of Monterey Bay. No charts of the area existed at the time, and Alessandro Malaspina's two corvettes approached from the north in densest fog, the fog coastal Californians know as completely opaque and stubbornly persistent. In his journals for September that year, Malaspina recounts the harrowing ordeal of overshooting the presidio and harbor, anchoring to the south and then, with zero visibility and using cannon shots as their guide, cutting their anchor cables and working their way back to the north and into the harbor safely. The journals are written with the poise and equanimity of a true leader and expert seaman.

Once they arrived, the weather cleared and Monterey became the spot where Malaspina's group of devoted scientists and astronomers, sailors and surveyors, artists and hydrologists spent twelve days rejuvenating and reveling in the beneficence of California landscapes. Haenke was the lone naturalist present, charged with collecting any and all botanical specimens that seemed noteworthy. He reveled in the fall blossoms astride the Rio Carmelo, and must have wandered down on the shore among the rocks or along the beaches of Point Pinos into what we know to be the magnificently rich intertidal zone of that area. He chose a few seaweeds to press and include amidst the mass of other artifacts. The splendor of the bladder chain wrack caught his attention, perhaps as the single, boulder-topped juvenile caught mine. Haenke could, possibly,

have been in the exact same spot. His specimen of *Stephanocystis* made it back to Spain along with a treasure trove of other botanical specimens and drawings.

Alessandro Malaspina's five-year expedition from 1789 to 1794, in service to the Spanish Crown, was fundamentally of the Enlightenment: his mission was to add as much order to the uncharted territories encircling the Pacific Ocean as possible. Malaspina's goal was to create a comprehensive encyclopedia and atlas to include the names and pictures of thousands of undocumented plants, animals, and birds, describe the ways and objects of newly encountered peoples, and to chart the as-yet-uncharted coastlines. Malaspina's hope was to broaden the worldview of the Spanish and other Europeans with this compendium of the unknown. He was, perhaps, the quintessential humanist of his time, and at the cusp of a new century, these objectives seemed within reach. To this end, Malaspina and his carefully selected crew of scientists, sailors, and artists were extraordinarily successful.

The Malaspina expedition returned to Spain in September 1794 after five years and two months away. According to María Dolores Higueras Rodríguez, who cataloged the naval archive of manuscripts related to the endeavor, the voyage brought back "one of the largest stocks of news and information ever assembled by a single expedition": spectacularly rendered charts of coastal territories, paintings of birds never before seen, and thousands of botanical and animal specimens. The plans for this material were ambitious. Specimens were to be distributed to the great botanists and scientists of the day to be examined closely and described within the Linnaean system. The superb new nautical charts were to be published in a comprehensive atlas to be used by navigators setting out for the Pacific Ocean. But Malaspina, the humanist, liberal, and forward thinker, returning from five years of encountering the "new," got ensnared in the age-old politics of court intrigue.

Within months of his return, thinking he was in the good graces of the queen of Spain, Malaspina wrote an incriminating letter criticizing the powerful chief minister, Godoy, whose spies amongst the servants got hold of the letter. Godoy had Malaspina arrested and tried. He was found guilty, thrown in jail, and then exiled, and his name was expunged from all records of his remarkable journey. Every project involving the knowledge he returned with was summarily halted, the materials disbursed to languish in libraries and archives, forgotten for many decades. The enormous imprint

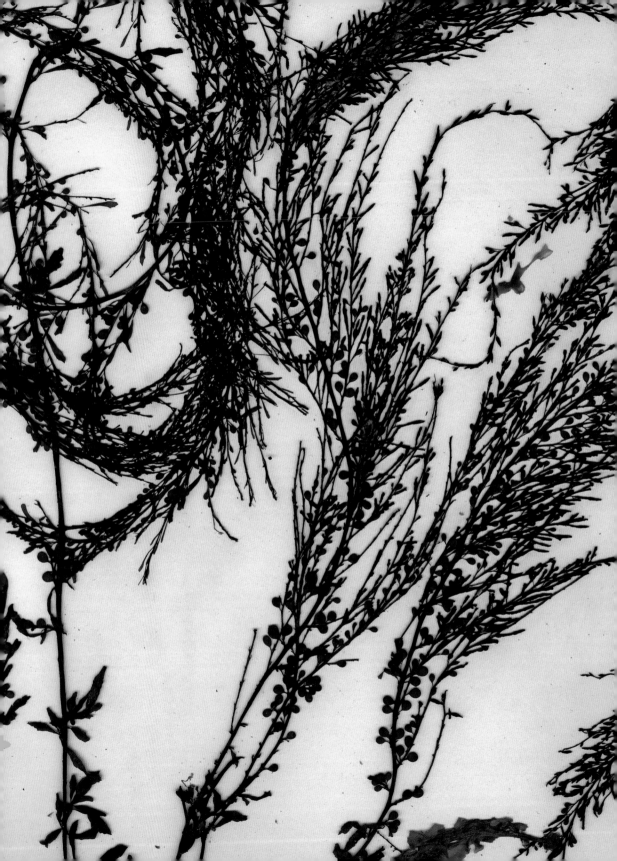

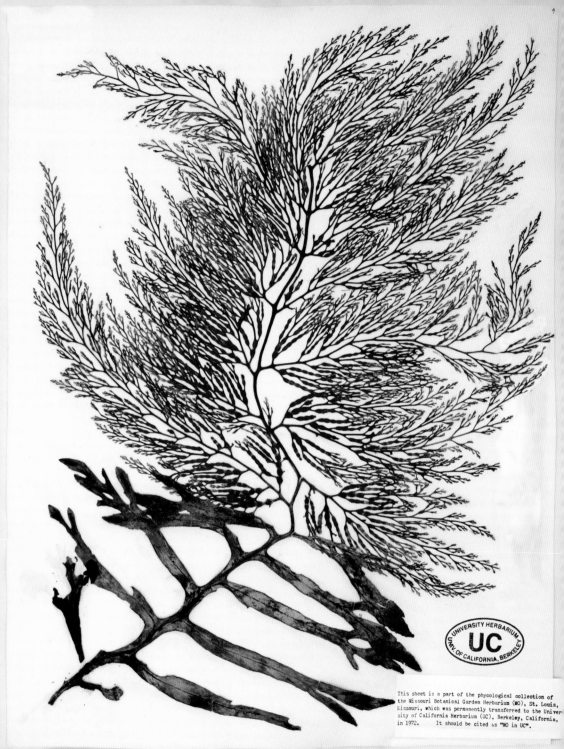

Cystoseira osmundacea
(Halidrys osmundacea
Monterey Peninsula, Calif.
Com. W. Rus.

Missouri Botanical Garden
25602
Herbarium

This page: *Stephanocystis osmundacea.* University
Herbarium, University of California, Berkeley,
no. 1974222. *Opposite*: *Sargassum muticum* (Yendo),
collected by Robert Setzer, Bird Rock, La Jolla,
California, 1971. University Herbarium,
University of California, Berkeley, no. 1837676.

that Malaspina's excursion might have had on European thought and politics swiftly vanished.

And Thaddeus Haenke's specimen of *Cystoseira*? Haenke's collections from California were first stored in a warehouse in Cadiz, Spain, and then sent to Prague where they lay deteriorating. The seaweed specimens were discovered twenty years later and sent to the phycological expert of the time, Carl Adolph Agardh in Lund, Sweden, who recorded twenty-eight species of algae from the Malaspina expedition, most with vague, uncertain, or erroneous labeling as to where they had been collected. One specimen was labeled "In mari australi," a term used for the whole Pacific Ocean in the Malaspina era. Agardh named it *Cystoseira expansa* in 1824. Agardh's son, Jacob, continued in his father's footsteps as the European expert in algae and confirmed that the specimen sent back by Haenke was in fact *Cystoseira osmundacea*. On a trip to Lund in 1975 to study the historic specimens, Paul Silva noticed a small handwritten note accompanying this *Cystoseira* specimen: written in a graceful script was the single word *Regismontanae*, the Latinization of Monterey. This overlooked scrap, probably in Thaddeus Haenke's handwriting, confirms that this specimen had been collected during the twelve-day hiatus of the Malaspina expedition in Monterey. This should have been the type specimen.

The modern era of phycological taxonomy has revisited and revised the genera *Cystoseira* and *Sargassum*, using molecular characteristics to devise new categories, and so our bladder chain wrack is now known as *Stephanocystis osmundacea*—*stephano* meaning crown in Greek. Despite Paul Silva's sleuthing, Haenke has not been credited with the first or type specimen of *Stephanocystis*. And while his specimens made the return trip to Spain, Thaddeus—or Tadeo—Haenke did not. He remained in Peru and collected botanical specimens throughout South America. He died from poison many years later. Malaspina's expedition remains elusive. His exemplary role as commander—bringing ideas and experts from different disciplines together—and the remarkable outcome of his voyage were rendered mute by the maladroit politics of the moment.

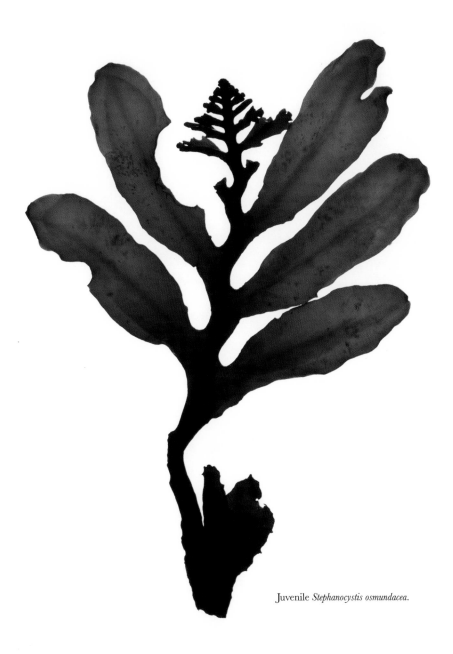

Juvenile *Stephanocystis osmundacea.*

63

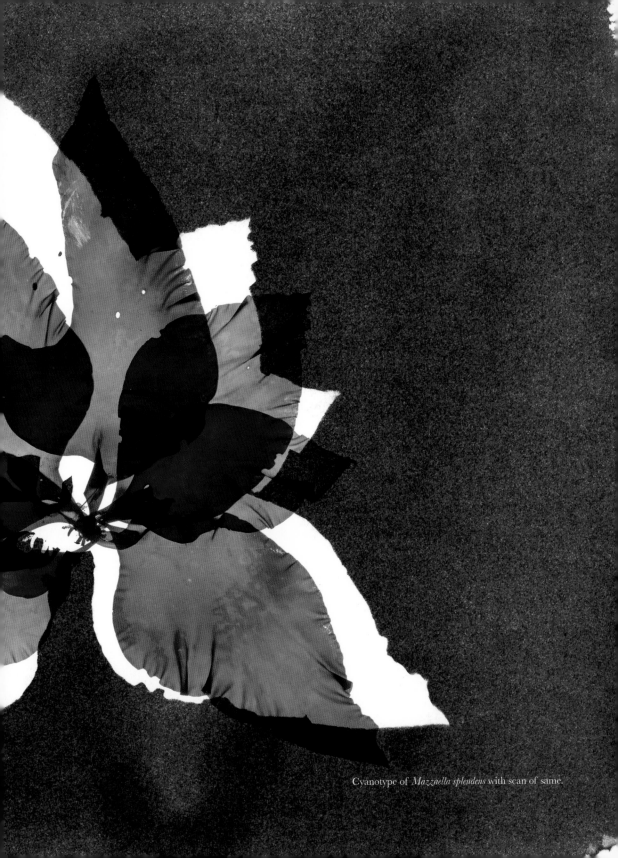

Cyanotype of *Mazzaella splendens* with scan of same.

Mazzaella splendens

Rainbow Leaf

Many years ago I took a course on intertidal ecology and we spent a day out on Duxbury Reef in Bolinas, where I was supposed to study the invertebrate inhabitants of the tide pools—the limpets and nudibranches and crabs and such. My attention was diverted when I happened to hold a scrap of darkened seaweed up to the blue sky. I was immediately floored by a spectacular shade of magenta. I hadn't imagined seaweeds could be so brilliant. Since then, one of my chief delights when beachcombing is to hold a piece of seaweed or kelp up to the sky and dive into its colorful luminosity, whether golden yellow, olive brown, pure green, or rosy red. All of these colors are a reminder of seaweed's essential role as primary producer of our near ocean waters, performing the unique transformation of light energy into organic matter.

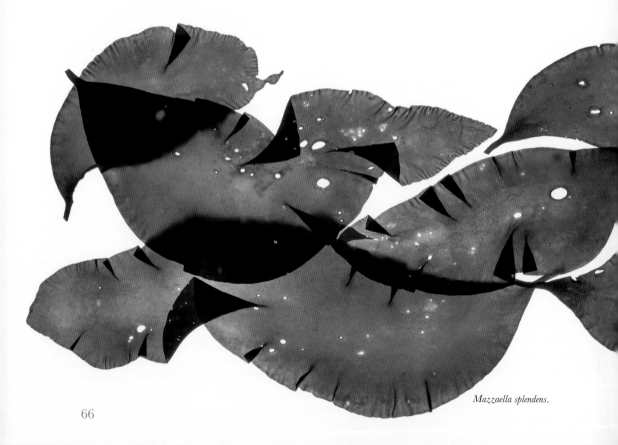

Mazzaella splendens.

The genus *Mazzaella* often takes the color prize with its various species sporting voluptuous shades of purple, especially *M. splendens*, or rainbow leaf, *M. flacida*, and *M. volans*. Deep plum ranging to violet are not colors we readily associate with ocean life, but *Mazzaella* illustrates the benefits color offers plant life under the sea. Most flowers are designed to attract—whether a purple iris or a pink cherry blossom. The reflected light of a flamboyant petal is a particular wavelength visible to pollinators—crucial to fruit production and regeneration. The job of absorbing light is left to the green things, the leaves. The daylight absorbed by leaves in the service of photosynthesis is a broad range of the visual spectrum, with an emphasis in the higher wavelengths of red. Absorbed red reflects green to our eye, so leaves are generally perceived as green.

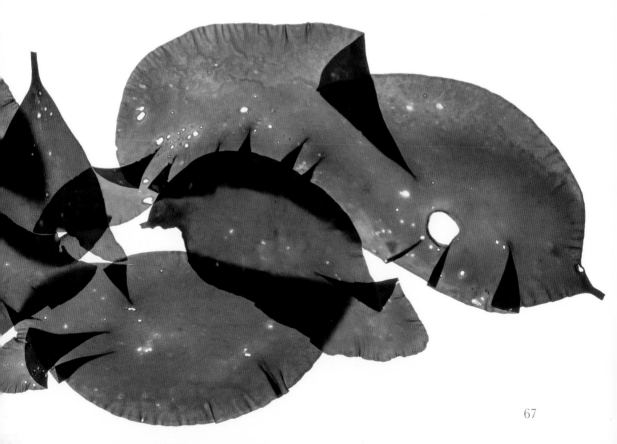

For seaweeds, the spectrum of light underwater is a bit more fractured. When sunlight travels through the ocean, the water density allows only the lower wavelengths of green and blue to penetrate at depths. The intertidal zone, then, has dual variables for a seaweed's light requirements: the amount of light and its color. In the shallows, light is plentiful and varied in color, but moving into the subtidal and deeper into the ocean, the photic zone dwindles and the minimal light will be of a particular color or wavelength. Seaweeds—some reds and browns live at depths of two hundred feet—must be resourceful with whatever light filters through the dense ocean waters.

A seaweed's color is determined by the combination of pigments housed in its chloroplasts. Within these substructures of the cell where pigments gather specific spectra of light, the mystical process of photosynthesis occurs. The green chlorophyll of algae efficiently absorbs the daylight available in the surface waters and above water in the intertidal zone where seaweeds hold to rocks. Chlorophyll is present in all seaweeds, but brown, red, and blue pigments have evolved alongside it to capture the shorter wavelengths of light that penetrate the deeper waters. Each algal species developed a unique combination of pigments to best capture the photons that strike its blades, and thus the range of colors in the intertidal is astounding.

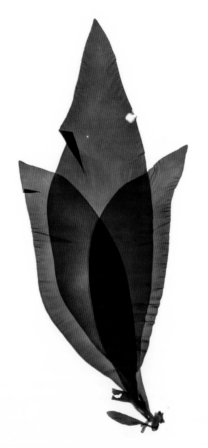

Mazzaella splendens.

Green algae (division Chlorophyta), like plants, have chlorophyll in their chloroplasts, so they are, in fact, typically green and often inhabit the upper intertidal zone of the beach. Chlorophylls are one of the three classes of plant pigments and are known as the powerhouse activators of photosynthesis, unique in their ability to trap and transform light energy. The chlorophyll molecule

is a large, ringed compound centered around a single magnesium atom that allows electrons to move freely. The ability to gain or lose electrons creates the potential to provide energized electrons to other molecules that will manufacture sugars—the fundamental mechanism of photosynthesis. The charged state is reduced back to its ground state by stripping an electron from water molecules (H_2O), leaving oxygen (O_2). Chlorophyll strongly absorbs light at the two ends of the light spectrum, red and violet, leaving the center wavelengths of green to reflect back to us.

Brown algae (division Phaeophyta), which include the kelps and rockweeds, have a third, brown accessory pigment called fucoxanthin, which, when combined in different amounts with the green chlorophyll, creates their array of colors. Browns can range from olive green to golden brown to yellow orange.

The red algae (division Rhodophyta) are the largest group of seaweeds. Their chloroplasts house red and blue accessory pigments that overshadow the single chlorophyll molecule they also contain. This accessory group of pigments, known as phycobilins, exists predominantly in cyanobacteria as well as the red seaweeds. When these pigments combine in varying amounts, the color can be dazzling hues of scarlet, pale pink, or deep purple.

For *Mazzaella*, the pigment mix is a single chlorophyll molecule masked by two accessory pigments from the phycobilin group: a red phycoerythrin and a bluish phycocyanin. These colorful, targeted pigments harvest photons at the shorter wavelengths of blue and green light that penetrate dense ocean waters better than the longer wavelengths of red light, allowing *Mazzaella* and other red algae to inhabit varying depths of the rocky shore. As *Mazzaella* specimens dry as detached scraps on the beach—or in my studio—the phycobilins persist and the blades become richly, deeply purple.

Out on the reef, the purple is not the first thing you will notice about *Mazzaella splendens*. If the tide is covering the *Mazzaella*, a liquid rainbow of colors will slide and glimmer across the fronds, shifting and eliding with the motion of the water. You will notice flashes of metallic blue and green on the surface of the blades a few inches underwater. This spectral iridescence has nothing to do with *Mazzaella*'s pigments or ability to photosynthesize. It is an incidental beauty. The iridescence is a result of light reflecting and refracting through a series of alternating translucent and opaque layers that make up the cuticle or protective outer layer of cells of the *Mazzaella* thallus or plant body.

Mazzaella splendens has up to seventeen layers in the cuticle, each of a slightly different thickness, and, like the layered nacre of an abalone shell, light bends and bounces around these various layers reflecting different wavelengths back to our eye. When the blade dries these outer layers become flakey, scattering light more randomly, and the magic is lost. But when beneath the water in a pool or surf channel where the moisture keeps the layers smooth like the hardened abalone, dazzlingly rich and specific colors can catch your eye—deep blue, vibrant purple, or metallic green.

This cuticle layer, beyond being visually extraordinary, acts as a kind of armor for the beautiful *Mazzaella*. It deters a host of herbivore grazers—the seventeen layers give a modicum of protection against the scraping of a snail or limpet's radula, the chomping of an urchin's powerful mouth (called an Aristotle's lantern, with five radially positioned teeth), or the tiny mandibles or pincers of the isopod or mesograzer. The color created by this layered armor is simply a beautiful byproduct.

The original name for *Mazzaella* bespoke this colorful iridescent magic. Until 1993, all of the *Mazzaella* were known as *Iridea*, a genus name given in 1826 by an exuberant French botanist named Jean Baptiste Bory de Saint-Vincent who at the time was publishing on algae from debtors' prison. Dawson Turner had shared the famous Menzies collections with Bory de Saint-Vincent, and over a century later, in 1937, the species name, *Iridea splendens*, was given by William Albert Setchell and Nathaniel Gardner, the well-known California seaweed duo. The poetry in this name is unmistakable. It honors the Greek goddess Iris, the personification of the rainbow, who travels as a messenger of the gods not only from one end of the world to the other with the speed of the wind but also into the depths of the seas. Perhaps that is what the reef's *Mazzaella* is providing us, a coded message of its own brilliance, its own ingenuity and cleverness.

But neither Bory de Saint-Vincent nor Dawson Turner could have seen the shimmering iridescent blues and greens of the *Mazzaella* in situ. Perhaps Menzies or Mertens described it for them. Certainly Alexander Postels, on his excursions aboard Lütke's *Seniavin* in the 1820s, got to know the underwater rainbow presented by the *Mazzaella* found along the coast of Alaska. But his lithographs of the two brilliantly colorful *Iridea*, spectacular in their form as well as their strength of color—lavender leaning towards scarlet—clearly depict the pigmented color of the algal organism itself. To capture the evanescent play between sunlight, water, and seaweed frond is extremely difficult; a

skilled watercolor artist can capture this, but my scanner portraits cannot. As it should be. I relish knowing that this particular alga has an elusive quality that I cannot capture. It has an essence that we can glimpse but cannot take away—kept tight in the cupboard of its own kitchen.

My scanner can, however, capture *Mazzaella*'s regal and rapturous purple. Purple is, as everyone knows, the color of royalty. The ancient purple claimed by royalty is, fundamentally, of the sea, and interestingly, a photographic process. Tyrian purple was made in the ancient Phoenician city of Tyre by extracting a colorless mucus from the Mediterranean sea snail (*Bolinus brandaris* or *Murex brandaris*—a small whelk), collected by the thousands. The snail makes a toxic mucus as a predatory tool, but when exposed to oxygen and sunlight, the mucus evolves. Once wiped onto fabric or any other material and fixed by sunlight, the mollusk-derived purple is fast and permanent, only becoming a deeper and more intense color with time. Its value to the ancients was beyond that of gold. To those studying the early stages of photography, purple as a photogenic substance offers an intriguing, light-sensitive emulsion, usually missing from the narrative of photography's beginning, which usually starts with blue or cyanotype printing in the 1840s. I cannot help but wonder if any ancient royal robe-makers placed natural objects on the fabric as it was purple-ifying—creating an early photogram or sun-print. It could have been leaves, or shells, or seaweed perhaps, left on the fabric to leave their mark against the deep purple ground.

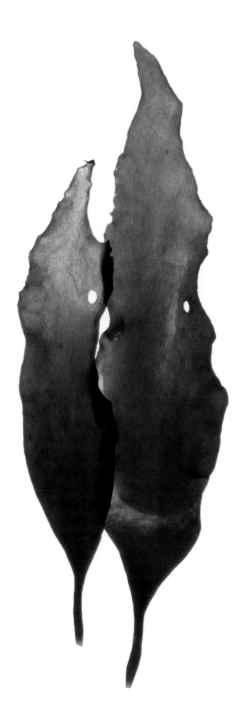

Mazzaella splendens.

One of my inspirations in this regard is Anna Atkins, an extraordinary polymath in Victorian England, whose deep Prussian-blue cyanotypes of British algae are striking examples of the intimate intersection of art and science. Atkins's father was Secretary of the Royal Society and Keeper of the Department of Natural History and Modern Curiosities at the British Museum, and he and Anna were particularly close following the early death of Anna's mother. Anna eventually married a railway promoter and wore the massive petticoats of the day but maintained close ties with her father and his scientific and experimental community. She never stopped experimenting herself. She became an accomplished botanist and algologist and perused the coast of her home in Kent, collecting algae. When William Henry Harvey released his *Manual of British Algae* in 1841, from his position at Trinity College in Dublin (well before his trip to North America), Atkins was inspired by the book yet frustrated that there were no illustrations. In the *Manual of British Algae* Harvey first defines his new color groupings for the seaweeds as "grass-green" (the greens or Chlorophyta), "olivaceous" (the browns or Phaeophyta), and "red" (the reds or Rhodophyta), but he did not produce images to visually describe the seaweeds until the later edition in 1849. In the interim, Atkins decided to do just that, using the new cyanotype techniques developed by her neighbor and friend John Herschel.

Cyanotype printing involves combining two ferric compounds to make a light-sensitive emulsion that is brushed onto paper. Once the paper is dry, a specimen can be laid on top of the coated paper and exposed to the sun. With a simple rinse of water, the shadow of the object clears to the color of the paper, usually white. The background, blasted by the ultraviolet rays of the sun, like royal purple from the murex shell evolves to an intense color, in this case blue. In both cases the sun itself is the catalyzing agent.

In 1843, Anna Atkins published thirteen copies of a book titled *Photographs of British Algae, Cyanotype Impressions*. Each book contained 307 images of algae with their names, each a unique "impression" bound into the volume. To make each image Atkins meticulously laid out her algae pressings on the sensitized paper and made several sun-prints of each specimen.

These reversed and ghostly images capture the transparency and scale of her seaweed collection. They are specimen portraits, not idealized illustrations, and as such established photography—or at least this method of camera-less photography—as an accepted method of scientific illustration. This book is considered the first photographically illustrated book—a landmark the credit for which usually goes to a man, Henry Fox Talbot. But we know it was Anna Atkins who did this.

In my favorite picture of Anna Atkins she is wearing a shawl at an open window watching over an exposure in progress—the wooden press propped against the windowsill. She emerges from a darkened interior, leaning halfway out the window, holding the side mullion for support. Her gaze is directed downward to the modest frame holding her paper and specimen, which almost disappears in the bright sunlight. She is plump and self-assured, holding still for the extended exposure, like her seaweeds in the sunshine. I consider my own scanning techniques to be within this lineage of camera-less photography that Atkins begat. When the object itself makes the image—hers placed on coated paper, mine placed on the glass platen of the scanner—it retains its own nature-based claim to specificity. This is the power of the process. Yet the sheer graphic joy and beauty, the emotional resonance the image a particular specimen imparts steers us toward art-making. This is a dichotomy that I relish within my own algal image-making. The algae themselves create a space where science and art hold each other in strong embrace.

To honor Anna Atkins I decided to try my hand at cyanotype printing. I ordered potassium ferricyanide and ferric ammonium citrate from the Photographers Formulary in Montana and set up my garage to coat paper in the dark. I coated various types of paper of differing sizes and pulled out my extensive collection of dried seaweed. I found my old photo-lab tray and filled it with water. I set the paper-seaweed-glass sandwich on the picnic table in my sunny backyard, exposing for four or six minutes, then floated the paper in a water bath in the shade, watching the algal shadow take hold amidst the

Mazzaella volans.

deep-blue ground. If the seaweed was flat and opaque this shadow or algal "impression" is the pure white of the paper, but if the sun was able to penetrate translucent blades or work its way around the edges of a more dimensional seaweed, the impression is nuanced shades of pale blue.

I have made cyanotypes of *Mazzaella splendens* and *M. volans*, the whimsical spoon-shaped version of *Mazzaella* found at Bodega Head that prefers the sand caught between rocks. I have captured *Pikea californica*, *Prionitis sternbergii*, and many other seaweeds as white-and-blue sun-prints. These cyanotypes are satisfying in their relatively

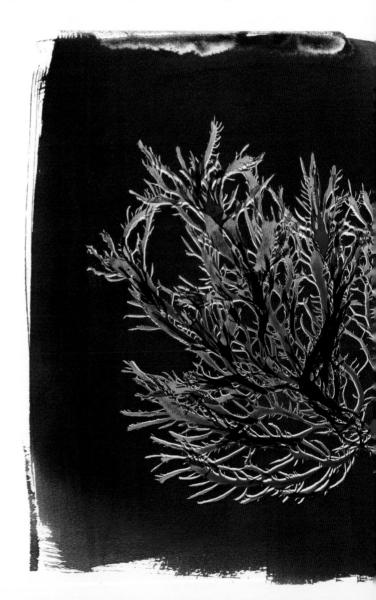

Cyanotype of *Pikea californica*
with scan of same.

quick manufacture of an image as object—or is it an object as image? In either case I have the blue print in hand, but no hint of the intense red or purple color of each specimen. I will have to leave the studio and go back out to the reef and explore the tide pools to glean a slender fragment of understanding of the *Mazzaella*'s nuanced life and place. Its vivid purple points to the photosynthetic pathway that is the foundation of algal existence. *Mazzaella*'s rainbow of metallic colors is a visual murmur hinting at the complexity of its role in an intricate world of infinite interactions.

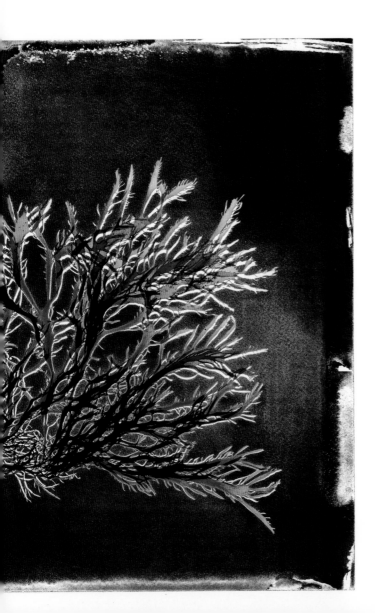

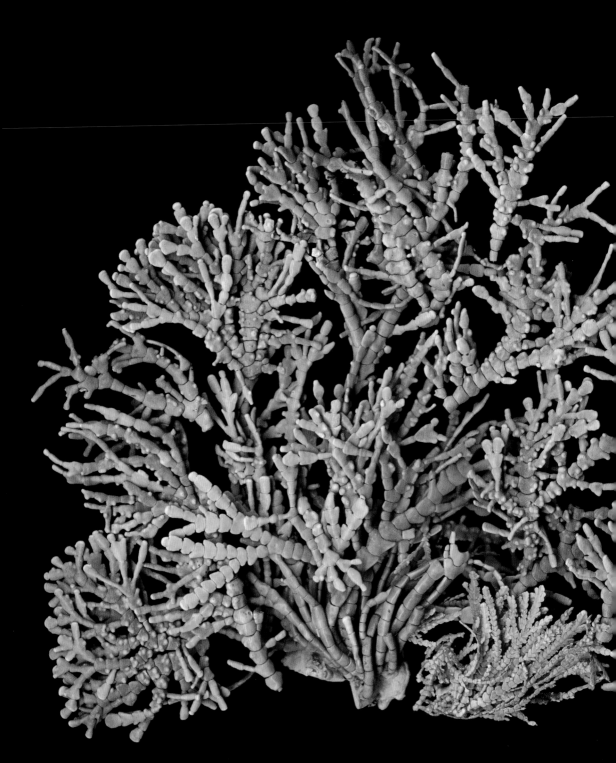

This page: Various articulated red coralline algae.
Opposite: Encrusted red coralline algae on bottle. Collection of Kathy Ann Miller.

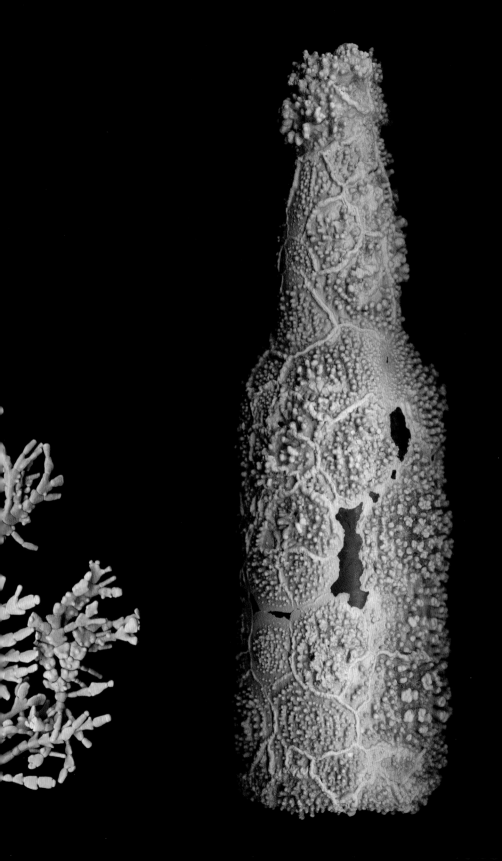

Corallina vancouveriensis

Red Coralline Algae

Coralline algae are unassuming—small in stature and often overlooked amidst the abundance of the nearshore rocky coast. Once pointed out, fringing a tide pool or encrusting a section of rocky reef, the coralline algae elicit an enthusiastic exclamation from human observers whose attention is more often turned elsewhere towards anemones, crabs, or larger kelps. They don't seem in any way missable to me, since the various shapes, textures, and colors of the corallines are often bright spots of pink in a sea of muted tones.

Although diminutive, red coralline algae play an outsize role in the diverse marine ecologies of the intertidal zone all over the world. They thrive in deep and shallow environments, cold as well as warm waters. The corallines are often the first colonizers of an area, providing a base structure for intertidal life to flourish. The bacteria living on them give off a chemical scent that encourages the settlement of invertebrate larvae, creating a nesting ground for tiny limpets, baby shellfish, urchins, and even other seaweeds. Coralline algae have two possibilities: they can grow away from the rock surface as a branching, articulated alga, or hug the rock as an encrusting form. When the articulated coralline breaks loose and washes up on the beach, it loses its rosy hue and becomes the bleached white of bones. Tiny and fragile, often unnoticed by beachcombers, it is a fantastic example of seaweed resourcefulness and very much worth our careful regard.

Cell walls are a seaweed's only structural support, and while many seaweeds fill their cell walls with flexible, water-retaining phycocolloids (what makes a seaweed goopy), the coralline algae do something completely different: they mineralize calcium carbonate in their cell walls, making a stiff skeletal armor much like a shell. Making a shell, however, is hard work and takes time. An articulated coralline might take five years to grow five inches. This is a very different timeline for growth than the large kelps, which can grow meters in a few months' time. The corallines are susceptible to drying out, so they are often found hugging the perimeter of a tide pool just below the

reflective surface of the trapped water. Unlike fleshy red algae, the calcified corallines are opaque. With light bouncing off them as opposed to going through them, they emerge as vivid pinks against darker rock or among olive rockweeds and darker red seaweeds. When noticing a tide pool sporting coralline algae at it edges, I often think of the artists Christo and Jeanne-Claude, who in 1983 executed a signature project to wrap in color eleven small islands in Biscayne Bay, Florida. *Surrounded Islands* became an archipelago of dark islands skirted with brilliant pink fabric reaching two hundred feet into the bay from the islands' shorelines. As viewed from above in photographs and the artists' sketches, the skirted islands recall the tide pools in feel if not in scale. The hue of pink is a very close match and the bright fabric tracing the contours of the dark, wooded islands corresponds to the mass of pink articulated algae growing inward from the rocky circumference towards the center of the darkened fragment of ocean, trapped amongst the rocks. I was entranced by *Surrounded Islands* then and I still am now, appreciating that I can recall it not by scrolling the Internet but by getting on my knees to inspect the delicate pink crusts and branches tracing the edges of the tide pools.

All corallines start growth from a small patch of crust glued to rock. Some stay prostrate, occupying space by stretching laterally and forming a tough, sometimes bumpy surface right on the rock. When various encrusting organisms meet, lines are drawn and borders are clear. Articulated corallines, on the other hand, grow up and out to form a branching structure made from bony segments connected by flexible genicula (meaning "knees" in Latin, as in "genuflect"). This flexibility is essential to survive the forces of wave action and tidal pull. The intergenicula, or calcified sections, can be chunky, flattened, wing nut–shaped, or cylindrical. Some corallines grow exclusively on surfgrass and others grow as a circular disc on top of other corallines, like a tiny shield. Often reproductive bumps rise from the surface or section, giving a cartoonish quality to the coralline.

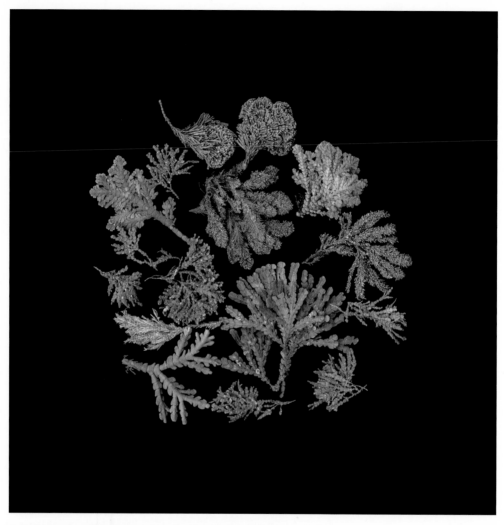

Articulated red coralline algae, various: *Corallina, Bossiella, Calliarthron* and others.

Because of their carbonate outer structure, corallines feel intrinsically different from other algae. When Linnaeus encountered the corallines he assumed they were animals of some sort, like shelled mollusks, or were related to the animal colonies that build coral. In 1758 Linnaeus placed them in the animal kingdom with the name *Corallina officinalis*. It took over fifty years for the corallines to be recognized not as animals or plants but as algae. In 1812 Jean Vincent Félix Lamouroux established the family *Corallinaceae*, which would, over the years, accept a profusion of coralline genera into

this peculiar corner of the ocean garden of algae. Six species of coralline algae are easily found on this Pacific coast but hundreds live around the world's oceans.

The reality is, however, that calcifying algae and calcifying animals do have a common concern—ocean acidification. All shell-building organisms extract calcium (Ca) and carbonate (CO_3) ions from ocean waters, making calcium carbonate ($CaCO_3$) to build their shells. Calcium carbonate is a magnanimous material. It is soft as chalk, except in the genetic mill of mollusks, corals, and coralline algae. It is the recycled cement of the seas—the brick, stucco, and rebar generated by marine life to build the stunning structures we consider with wonder. As carbon dioxide (CO_2) is absorbed by the oceans it tends to combine with water and free carbonate ions to make two bicarbonate ions. This tendency pulls carbonate out of action for use by the shell builders. It is as if the brick supply were getting hauled out of circulation, unavailable to the plethora of organisms—coralline algae, scallops, snails, oysters, coral, tiny sea butterflies, and microscopic foraminifera—that need it to make their protective housing. The effect of ocean acidification on coral reefs has been well documented, while the calcifying marine algae fly a bit farther under the radar.

Coralline algae are also harbingers of other signs of ocean stress. Whether encrusting or articulated, the corallines have clearly come up with a good strategy for survival in the predatory world of the intertidal. Most soft-tissue seaweeds succumb to some form of herbivory, becoming leafy lunch for limpets, chitons, snails, and urchins. But corallines, with their tough calcified armor, are hard to eat. In the subtidal regions of the Northern California coast where the historic urchin predators, sea otters and *Pycnopodia* sunflower starfish are no longer around to keep urchin grazing in check (the effects of starfish wasting disease and the eighteenth- and nineteenth-century sea otter fur trade, mentioned in previous chapters), the crusting coralline are often the last algae standing. Recent reports that the starving urchin hordes, with no more fleshy kelp to feed on, are now attacking the corallines are particularly alarming. I recently helped inspect the innards of urchins near Fort Bragg, the epicenter of bull kelp demise, to see what they were eating. I was amazed at how much coralline algae was found in the impoverished urchins' digestive systems.

Fortunately, the corallines' range extends even deeper than urchin territory. Their resourcefulness allows them to thrive at depths as low as 350 feet, at the limits of the

photic zone where only a few rays of light penetrate, and to survive hundreds of years. But it is counterintuitive to think of these organisms as light harvesters—how does light penetrate their calcified walls? Photons of light actually ping through the crystals of calcium carbonate, igniting the pigments within chloroplasts of interior cells to initiate the magical process of photosynthesis. These red pigments give the algae its rosy color.

One particular coralline alga that ranges the Pacific Coast from Alaska to Baja California is *Corallina vancouveriensis*. Its type locality is Port Renfrew, British Columbia. The intricate bony matrix of branches fanning out from a central rib of cylindrical sections is so fine and delicate that it is most often experienced as undifferentiated globs of pink in the tide pool. It takes a close look (even a magnifying lens) to see the delicate sections that make up the heavily branching thallus. But this multitude of branches and matting

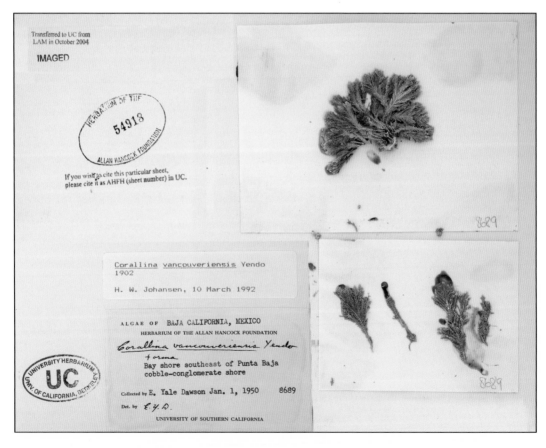

Corallina vancouveriensis. University Herbarium, University of California, Berkeley, no. 1844981.

quality holds water within and between the parts, so this coralline is able to withstand the desiccating sun of the higher intertidal better than its larger cousins.

Corallina vancouveriensis was collected and named by the Japanese phycologist Kichisaburo Yendo in 1901 when he was invited to visit the first marine lab established on the west coast of North America, named, oddly enough, the Minnesota Seaside Station. The lab was set up by a remarkable woman from the Midwest named Josephine Tilden. Tilden grew up in Iowa and then Minnesota, and was asked to teach at the University of Minnesota after receiving her undergraduate degree there, but on the stipulation that she pursue her research on algae. She proposed to study the algae of the Pacific, no small challenge from her vantage point in the middle of the country, and she became the first woman to join the faculty of the University of Minnesota, in

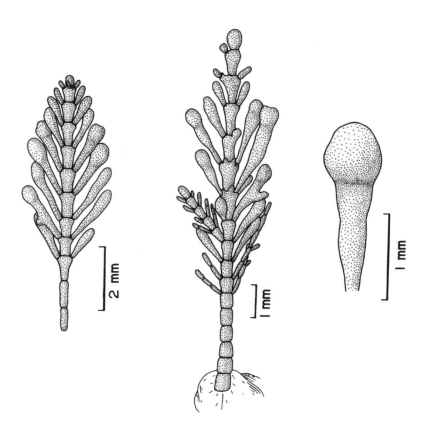

Corallina vancouveriensis. Illustration by Ernani Meñez from Scagel, *Guide to Common Seaweeds of British Columbia* (1972).

1895. On completing her master's degree, Tilden spent two summers traveling with her mother (since it was considered improper for a woman to travel alone) to Puget Sound to collect seaweeds and embark on her Ph.D. In 1898 Tilden's nose for good algal collecting sites led her to a remote and wild bit of coast adjacent to Port Renfrew on Vancouver Island's western edge. Here she found a sandstone ledge stretching horizontally into the Pacific with profuse beds of marine algae and pocked by deep, rounded tide pools. Drained at low tide, the seaweed beds and rounded pools became an accessible intertidal wonderland complete with robust stands of *Postelsia* and luxuriant petticoats of coralline algae edging the potholes. She named this spot Botanical Beach.

Josephine Tilden's intrepid approach to finding this particular place impressed Tom Baird, the homesteader she had enlisted to get her there—by rowboat—and he gave her a chunk of his newly acquired land. Over the following years, Tilden and her steadfast colleague, professor of botany Conway MacMillan, directed the building of a rudimentary dormitory, staff living quarters, and lab buildings just a few feet from the beach. In 1901, professors from four Midwestern universities were brought together to open the station, teaching courses for undergraduates and directing graduate research. Each subsequent summer until 1907, Tilden brought groups of students on the eight-day journey by train and boat from Minnesota to Botanical Beach. At least half of these were women, instructed to bring "short" skirts "at least twelve inches above the ground" and hobnailed bicycle boots. Students and professors would spend four weeks at this remote outpost studying the taxonomy of the algae—what things were named and why—and the ecology of this remarkable world. For a group of Midwestern farm kids who had never seen the ocean, pressed and challenged by the formidable Josephine Tilden, traveling to this reef at the edge of the rain forest must have been the experience of a lifetime.

In 1901 Tilden and MacMillan persuaded the distinguished phycologist Kichisaburo Yendo to come from the Imperial University of Tokyo to teach about the red algae, or Rhodophyta. Perhaps only a woman could have made it all work. MacMillan was the director, but Tilden organized everything: "She purchased and packed the supplies, supervised the kitchen and library, taught, studied, and collected algae for university classes," reports Gayle Hansen, who has written extensively about Josephine Tilden.

During the summer seaside station courses, Tilden encouraged research of all sorts—phycological, geological, botanical, ecological. Evening lectures and performances highlighting this work were given in the natural amphitheater created by the eroding sandstone at one end of the beach. The most memorable of these presentations are collected into two volumes bound in red leather and embossed with a striking gold *Postelsia* plant, its hefty holdfast clinging to a mussel shell. Tilden's foresight in publishing these volumes, titled *Postelsia: The Year Book of the Minnesota Seaside Station*, is our good fortune. The marine laboratory at Botanical Beach never got the long-term financial support she had counted on from the university. Heartbroken, Tilden returned to Minnesota after the summer of 1907, never to return. Tilden continued to travel the globe with students on algae-collecting expeditions, but the two volumes of *Postelsia* are the only legacy of her pioneering seaside station. Despite constant financial hardships she held on to the property on Vancouver Island, with its neglected and collapsed buildings, until 1948 when it was sold. It is now a regional park. I had the chance to go to Botanical Beach, to bushwhack into the underbrush looking for remnants of the marine lab and other buildings. The forest there is a powerful force, swallowing structures easily, but an old rusted piece of corrugated tin was found and held aloft to say: "Josephine, we are here to honor you and to honor the seaweeds that brought you here."

The reef itself is spectacular. Remarkably deep and rounded tide pools fall away from the surface of the stone. The entire reef is tinged pink from the underlying coralline algae, both encrusting and articulated, with kelps and seaweeds emerging from it. As you venture towards the outer limit of the tongue of rock sticking into the Pacific Ocean the coralline algae become more robust, and on close inspection it is in fact the delicate *Corallina vancouveriensis* that dominates. Here the delicate *Corallina* grows in dense clusters, like mini pink-tinged cauliflowers. Packed together, something formidable results from something so fragile.

What a trip it must have been for Yendo, traveling in the summer of 1901 from Japan to Port Renfrew and then out to Botanical Beach. Yendo joined the teachers in giving classes on the reef in the mornings, able to use the prolific examples of algal life right at hand. He also collected and did research, paying "special attention to the calcareous algae, in which I have been deeply interested." Yendo's two evening presentations are included in the 1901 volume of *Postelsia: The Year Book*

of the Minnesota Seaside Station. Yendo's first presentation, complete with delicate illustrative prints, describes the many uses of seaweeds as food in Japan (a foreign concept to milk-fed Minnesotans, I am sure), and the second explains the distribution of various seaweeds throughout the Japanese islands. Yendo brought specimens of coralline algae back to Tokyo and in 1902 published his description (in the traditional Latin) of the delicate *Corallina vancouveriensis*, collected at Botanical Beach amidst the women and wonder of the Minnesota Seaside Station. In this paper the author "expresses his deepest thanks to Professor Conway MacMillan and Miss J. E. Tilden, who cared for him very kindly in every way during his stay at their private station."

Ever since, in the taxonomic tradition of listing the first namer of a species, the delicate fan-shaped coralline found at the margin of the tide pools carries the moniker *Corallina vancouveriensis* Yendo.

Opposite: *Corallina vancouveriensis*. University Herbariu University of California, Berkeley, no. 14703

LANDS END

Land's End 30.iii.1971
on giant barnacles

HERBARIUM OF THE UNIVERSITY OF CALIFORNIA

MARINE ALGAE OF CALIFORNIA
SAN FRANCISCO

Corallina vancouveriensis Yendo

Lands End. Boulders and gravel exposed to heavy turbulent
surf; site additionally stressed by chlorinated sewage
outfall.

On rocks and large barnacles in midtidal zone. Growing
with Mytilus.
Leg. Paul C. Silva 10304 30.iii.1971
Det. PCS

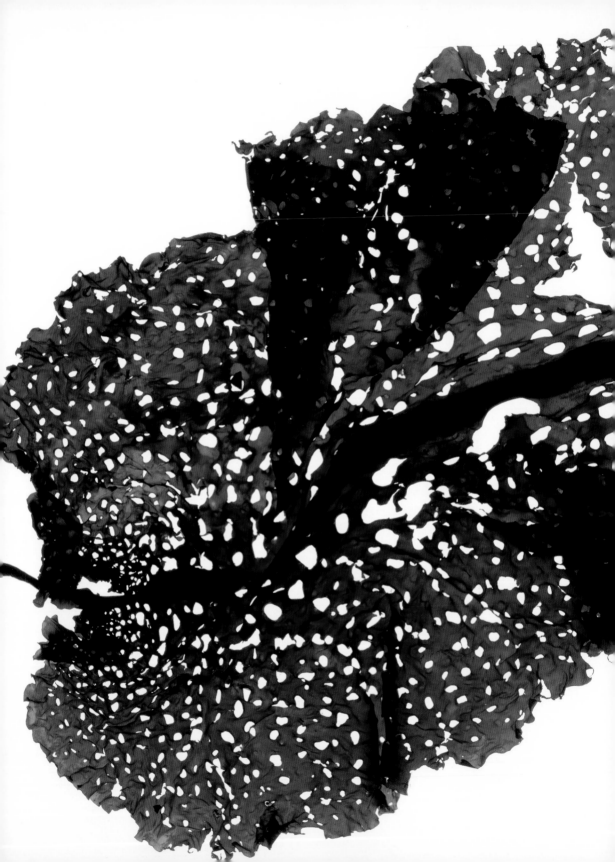

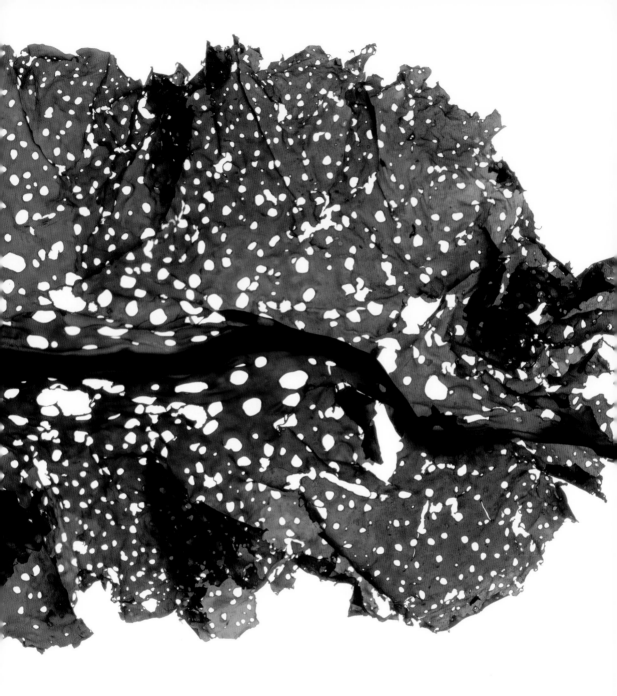

Agarum fimbriatum.

Agarum spp.

Colander Kelp

Georg Steller was an astute early-eighteenth-century observer of nature, remembered through the names of animals familiar to us, the Steller's jay and the Steller sea lion, as well as Steller's sea cow, a long-extinct marine mammal, now a symbol of man's crass stumbling. Georg Steller was the first Western scientist to set foot on Alaskan soil and someone we might recognize today as a precursor to John Muir—a man comfortable on his own in the wilderness, eating out of his tin cup, casting a small footprint from his wanderings. In 1740, this was not the normal method of scientific investigation. A scientist of that era typically set forth with an entourage of assistants, complete with cook and plenty of wine. I encountered Steller's life story when researching the first descriptions of a remarkable brown kelp called *Agarum* by an early phycologist named Samuel Gottlieb Gmelin. *Agarum* is a kelp that, once encountered, one can never forget—it is spectacularly holey.

My best specimen of *Agarum* came up with an anchor in Penobscot Bay, Maine. I was with friends on an excursion in a small outboard. We ran out of gas and threw over an anchor, which, luckily, caught bottom in time to keep us a few yards shy of a rocky ledge. We phoned for relief and gas was on the way, but being far from shore, we had plenty of time to ponder the bay itself, the islands and ledges, the distant mainland, and the fabulous sky with clouds dotted here and there. It was a beautiful afternoon. We pored over charts to determine which tiny islands, of the many in this remote corner of the North Atlantic, we sat next to, so we could inform our rescuers.

Nothing about the scene we were taking in, nor the chart we consulted—replete with ocean-depth and navigational markers—gave us any indication of the vast world below the reflective surface of the bay. It was only when help arrived, gas was poured into the tank, the engine was restarted, and the anchor was pulled up that a hint of a remote and fecund watery universe was revealed. A large fresh kelp came up with the anchor, typical detritus that is usually tossed overboard. I grabbed the brown jumble just in time and discovered it to be a beautiful colander kelp called *Agarum clathratum*. Delight

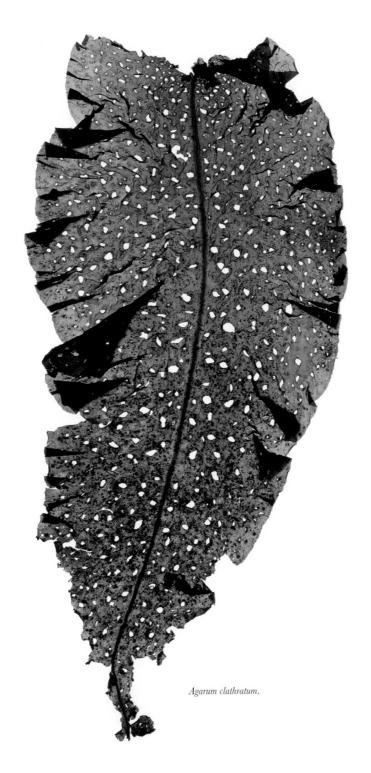

Agarum clathratum.

overpowered my annoyance that the gas tank had not been checked before we'd set out.

The anchor had escorted from the bottom an elongated heart-shaped blade of magically holey kelp, orangey brown when held up to the sky. The only piece missing was the holdfast, severed by the anchor and left at the ocean floor. Otherwise the blade was complete, a rarity to find washed up on a beach. This Atlantic sampling was very much like a beautiful *Agarum fimbriatum* specimen I found many years ago in the wrack near Mendocino; it now hangs in my studio, always a reminder of the ocean's botanical wonders beneath the waves. *Agarum* is one of those organisms that you can't quite believe is real. It is also hard to believe that something so fabulous—with its plethora of perfectly round holes equally spaced throughout its robust single frond—is not rare, but common throughout many oceans in the world. It is one of the few seaweeds that exists on both the Atlantic and Pacific coasts of the United States, having migrated down both sides of North America from the Arctic after the last ice age, as well as being abundant throughout the chain of the Aleutian Islands along the top of the Pacific.

Agarum is featured in Samuel Gottlieb Gmelin's volume of marine algae, *Historia fucorum*, published in Russia in 1768, just thirty-two years after Linnaeus established his binomial system of botanical and zoological nomenclature. For the first time, images of seaweeds from around the world—collected by diverse explorers and naturalists—were depicted, named, and described in a single volume. By giving them names within the Linnaean system, Gmelin's *Historia fucorum* can be considered an origin point for taxonomic efforts amongst seaweed lovers. It was a springboard for partnerships between the naturalist-collector and the expert describer to categorize the botanica of the oceans and gave the world of seaweeds, or *Fucorum*, the status to be carefully observed and studied in its own right.

S. G. Gmelin was a peripatetic genius. He wrote *Historia fucorum* in less than a year, having just arrived in St. Petersburg as a new member of the Russian Academy of Sciences. Peter Simon Pallas, his university friend from Germany, had given him a collection of seaweeds from the Dutch and English coasts of the North Sea. Pallas recognized Gmelin's enthusiasm for the "beloved subject of sea-weed" and encouraged him to write a treatise, which of course would be in Latin. Gmelin also used older collections received from his uncle, Johann Georg Gmelin, a predecessor at the academy in St. Petersburg who had spent years exploring and botanizing in Siberia. In 1768

genus and higher taxonomic groupings of the seaweeds were very much in flux, but many of the species names that S. G. Gmelin assigned in *Historia fucorum* are familiar to us today. Getting seaweed collections to the "expert" to describe and name, however, was no small endeavor in Gmelin's era. Mounting and labeling specimens with data concerning where, when, and by whom they were collected was a first step. Having them packed into boxes and shipped across oceans or overland across continents and stored, perhaps for decades—without being eaten by bugs—was another feat. How the beautifully depicted *Agarum* got to Gmelin is a story pieced together from historical fragments and held together by imagination and conjecture.

W. A. Setchell's personal edition of Gmelin's *Historia fucorum* resides in a locked case in the Marian Koshland Bioscience and Natural Resources Library at UC Berkeley. The book is spectacular. I had reviewed the digitized pages online, but this did not prepare me for seeing the real thing. My breath was in my throat as my gloved hands leafed through the codex to find the etched illustrations pasted into the rear of the volume, meticulously folded to open accordion-style out from the book. Many familiar names, such as *Plocamium*, *Osmundea*, and *ligulatus*, are captioned to fastidiously engraved drawings—some with telltale smudges at the corners where the engraver did not wipe the plate clean—each more delicate than the next. Plate XXXII, *Fucus agarum*, and plate XXXIII, *Fucus clathratus*, as well as a description without a plate of *Fucus fimbriatus* on page 200 are clearly versions of the *Agarum* we know on the Pacific and Atlantic coasts, the identifying holes making it hard to mistake. Their locus is listed by Gmelin as *Oceanus India orientales et mare Kamchaticum*. The collector is listed as Steller, who lived from 1709 to 1746. In the case of these few *Agarum* specimens, the partnership across time and space of collector and describer is revealed: Georg Steller collected them and S. G. Gmelin described and named them.

Georg Steller had the keen instincts of an extraordinary naturalist. Like so many scientists in eighteenth-century Russia, he was German, but Kamchatka, the peninsula at the farthest reaches of the Russian empire to the east, was his home base for scientific exploration. Kamchatka is a continuation of the cold-water North Pacific habitat that extends east across the Aleutians, down the coast of Alaska, and south to California. Steller spent his short career engrossed in this cold and unforgiving environment, carefully noting the flora and fauna that many had never seen before. On his way to

Kamchatka in 1739, freshly educated in the new Linnaean system of nomenclature, Steller stayed a few weeks with the older botanist J. G. Gmelin and kept in correspondence with him until his own death in 1746.

After much haggling with the authorities in St. Petersburg, Steller was assigned as naturalist on the ill-fated second Bering expedition to the North Pacific, which left Kamchatka in 1740. The expedition was to explore and map eastern Siberia and the northwestern coast of North America, but Vitus Bering, the commander, was ill from the start and rarely came on deck, leaving Steller and a dysfunctional crew of bigoted officers in constant conflict. The officers argued incessantly with each other and with Steller, and they were often lost in the raging seas of the North Pacific. Finally, by happenstance, they reached Kayak Island off the Alaskan coast and Steller managed to get ashore for just a few hours to madly collect and record what he saw. He thus became the first Western naturalist to encounter and describe in remarkable detail the natural phenomena of the Aleutian Islands and the eastern tip of Alaska.

Tab. XXXII.

Fucus agarum (*this page*) and *Fucus clathratus* (*opposite*). Illustration by S. G. Gmelin from *Historia fucorum* (1768, pl. XXXII and XXXIII). From specimens collected by G. Steller.

Steller's diaries from this trip are gripping to read. He describes in detail not only the incompetence of the crew aboard ship but the fauna—sea lions, sea otters, and sea cows—terrain, and flora of these islands, previously seen only by ancient cultures and Aleuts, and at times Koryaks and Chukchis ranging from Kamchatka and Siberia. Steller describes the various floating seaweeds, noting their typical habitat, as indicators of land close by. He was distraught to be given such limited time on "American" land. The return voyage towards Russia ended in disaster with the ill captain and the feuding crew running aground on Bering Island just miles from the Kamchatka Peninsula. Bering died on the island, as did twenty-eight of the crew overwintering there. The remnant crew survived scurvy by eating sea otter meat (unlike humans, sea otters can produce vitamin C and have trace amounts of it in their meat). They returned to Kamchatka the following summer in a makeshift boat reconstituted from their shipwreck, but none of Steller's extensive collection of specimens from the island, including a stuffed sea cow, were allowed onboard. A few sea otter pelts came to Russia with the ragtag crew, however, initiating the frenzy that followed—the sea otter fur trade.

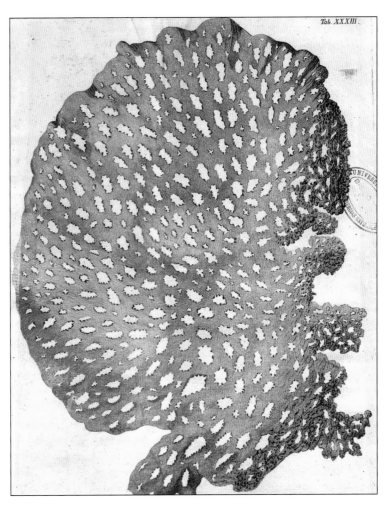

Steller remained in Kamchatka for two more years to complete his natural

history investigations, going so far as to build a boat, engage a crew, and return to Bering Island, the scene of his shipwreck. We know that *Agarum* flourishes throughout the Aleutian Islands and along the Kamchatkan coast, so I can imagine Steller collecting various specimens from the coastline of this island he must have known so well. He overwintered on the barren island, returning to the mainland the following summer, and left Kamchatka in 1744 laden with boxes of specimens of all kinds. Our lovely *Agarum*s must have been in there, labeled from *mare Kamchaticum*. Or perhaps they were sent with an earlier load of specimens.

Steller never made it back to western Russia—he died en route in 1746, after he was found alone, inebriated, and almost frozen in a stagecoach by the roadside. But Steller had written the senior Gmelin before his death, expressing reverence for him as a scientist and a superior, and was anxious to know if his earlier report and specimens had been received by the Academy of Sciences in St. Petersburg. According to the notes by the younger Gmelin in his *Historia fucorum*, we have to assume that Steller's specimens made the journey back to St. Petersburg, across vast tracts of Siberian wilderness.

The younger Gmelin rushed to finish his *Historia fucorum* in 1768 so that he could participate in one of the grandest scientific adventures of the time, the occasion of the passage of Venus across the sun in 1769. Catherine the Great was determined to prove that Russian science measured up to its European counterpart and lavished huge sums on astronomers and naturalists for travel to remote areas of the Russian empire to measure the planet crossing the face of the sun as well as other scientific findings of interest. Gmelin was sent south and crisscrossed the Caspian Sea, recording natural history and ethnographic details in his diaries. He wound up being captured by a Kaitak warlord and held for ransom. Gmelin's daily journal continued during his imprisonment in a dank cell, but he contracted pneumonia and died in 1774 before the envoys of the Russian empress could rescue him. He was thirty-one years old.

Many years later the diaries of Gmelin and Steller were translated, edited, and published in Russia by Peter Simon Pallas, Gmelin's compatriot and friend. When annotating Steller's diaries (published in 1793), Pallas regularly consulted Gmelin's *Historia fucorum* and noted the names assigned by Gmelin to the seaweeds spoken of by Steller with insight and familiarity.

The particular *Agarum* that Steller most assuredly sent east to St. Petersburg would

have been the large and spectacular *Agarum clathrus*, whose former names include *Thalassiophyllum clathrus* and *Fucus clathrus*. It is a spiraled wonder of flouncing, twisting blades of concentrically holey kelp tissue, an expansion of the flat-bladed *Agarum fimbriatum* and *clathratus* into dynamic three-dimensionality.

All of these robust *Agarum* species thrive in the cold waters off Alaska and extend west across the Aleutian chain to Kamchatka. They are a deep golden brown and flamboyant and sculptural. The various *Agarum* varieties all grow below the lowest tides to between fifty and sixty feet deep. These are perennial kelp. They have a small but sturdy branched holdfast that keeps the plant attached to the rocky bottom and persists from year to year, and a single stipe that gives way to a single, profusely perforated, flattened blade. It is the meristem—where stipe meets blade—that generates the magically holey fresh kelp tissue. In contrast, a natural sloughing away at the edges of the blade creates a worn look, the result of ocean wear and tear.

James Estes is a California ecologist who has spent his career in the Aleutian Islands looking at the nuances of the trophic cascade of sea otter, urchin, and kelp. In looking at the waters off one of the islands under study where otter populations have remained viable and robust, Estes noticed that *Agarum* was well represented as a subtidal kelp in the deeper water, while kelp of the genus *Laminaria* dominated the flora of the shallower zone, from the low tide line to about thirty feet deep. This separation represents some classic seaweed zonation whereby different species become dominant each in its own stratum of the tide zone. Estes analyzed the kelp forests where sea otters kept urchin grazing to a minimum, and he made the keen observation that the plentiful urchins would be kept in check, but only in the shallower waters, an easy dive for sea otters, who typically can hold their breath for up to ninety seconds. The foraging efficiency of the otters drops substantially around the deeper *Agarum*. What was keeping the holey seaweeds from being denuded like other kelps in urchin zones? Estes did a bit of a taste test with urchins to find out which kelp they preferred to eat, and he found that they preferred the *Laminaria*, not the *Agarum*. Urchins were abundant in the deeper *Agarum* realm, and Estes wondered why *Agarum* was low on the urchin lunch list—what might give the *Agarum* some defense against the urchin herbivory? He suspected a secondary metabolite called phlorotannin, a compound ubiquitous in brown algae. It turns out that *Agarum* has some of the highest concentrations of phlorotannins of all brown

marine algae, and *Laminaria* has an order of magnitude less. Apparently, urchins and other herbivores don't like to eat kelp with high levels of this large-molecule chemical compound.

Kelp chemistry as a defense against herbivory continued as a line of inquiry for Estes and his colleagues, and they eventually developed a fascinating analysis of brown algae's different levels of phlorotannins in the South Pacific versus the North Pacific. The cold temperate waters off New Zealand are similar to the North Pacific, with a major exception—sea otters have never existed there. As a result, algae, especially brown algae, and invertebrates such as urchins, limpets, and abalone that feed on algae are in a duel with only each other, a two-tiered food web instead of the three-tiered cascade of our northern ecosystems that include the otter at the top. James Estes and Peter Steinberg surmised that without otters, the brown algae of the South Pacific evolved higher levels of phlorotannins to discourage being eaten, while the invertebrates evolved a bit more of a taste for phlorotannins, an evolutionary stalemate that keeps the kelp and urchins in close habitation, with neither one outdoing the other. Sure enough, the kelps surrounding New Zealand have two to three times the level of phlorotannins that their North Pacific counterparts have. The kelp of the North Pacific, evolving with the sea otters keeping urchins in control, could put their metabolic energies into growing more robust algal biomass rather than the protective chemistry. The unfortunate irony of this evolutionary quirk is that without the phlorotannin defense, and with otters wiped out by the fur trade, these kelp are that much more delicious and nutritious for the grazing urchins and the abalone feeding on the drifted detritus. There are places along the historic range of the sea otter—some of the Aleutian Islands, for example, and the far Northern California coast—where otters have not returned or been reintroduced. It is in these places that the kelp forests are under siege. The lusciously delicious *Nereocystis* and *Pterygophora* kelps can be reduced to rubble by voracious urchin grazing when other stressors reduce a kelp's resilience.

And the perforated *Agarum*? As other kelps succumb to warmer oceans and urchin hordes, it would be reassuring if *Agarum* were there, all along the West Coast as a fallback with its phlorotannin defenses as well as its deceptive holes (I often think that

Opposite: *Agarum gmelini* (named after S. G. Gmelin).
Illustration by Alexander Postels from *Illustrationes algarum* (1840). Now *Agarum clathratum*.

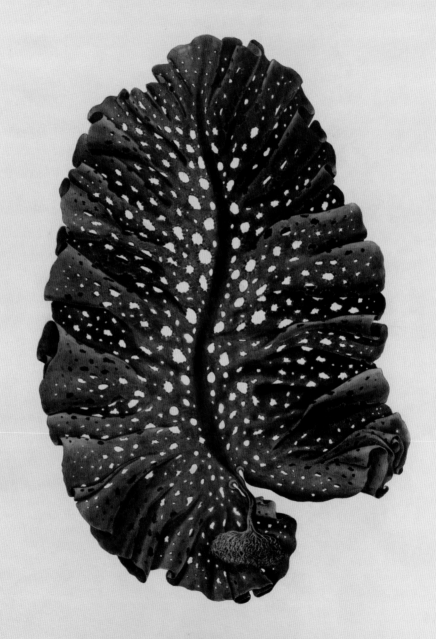

TAB: XX. AGARUM GMELINI *undulatum.*

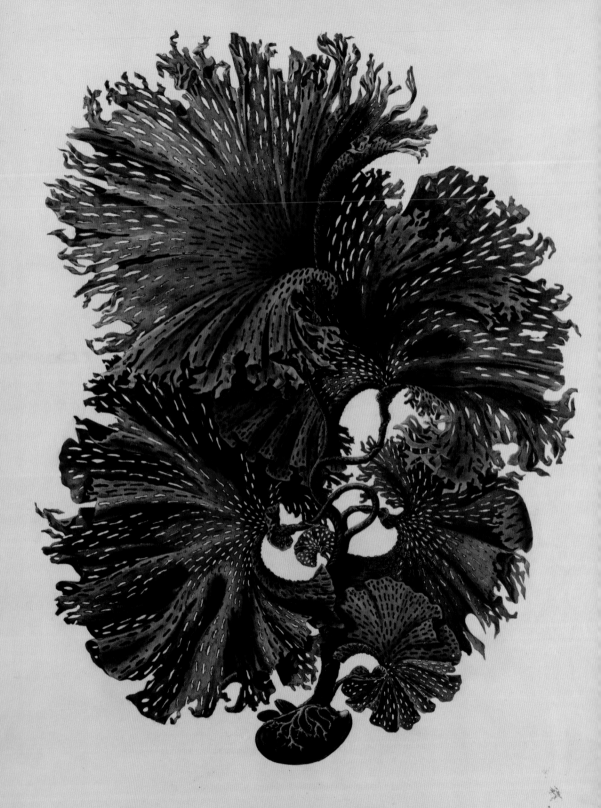

TAB: XVIII. **THALASSIOPHYLLUM GLATHRUS.**

something has been eating it). But the North Pacific's *Agarum* is generally an Alaskan and Russian kelp. It ranges where Steller sailed with Bering—from Kamchatka, along the Aleutian chain of islands to Kayak Island, and then to southern Alaska. There is, however, an interesting disjuncture in *Agarum fimbriatum*'s Pacific Coast range. It is found in the mid- to subtidal waters of Alaska, south to Puget Sound, and then disappears, only to be found again in deep waters off the Southern California bight near the border with Mexico. So my glorious specimen found on the beach at Mendocino is an oddity. Where was it from? My friend Lina, in ten years of daily beach walking on the shore at Point Reyes, has found only three specimens of *Agarum*, a lean count. This beautiful kelp keeps its holey mysteries tight to itself, perhaps holding its own again the urchin onslaught in unseen waters, waiting for the return of its compatriot, the sea otter, to mitigate our human foolishness.

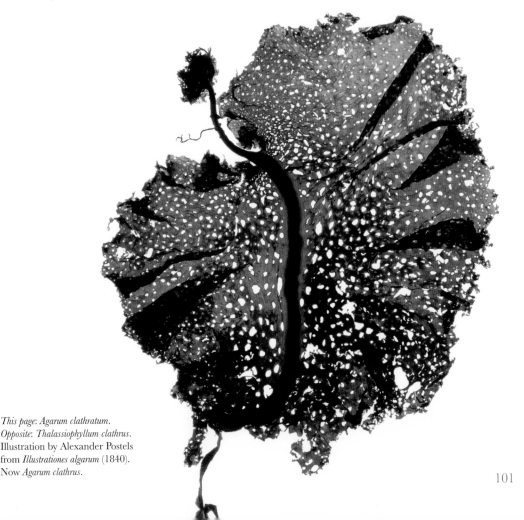

This page: *Agarum clathratum*.
Opposite: *Thalassiophyllum clathrus*.
Illustration by Alexander Postels
from *Illustrationes algarum* (1840).
Now *Agarum clathrus*.

Pyropia with *Porphyra pertusa*. Image by author, incorporating illustration by Alexander Postels from *Illustrationes algarum* (1840).

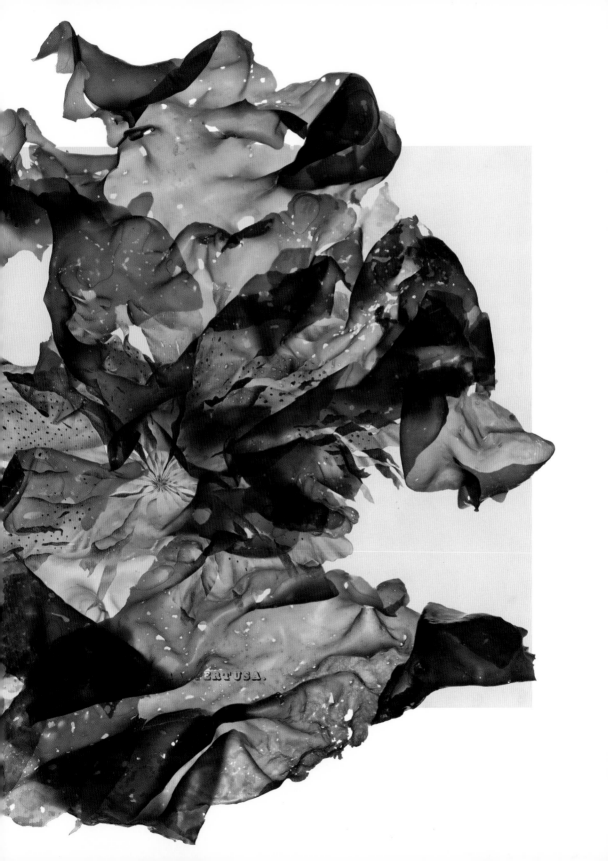

PERTUSA.

Pyropia spp.

Nori

The ancient Greek word πορφύρα is transliterated as *porphura* and translates into English as "a purple garment." The word means purple fish, purple dye, or purple cloth. As *Porphyra*, this word is well known to phycologists and seaweed lovers as the genus containing, among many other species, nori—the thin seaweed ubiquitous in Japanese cuisine, most notably used to wrap sushi. As has often happened in the past ten years, with molecular analysis and both nuclear and plastid gene mapping, the order Bangiales, which contains *Porphyra*, has been restructured. *Porphyra* has been reduced to five species and the *Porphyra* of the Pacific Ocean reassigned to the genus *Pyropia*. It is a tough switch. *Porphyra* is one of those foundational genus names learned, and probably even remembered, on a first foray into the world of marine algae. It makes sense, since *Porphyra* or *Pyropia*, "purple cloth," is often brilliantly or deeply purple, so purple it often appears black.

Pyropia is easily found along the shore if you know what to look for. At low tide on a cobble beach it might pose as hints of purple seaweed cellophane plastered to the tops of rounded rocks. On a rocky outcrop, it might emerge as a tuft of ruffled, translucent shadowy red, or on a vertical wall of rock it could hang as a curtain of elongated layers of dusky green. These would be variations of *Pyropia*, which despite these color variations is in the red category of seaweeds (division Rhodophyta). This prolific and common seaweed is found on the east and west edges of the Pacific and around the globe. Distinguished by its three-dimensional flounce and graceful transparency—only two cells thick—its delicate

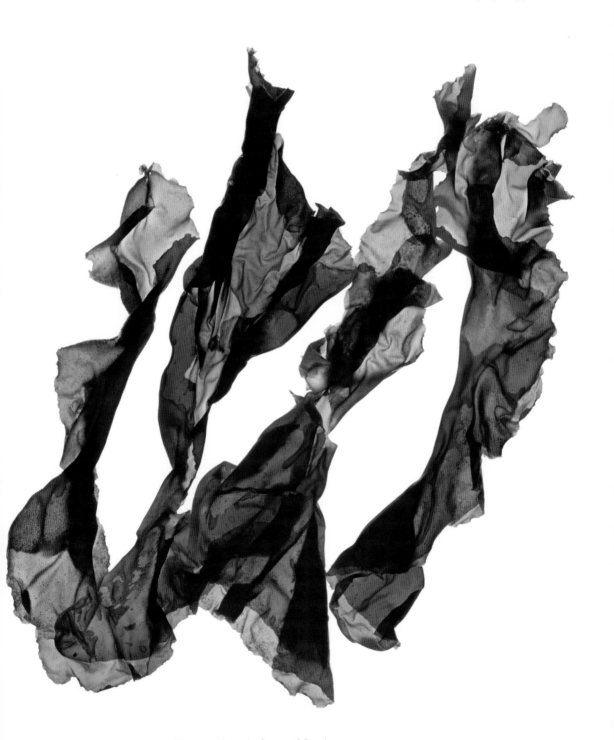

This page and *opposite*: Scraps of *Pyropia* spp.

nature belies a remarkable toughness. Try pulling on a bit of wet *Pyropia* and it will stretch like a rubber band. This stretchiness is a trademark of the red seaweeds, a sure sign the specimen falls into neither the green nor the brown categories.

Seaweeds have to survive the stresses of the intertidal zone—where the tide floods in and withdraws twice a day—with resolve. With only two cells' width of algal flesh, *Pyropia* is particularly susceptible to drying out as the tide recedes and the daytime sun dries out the reef. Many species of *Pyropia* lose from 85 to 95 percent of their cellular water during a daytime low tide, turning into a crisp sheet, but they rehydrate when the tide returns. Imagine the kingdom of flowers shriveling and rejuvenating twice a day! For photosynthesis to work optimally, the sun's energy must be regulated when too strong. At low tide, *Pyropia* uses protective carotenoids to dissipate the overabundance of photons as heat, channeling them away from the photosynthetic pathway. Other algae use similar methods to survive the stress of low tide.

Scraps of *Pyropia* spp.
Note fertile red edges.

On the other extreme, *Pyropia* can withstand freezing cold and, apparently, scouring sand. Not long ago I encountered a boulder covered with healthy *Pyropia* at the water's edge on an otherwise sandy beach. It was a boulder I rarely see on my frequent walks there, but a particularly vehement storm had transported massive quantities of sand off the beach, revealing the long-covered boulder. All day this irrepressible batch of *Pyropia* stuck with me, emergent for perhaps only hours before being covered again with sand.

Pyropia, in all its various guises, is a poster child for the complex reproductive cycles that the red seaweeds present to their watery world. It is assumed that the complexity of a seaweed's life history, with alternating haploid gametophyte and diploid sporophyte generations, engenders evolutionary success. Red algae have been growing in our oceans for a billion years. But all the various stages of the cycle happen underwater, or in the middle of wave-crashed, rocky, remote places, making full understanding of many seaweeds' reproductive strategies incomplete. To keep us humans on our toes—and at some points completely confused—marine algae often present completely different forms and qualities at different stages of their life cycle.

The *Pyropia* that we find on the rocks represents the haploid (single set of nuclear DNA) portion of the life cycle and can be either a female or male blade (and sometimes both). If it is spring, the female blade might have a reddish texture at its margin or edge. These are the female gametes or eggs, ready to receive some floating sperm released by a nearby male plant. Fertilization happens right on the female blade in a noticeable container or bump. The fertilized zygote—now with two sets of chromosomes—grows within this protective pouch and is eventually released to float to the ocean floor, where it bores into a seashell. There it germinates into a branching and stringy sporophyte called the conchochelis, which has chromosomes from both the male and female gametes. This is the alternate, diploid generation of *Pyropia*, manifesting as purple splotches on a host shell, usually an oyster or a scallop shell. It looks nothing like the leafy gametophyte *Pyropia*. And while the sporophyte of this species is microscopic, it does the same thing that the giant bull kelp sporophyte does: it releases its spores into the water column in the fall. Once landed on a rocky substrate, these spores start the process of meiosis or cell division, whereby the chromosomes are divided. Each division develops into a genetically discrete plant, growing into a male or female blade of *Pyropia* hanging from a rock face or plastered atop a cobbled boulder.

Many seaweeds have an alternate generation that is mysterious or cryptic. The grand and enormous bull kelp's gametophyte phase (creating male and female germ cells) is so tiny, lodged in cracks on the ocean floor, that it has never been seen in the wild. *Mastocarpus*, or cat's tongue, as it is commonly called, can dominate the tops of rocky outcroppings, making a four-to-five-inch carpet of its almost black cleft-tongue-shaped blades. This is the gametophyte phase, and finding the male versus female plants is a nice challenge. The males are smooth and the females are very bumpy. On the same rocks, one might also encounter a soft, black crust known as a tar spot. This is the *Mastocarpus* sporophyte phase. They would never be considered the same species by any standard that we expect—except that they are. *Pyropia* is part of this gang of red seaweeds with heteromorphic—not the same looking—alternation of generations. It took a remarkable woman's very close observations to figure it out, and these observations were very much appreciated in Japan.

Pyropia and *Porphyra* are better known to nonscientists by the Japanese name, nori. The first time I encountered nori was in 1984 in a tiny Japanese grocery store in the East Village of New York, where I lived. I had never before heard of sushi, and I certainly had never heard of nori. In 1901, when students at the Minnesota Seaside Station assembled for an evening lecture and heard from Dr. Kichisaburo Yendo about the various seaweeds of Japan and how they were collected, prepared, and eaten, they too had certainly never heard of nori nor thought about eating seaweed. The first volume of the journal of the Minnesota Seaside Station, compiled by Josephine Tilden, begins with this talk by Yendo and includes three folded prints. One depicts the indigenous Ainu people of the northern island of Hokkaido gathering long green straps of *Laminaria* into massive loads. The colors in the image are bright green and yellow with the red Japanese sun looking over the scene. The second colored print, in contrast, is pastel pinks and blues and shows a single girl in a canoe with her basket, out to collect nori, and the third, uncolored print shows the process of nori manufacture, a busy urban scene.

Yendo lists many seaweeds with names we now recognize (kombu and the related tea kombu-cha, as well as funori and others) but it is nori, or *Porphyra*, that is emphasized as the seaweed used by "every class of people" in the greatest variety of ways, sushi being the "sandwich" of Japan. "When baked before a gentle fire," Yendo explains to the

students for whom beef, bread, and potatoes were the regular fare, "*Porphyra* acquires a remarkably agreeable flavor; the rule of the cooks is to bake until the purple color changes to green." He estimated that in 1894, 11,232,900 sheets of nori were produced in Japan from "twig" farms where *Porphyra* would collect as purple leaves on branches stuck into the shallow, sandy bottom of protected coastal bays. Women and girls with small fingers were the chief harvesters of the delicate nori.

Nori farming techniques in Japan were only updated to a degree over the next half-century. In reality the nori farmers of Japan had never really cultivated nori, they had simply been gathering it. It was assumed that the nori spores would float in the seawater and, landing on a place to grab hold, grow into a new seaweed. But no one had actually seen it happen. The nori usually grew abundantly from October through February, but then it would all but disappear through the summer months. In some years the Japanese nori harvest was plentiful, flooding the markets, and in other years it was sparse, becoming a luxury item. In 1949 disaster struck the industry. A series of typhoons combined with fertilizer and pollution runoff devastated the nori beds, which would not regrow. No one could figure out what to do. The industry was in crisis. Then in October 1949, a 150-word paragraph in *Nature* magazine written by an Englishwoman named Kathleen Drew-Baker gave the Japanese scientists and seaweed farmers a hint towards solving their conundrum. Drew-Baker had never been to Japan, but she had studied *Porphyra*.

Kathleen Drew was clearly brilliant from a young age. In 1922, she became the first woman to graduate with honors from Manchester University, completing her master's degree. She had found her subject, marine algae, and was awarded a research scholarship and then became the first woman to be awarded a Commonwealth Fellowship, to study in America for two years. Her first stop was an extended stay at the University of California at Berkeley to study with the renowned seaweed duo William Albert Setchell and Nathaniel Gardner, and then she spent shorter stints at Friday Harbor Laboratories in Washington State and Woods Hole Marine Biological Laboratory in Massachusetts. Her personal herbarium gives clues as to where she collected—Moss Beach in California, Puget Sound, Hawai'i, Cape Cod, Maine—and reminds us that her scientific intellect was, as for many great ecologists, combined with a deep love for the ocean. Seaweed collecting for Kathleen Drew was serious and scientific, but it

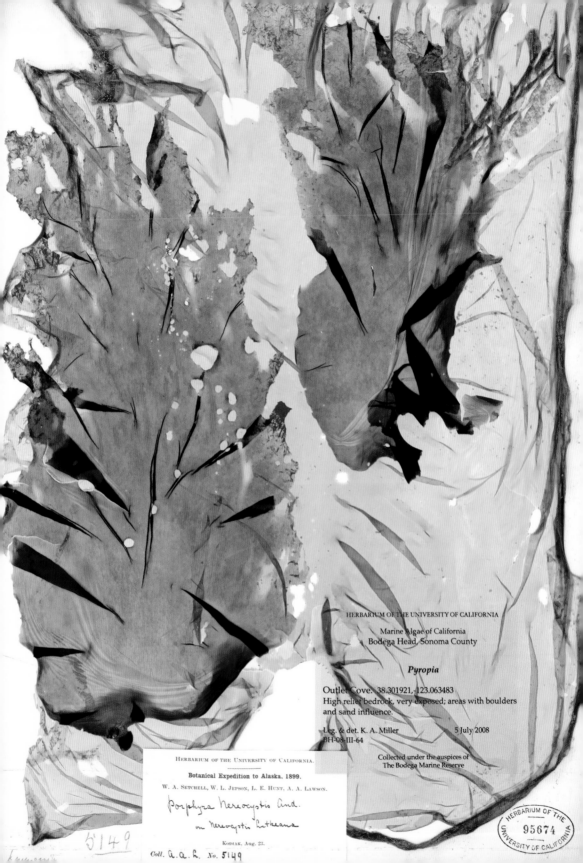

5149

also made magical moments, like overnight camping by the sea and special friendships bound by a proximity to a wild world. The result was a personal herbarium of almost twelve hundred specimens as well as experiences never forgotten.

By the time Drew returned to England as an assistant lecturer in biology, she had established her main focus of investigation: the red algae and their cryptic modes of reproduction. Following the strictures of the times, she gave up the position as lecturer when she married Dr. Henry Baker, but she managed to secure an unpaid research situation to continue her studies. She wrote papers at a prodigious rate. Her husband built her an idiosyncratic but functional tidal tank, one of the first of its kind and an essential tool for close observation of the thousands of seaweed samples she collected from the rocky Welsh shores of the Irish Sea. The coasts of southwestern Japan and northern Wales both sustain the common red algal genera *Porphyra* and *Pyropia*. Drew-Baker had noticed with intrigue the fall bloom of *Porphyra*, locally known as laver. She focused her attention on this algae and what she initially supposed was a different species, the filamentous algae *Conchocelis* that grew as splotches of red or purple in old oyster shells. Her great discovery was that these two were not different species but different life stages of the same one. The familiar *Porphyra* in the local laverbread and what the Japanese press into sheets of nori were but one stage of an alternating generational cycle. Drew-Baker wrote up her observations and a simple description of the two stages of *Porphyra*'s life history.

Scientists in Japan, upon reading Drew-Baker's note in *Nature* magazine, were able to experiment and set up systems using beds of seashells to seed and grow nori systematically. The modern-day, multibillion-dollar nori industry was born. Kathleen Drew-Baker continued her research and initiated the British Phycological Society, and as its first president she brought seaweed scientists together to discuss and collaborate. But, like ecologist Rachel Carson a few years later, she died prematurely of breast cancer in 1957, when she was fifty-six. She worked until her last days, having hidden her illness. Before her death, Kathleen Drew-Baker burned her letters, diaries, field notes, drafts, and papers—as if to blot out her existence. So it is deeply poignant that every year on April 14 she is remembered. On the other side of the globe, there is a festival in her

Opposite: *Pyropia* with *Pyropia* (formerly *Porphyra*). Image by author. *Pyropia* spp. collected by Kathy Ann Miller, Bodega Head, California, 2008. University Herbarium, University of California, Berkeley, no. 1965038. *Porphyra* growing on *Nereocystis*, Kodiak, Alaska, 1899. University Herbarium, University of California, Berkeley, no. 95674.

honor at the Sumiyoshi shrine near the acres of crosshatched ropes that are the tidal nori farms of Ariake Bay, one of Japan's inland waterways. The nori farmers owe Kathleen Drew-Baker their livelihoods and uphold her memory with a statue dedicated to the Englishwoman known as "the Mother of the Sea."

Nori or *Pyropia* is not only important to the Japanese people but has been an essential element of the diet and cultural and economic exchange of indigenous peoples up and down the west coast of North America for centuries. Nancy Turner is an ethnobotanist who has worked among the First Nations elders of British Columbia and Alaska Natives for many years, gleaning their wisdom and practices, and she has documented their use of plant-based resources in a complex cultural economy. In a 2014 paper she listed twenty-two examples of plants and plant products traded or exchanged among the indigenous peoples of northwestern North America. Included in this list is one seaweed: *Pyropia abbottiae*, commonly known as black seaweed, collected each spring from the rocks of the coast from Alaska to California, dried, and made into cakes or squares. It is highly nutritious as well as delicious and was traded along the outer and inner coast of British Columbia and with interior peoples for foods and commodities not available on the coast. The people of Gitga'at Nation living on the north coast of British Columbia are known for the high quality of their edible seaweed. Their word for black seaweed, *leq'ask^w*, is found in variation across their own speaking communities and among different language groups across the region—the trade brought the word. In California, traditional gatherers on the northern coast include the Yurok people who dry their *chege'l* in round cakes. Some of their inland neighbors restoring traditional nutrition (and languages) still trade for it, calling it *lah* in the Hupa language and *xêem* in Karuk.

Group of *Pyropia perforata*. Note fertile edges.

Pyropia is perhaps the seaweed with the most names around the globe. It is the algae that is farmed and eaten in more coastal countries and cultures than any other seaweed. Nonindigenous American culture is virtually alone among nations with a coastline in missing out on this culinary and ethnophycological phenomenon. Commercial algae farmers and harvesters today are making efforts to enlighten that palate. Their efforts must work in tandem with coastal foragers who advocate sustainable gathering to protect a vulnerable, wild ocean resource from overharvest, as well as with indigenous people carrying on their traditional gathering who want to protect their ancestral places and food sources.

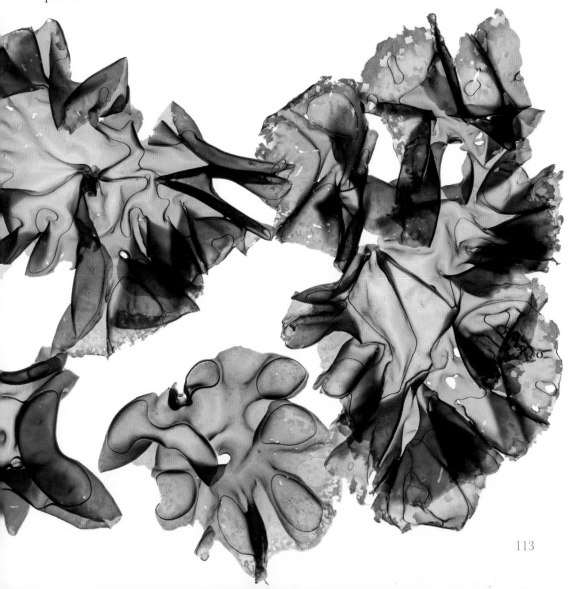

POSTELSIA

1901

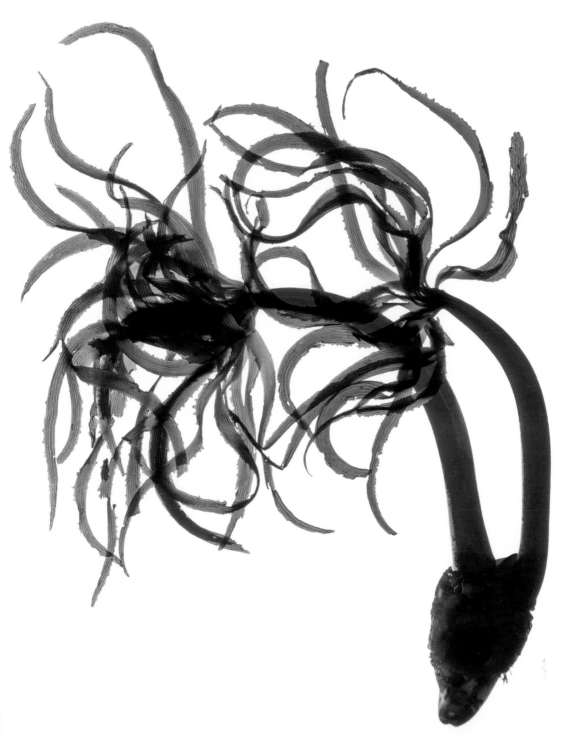

This page: *Postelsia palmaeformis*.
Opposite: Cover of *Postelsia: The Year Book of the Minnesota Seaside Station* (1901).

Postelsia palmaeformis

Sea Palm

Postelsia palmaeformis is the coolest kelp there is. It seems different from other kelps and seaweeds—kookier, more Dr. Seuss-worthy. Called sea palm because it looks like a diminutive palm tree, it is found nowhere else on earth but the wave-crashed rocks off the coast of Northern California, Oregon, Washington, and British Columbia, from the headlands of San Luis Obispo to Vancouver Island. Unlike its kelp compatriots, it does not venture north to Alaska. Usually *Postelsia* is viewed from afar, growing on barren fragments of the continent that have broken off and sit exposed to the wide Pacific, patiently being pounded into the sands of time. Getting to kneel down and put one's nose into a *Postelsia* forest is a rare event. I got to do this not so very long ago, and it has stuck with me.

Our tide charts alerted us to an early morning minus tide. We emerged from our tents at daybreak and headed down various pathways through scrub and dune, with the angled sun sifting through grasses and wildflowers. Arriving at the edge of the land, we scrambled down a sandy bank to a platform of rock that strikes out from the edge of the continent into the crashing surf of the Pacific Ocean. The fog is persistent here at the shoreline, and jackets, gloves, and hats refute the heat wave only a few miles inland.

I am with Larry Knowles, a commercially licensed seaweed harvester who has been exploring and diving this section of the Mendocino coast for thirty-plus years. A deep channel pulls pulsing sets of waves in from the surf break along one side of this stone outcrop. Brown kelps spot the deeper water of the cut, and the horizontal rock is a veritable nursery of ocean flora. Larry voices delight and relief at the fecund late-June bounty of seaweeds. He reports that in the past two years this particular rock has been nearly barren, a result of the warm blob of ocean water that had expanded south from Alaska since 2013 and sat off the California coast, inhibiting kelp and seaweed growth, which requires cold temperate waters. But this spring is different. The upwelling is rich and cold. Larry knows this intrinsically since he is in the water often, spearfishing or harvesting seaweeds—the cold infiltrating his neoprene wetsuit and booties. He is

delighted! And this garden show of a reef is the result of the cold: brownish red *Mastocarpus papillatus*, or cat's tongue, and neon-bright, olive-green rockweeds dominate the top of the rock face, while the sides of the channels are draped with curtains of *Mazzaella splendens*, shimmering their refracted colors of blues and purples. Random fingers of celadon *Halosaccion*, or sea sacs, point skyward amidst leafy seaweeds, and the channels are peppered with bent, brown stipes of *Laminaria setchellii*, whose leathery straps of blades reveal themselves when the surge retreats. In tide pools along the reef, luscious aquamarine anemone sit under the trapped water, their tentacles open, not offering but waiting for something to grab. Their color contrasts nicely with the pink algal skirt surrounding each pool at its waterline—the red articulated coralline algae are healthy and robust.

A colony of *Postelsia palmaeformis* clings to the far reaches of this tongue of stone that reaches out into the dramatic energy of the breaking surf. The sea palm grows directly on the rock and on an adjacent mussel bed. I head out to inspect, rewarded by a group of brilliant celadon-green gumby trees, the tallest no more than eighteen inches, the cluster making a diminutive forest. Each stout "trunk" (stipe) emerges from a dense holdfast of stubby haptera, or rootlike branches, holding tight to a group of mussels or the rock face itself. And hold tight it must. The sea palm must withstand tremendous forces to remain in place. This particular niche of the intertidal zone rages with water dynamics and torque up to forty-one times the pull of gravity. Rasta-like dreadlocks of grooved blades emerge ebulliently from the top of each hollow, bendy stipe, then droop down almost to the rock face. Right away I spot two little *Postelsia* growing at the base of what would be an older sister, pint-sized copies of the teenage sibling.

Postelsia is one of the only macroalgae for which the terms we understand from plants on land—trunk, roots, and leaves or palm fronds—map onto the kelp's form. It really looks like a little palm tree. Dr. Seuss's truffula trees from *The Lorax* come to mind, or we can imagine a Lilliputian hike through the *Postelsia* forest. The "trunks" bend

prostrate with each wave and bounce back to upright as the wave recedes. We would not be able to hold on to these stipes to save ourselves from being washed away, however, as they are uniformly smooth and slippery, maintaining a wet, shiny gloss during the brief airtime. *Postelsia* is the only fleshy seaweed that makes a stipe stiff enough to combat gravity and stand upright when exposed at low tide, and this immediately feels familiar to us. As terrestrial beings we take for granted the force of gravity in shaping things and think nothing of the energy a tree must devote to making a rigid trunk.

But the quotes around the terms "trunk," "root," and "leaf" when speaking of *Postelsia* are important. Trunk, root, and leaf, even the word "tree," all imply a differentiation of task and purpose that the cells of the *Postelsia* do not exhibit. While it has coevolved along a similar morphological trajectory as a tree, the likeness is superficial. *Postelsia*'s uniform avocado-green color illustrates this difference. The kelps do not hoard nonliving tissue like trees do as wood, and algal cells do not differentiate as do plant cells on land. All of *Postelsia*'s cells photosynthesize to a greater or lesser degree, each housing the green and brown pigments that give it its singular color. The holdfast has the simple function of holding the organism to its substrate of mussel shells or rock; it does not perform a task that "root" implies, which is the uptake of nutrients. All algal cells have the ability to access nutrients directly from the ocean. *Postelsia* is particularly rich in iodine, iron, magnesium, and potassium, as well as vitamins A, C, and the full line of B vitamins, including B_{12}. And unlike a tree, which takes years to amass its woody trunk and branches, the sea palm is an annual. It grows for one year and then lets go its hold. The adult sea palms are swept away with the winter storms and can often be found stranded on sandy beaches, their holdfasts still clinging to mussels.

The life cycle begins when, at low tide, spores slide down the grooves of the drooping blades of a mature *Postelsia* and are deposited at the foot of the parent organism to grow in close proximity. The spores have only the time between waves to take hold. Unlike other kelps, whose spores are disbursed by the ocean currents, these stay close to the parent and develop into microscopic sexual plants either male or female. Like its closest cousin, *Nereocystis luetkeana*, this sexual phase of *Postelsia* is remote in size and place, leaving much to be wondered about what actually happens. How do the egg and sperm find each other? How do they not get swept away? It is supposed that a fertilized egg, or gamete, begins development of the erect *Postelsia* but overwinters, invisible

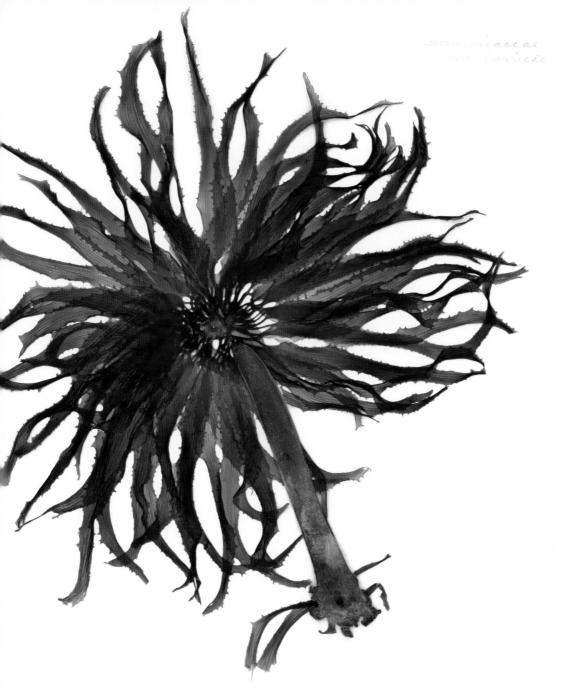

Postelsia palmaeformis. University Herbarium,
University of California, Berkeley, no. 1977066.

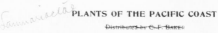

Laminariaceae PLANTS OF THE PACIFIC COAST

Distributed by C. F. Baker

No. *Postelsia palmaeformis* Rupr.

Pearson's Beach, Santa Cruz, Cal.

Mrs. J. M. Weeks. July 97

Determined by

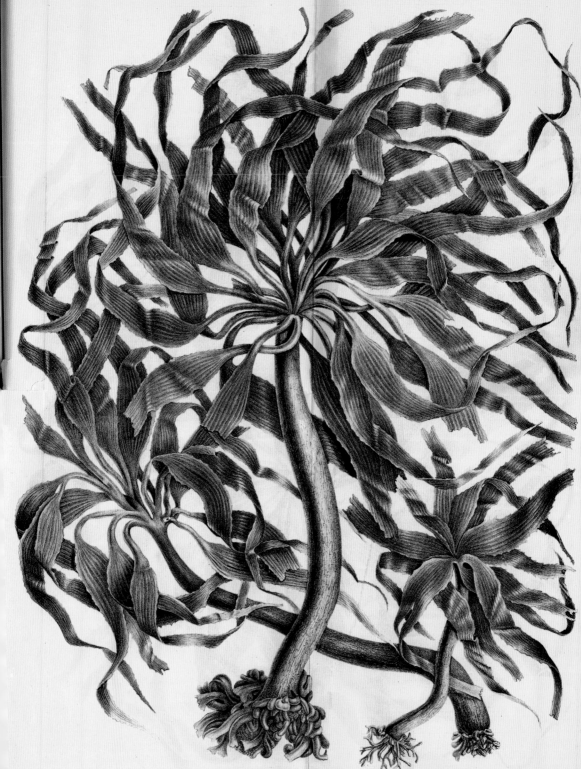

Præv. fecit.

Het. B. Lepicimi.

Postelsia palmaeformis.

amongst the rock cracks or mussel beds near the parent. It grows rapidly into the young sea palm with the longer days of sunshine in spring. The parent plant has washed away during the winter, leaving space for the next generation—my *Postelsia* siblings—on the same patch of rock.

The type specimen of *Postelsia* was collected on the "exposed shore" of an islet at the entrance to Bodega Bay on the Sonoma coast, about one hundred miles south of where I stand on this rock shelf at MacKerricher State Park in Mendocino. The original *Postelsia* was collected by the Russian naturalist Ilya Voznesensky, sent to North America by the Academy of Sciences in St. Petersburg to follow in the footsteps of Georg Steller. One century after Georg Steller set foot on Alaskan soil at Kayak Island in 1741, the Russian presence in America—Bolshaya Zemlya or "Big Land" as it was called by the Bering expedition searching for its coastline—was coming to a close. The Russians and others had trapped, killed, and butchered the natural abundance that brought them there—the sea otters and seals in the oceans and the foxes on land—for their pelts and skins, fodder for a greed that our human species seems incapable of evolving beyond. The gentle sea cow was killed as food for the fur hunters and within a few decades went extinct in conjunction with the collapse of the trophic cascade as sea otters were extirpated. With the natural bounty depleted and Mexico and Britain vying for territory, the Russians wanted to bow out. But before Russia abandoned its colony at Fort Ross, the Academy of Sciences in St. Petersburg sent Voznesensky to survey the plants and animals of the Sonoma coast adjacent to that colonial base. He spent the decade from 1839 to 1849 traveling and collecting specimens along the Pacific Coast from Alaska to Mexico.

In 1842 Voznesensky sent some of his collections back to St. Petersburg before moving south to Baja. Many of the vibrant kelps he found off the coast of Northern California were included in the Academy's collection and examined by Franz Josef Ruprecht, the chief botanist of the Academy at that time. Ruprecht and his compatriot, artist Alexander Postels, had just completed the magnificent *Illustrationes algarum*, describing in oversized images (Postels) as well as scientific Latin (Ruprecht) many species from

Opposite: *Postelsia palmaeformis*. Foldout plate from Ruprecht (1852, pl. VI). Collection of Michael J. Wynne.

the west coast of North America, but none had been collected south of Alaska. The Voznesensky specimens were all from the California coast. Ruprecht published a paper in 1852 titled "Neue Pflanzen" describing five of these kelps and one seagrass. Three healthy and dynamic sea palms are shown in one of the spectacular engravings done for this publication. The thick stipes cross each other, and the profusion of corrugated blades from each stipe intertwines and explodes outwards to the limits of the page. Ruprecht gives *Postelsia palmaeformis* its own genus, in which it is the sole species.

Setchell and Gardner reported in 1920 that according to Ruprecht the sea palm was called *kakgunu-chale* by the native people living at Bodega Head. Voznesensky must have included a note with his specimens for Ruprecht, and while we can guess that it was Coast Miwok people helping Voznesensky, we can feel assured that their name for this widespread and surely essential element of their world did not have anything to do with a palm tree. The Coast Miwok language was nearly lost, but Sky Road Webb, whose mother was Coast Miwok, has been learning the language from old recordings at the Phoebe Hearst Museum at the University of California, Berkeley, and any other source he can come by. He explains that figuring out a Coast Miwok word takes some triangulation from various sources because transcriptions vary greatly depending on whether the writer was a Spanish or English speaker or heard the word a certain way. The boomerang across time and space of this word, *kakgunu-chale*, for this particular organism, a bottle-green treelike kelp plucked off of a wave-drenched rock in the entrance to Bodega Bay, went like this: It would have been heard by Voznesensky, a Russian speaker, and written perhaps in Cyrillic to Ruprecht, a native German speaker, who made a note about it in his 1852 publication, which was mostly written in Latin. When this was translated by Setchell and Gardner in 1920 they included the term *kakgunu-chale*, which Paul Silva mentioned in a journal article he wrote about the story of *Postelsia* in 2004. I was shown this exposé by Kathy Ann Miller in 2014.

I was curious whether I could find any other reference to this term. In 1932 a UC Berkeley anthropology student named Isabel Kelly lived for five months in the small fishing and ranching community of Bodega Bay and spent every afternoon interviewing a man named Tom Smith, also known as Tomás Comtechal. Tom Smith was about ninety at the time and had been a respected leader—a singer, doctor, dance leader—in the Coast Miwok and other Indian communities of that area. His

grandmother had been born in a village called Tokau, located on the eastern side of the Bodega Head peninsula, about a mile from its southern tip. I realized that this is precisely where the living quarters for the Bodega Marine Laboratory are, where I stayed during my first and most recent seaweed workshops. Isabel Kelly wrote, "My informant is one of the world's nicest people. He spends his evenings singing, so he may remember things to tell me the following day."

The transcriptions of Isabel Kelly's eight filled notebooks are a maze of cryptic notes pairing Coast Miwok words with place names, flora and fauna, dances, stories, names of other tribal groups, and on and on. I held my breath as I noticed a seaweed specimen listed as B-30 among the plant specimens collected in April 1932 and

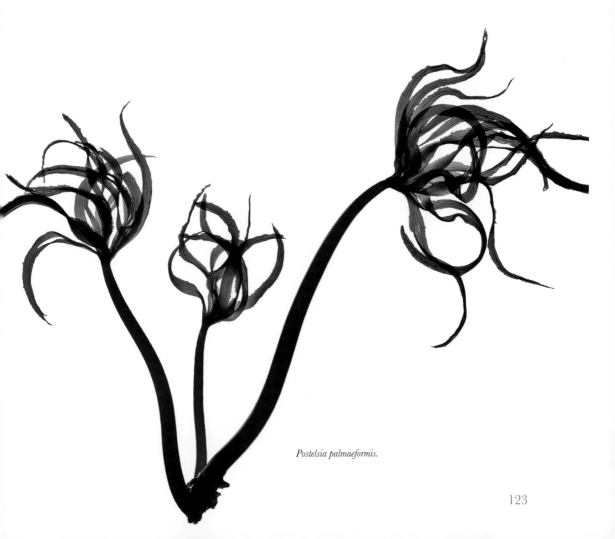

Postelsia palmaeformis.

123

identified by Smith. The Coast Miwok term for edible seaweed seems to be *haskula,* and this is assigned to specimen B-30 with a single descriptor: eaten. But while the plants are all identified with their common name and Latin binomial, the single seaweed specimen has no identity from the English or Latin side. Two other Coast Miwok terms emerge from the notes: *tcola* for those seaweeds other than *haskula* that are too tough to eat, and, in one brief reference, *koo'-yukoo'-yu,* a kelp with a "large cylindrical stem." Could this be our sea palm? It could also reference bull kelp. Both have cylindrical stipes and are plentiful in that region. A full review of the notes makes clear that seaweed

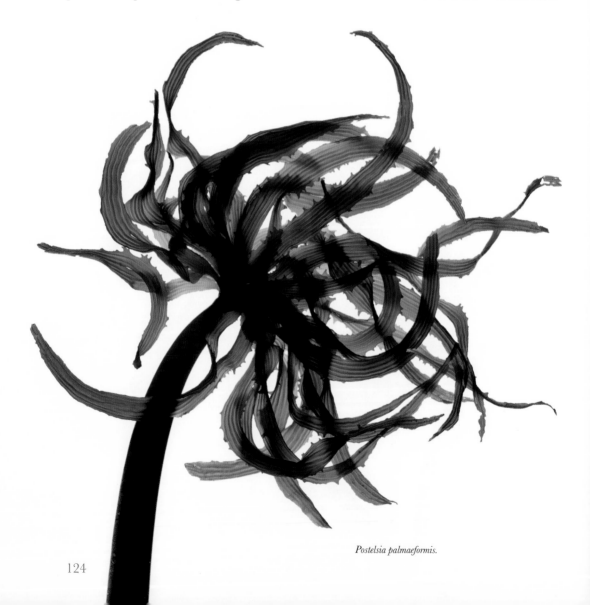

Postelsia palmaeformis.

was collected and dried in cakes, that four locations around Bodega Bay, the center of the Coast Miwok tribal area, were considered the best for seaweed collecting, and that *haskula* referred to seaweeds good for eating. But a specific name for *Postelsia* was not in the massive tome of notes. I am not surprised. The seaweeds keep their secrets to themselves.

And so the term *kakgunu-chale* trickles down to us, a ghost of sorts, from the tiny population of the fifteen hundred or so pre-1770 speakers of Coast Miwok. The Miwok were never given a chance to pass down their names from one generation to another. In 1817 the mission at San Rafael was built and many Coast Miwok were forced to live and work there. In 1837 a smallpox epidemic decimated the indigenous populations in the area around Bodega Bay. In the nineteenth century and the first half of the twentieth century, California Indian children were forced into boarding schools, as were native children elsewhere in the United States and First Nations children in Canada. Among other abuses, English was required as the only language at these schools, and the culture of the children was squelched, relegating the words and language of their ancestors to wax cylinders in the Phoebe Hearst Museum of Anthropology at UC Berkeley (to await ongoing language revival by descendants of survivors).

Regardless of what it is called, *Postelsia palmaeformis* (our decidedly Western-facing Latin name) could be part of any diet—traditional (Coast Miwok, Pomo, and Yurok are all in *Postelsia* country), or that of bohemian locavore foragers, or I could use it in my own kitchen. The stipe can be easily pickled, and the blades are sweet tasting. But it is now a protected wonder in California and one must have a commercial license to harvest the sea palm in the state. Even so, care must be taken to harvest it properly: just the ends of the sea palm's blades are clipped by the authorized few, provoking a more robust growth each spring. It is now illegal to harvest sea palm in Oregon, Washington, and British Columbia.

The miniature forest at the edge of the rock outcrop at MacKerricher State Park in Mendocino was as large a cluster of *Postelsia* as I have seen in years. Back at home I add a few dried blades from last year's harvest, carefully clipped by Larry from the *Postelsia* "trees" that have since washed away, to the beet and cabbage soup I am making. That hint of the ocean gives my soup a subtly rich and inspiring flavor.

HERBARIUM OF THE

ALLAN HANCOCK FOUNDATION

7271

If you wish to cite this particular sheet,
please cite it as AHFH (sheet number) in UC.

ALLAN HANCOCK FOUNDATION
HERBARIUM

Name: *Macrocystis pyrifera* (L.) Ag.
Family: *Lessoniaceae*
Locality: Palos Verdes, Los Angeles
Habitat: attached to rocks at minus 2 ft.
Color: Brown
Collector: Nothnen (. Crafter # 75
Det. Crafter – Clone
Date: Mch. 1, 1942.

THE UNIVERSITY OF SOUTHERN CALIFORNIA

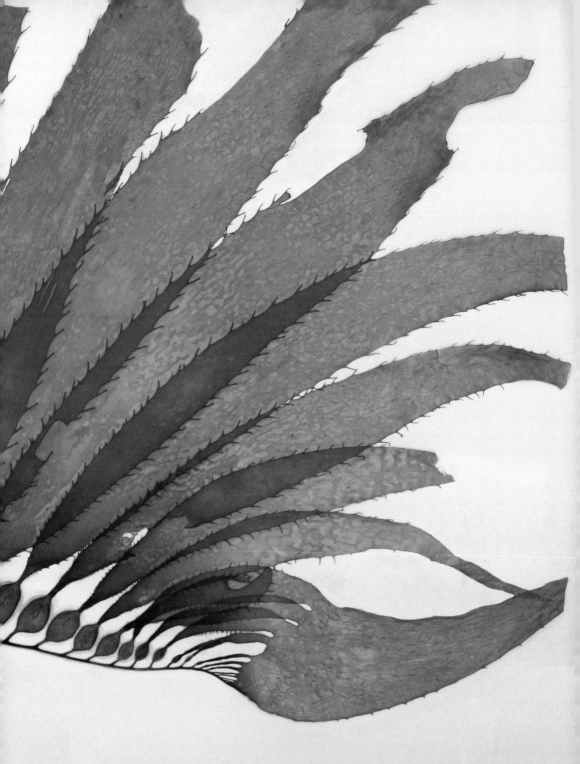

Macrocystis pyrifera, collected by Norman C. Cooper, Palos Verdes, California, 1942. University Herbarium, University of California, Berkeley, no. 1833881.

Macrocystis pyrifera

Giant Kelp

"Kelp" is not really a scientific term, but everyone uses it. For scientists, divers, beachcombers, and coastal wanderers the name refers to the big, fleshy marine algae that tend to be shades of golden or olive brown. Kelps are a subset of the class Phaeophyceae—the browns. Only the kelps have gas-filled bladders, or pneumatocysts, to keep their bulky thalli afloat. Many of them tend to congregate beyond the surf zone in what has come to be called the kelp forest. Perhaps the most magnificent of these is *Macrocystis pyrifera*.

Macrocystis pyrifera, or giant kelp, is a resplendent organism and one of the most recognizable kelp of the Pacific coastline. Scuba divers go rhapsodic and starry-eyed when they recount their underwater experiences looking upward into the amber forest of *Macrocystis* giants, a constantly moving canopy of marine foliage splayed across the ocean's surface glowing in the sunlight. A graphic array of bladders branch continuously off the main stipes of *Macrocystis*, and each bladder sports a luxuriously textured blade off the end. This kelp is the main act of the Monterey Bay Aquarium's central exhibition for good reason. Its exuberant growth and sheer beauty are breathtaking. It can reach lengths of one hundred feet or more in a single season. *Nereocystis* (bull kelp) dominates the subtidal forests north of San Francisco Bay, but south from San Mateo to Mexico and also throughout British Columbia and north to Sitka, Alaska, *Macrocystis* comprises the massive kelp forests aggregating beyond the breakers, twenty to eighty feet deep. The kelp forests of Southern California are legendary in their massiveness.

Sporophyll blades, *Macrocystis pyrifera*.

In his memoir *Two Years Before the Mast*, Richard Henry Dana, Jr. returns to California in 1859 after his main trips sailing up and down the California coast from 1834 to 1836, and he is told that "the climate has altered; that the southeasters are no longer the bane of the coast they once were, and that vessels now anchor inside the kelp at Santa Barbara and San Pedro all year round." This was unheard of twenty years prior, when ships had to escape ruin by quickly heading out to sea when a storm was coming. The immense kelp beds all but trapped the large square-rigged trading vessels in the harbors of Santa Barbara, San Pedro, and San Diego, so ships generally anchored outside of them.

California beaches from Half Moon Bay to San Diego are piled with giant kelp castoffs. I cannot help but put a few dried *Macrocystis* bladders in my pocket when I walk the beach in Los Angeles, Santa Barbara, or Monterey. Their rich orange hue is baked in by ultraviolet light, and the ovoid shape with a curvilinear blade creates a delightfully idiosyncratic tiny *objet*—ocean made. Someday soon I hope to go to South America and collect *Macrocystis* pods along the beaches there as well. *Macrocystis pyrifera* has a wide-ranging biogeography, making forests along the Chilean Pacific Coast and around Cape Horn up the southern coast of Argentina, as well as around both islands of New Zealand. It even thrives in warmer waters nearer the equator off the coast of Peru. All these forests are of the same species—how it crossed the equator and spread out from the northern hemisphere to the southern is still a matter of speculation. During the Pliocene, oceans cooled when the Panamanian Portal closed and many species moved south. More recent glacial cooling in the Pleistocene and increased upwelling prompted movement of algae north and south. Like humans finding far-off islands,

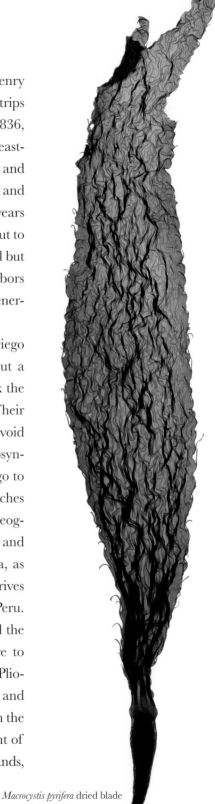

Macrocystis pyrifera dried blade
accentuating the rugose texture.

129

rafted kelps with viable spores travel great distances and could have established on shores far from where they started.

The world of the giant kelp still harbors its mysteries. In 1992, a kelp bed of *Macrocystis* was discovered at a depth of sixty-eight meters (223 feet) around the tiny Prince Edward archipelago south of South Africa. This depth is way below anything ever expected of this typically shore-bound kelp and might imply that it can live in more tropical zones than thought, just far below the surface.

Macrocystis pyrifera is a perennial kelp, growing anew each spring from a holdfast that persists through the winter. The holdfast's connection to its rock is a magnificent thing—one of those feats where nature far exceeds human engineering. Despite the immense torque and forces of ocean current and wave action, the holdfast's glue is strong, keeping its attached kelp or seaweed in place, one of the basic requirements for a seaweed's success. The root-like strands, or haptera, of the young plant are negatively phototactic, growing away from light, or downwards, and spread out rapidly, grabbing a rocky portion of the benthos (sea bottom). They extend sticky fingers that adhere to the substrate with a secreted polysaccharide glue, multiplying and building an inner core. As the holdfast ages, the newer, colorful haptera—they can be red, pink, even bluish—grow

Macrocystis pyrifera. Illustration by E. Yale Dawson from the cover of ZoBell and Dawson, *The Seaweed Story* (1954).

over the inner core, making a massive, cone-shaped edifice that becomes an underwater cathedral to hundreds of species that seek refuge in its catacombs. More than 175 species have been identified as living on and in the holdfasts of the *Macrocystis* plants, including kelp fish, anemones, brittle stars, snails, crabs, and even the kelp gribble, *Phycolimnoria algarum*. The purse-shaped egg casing of the swell shark secures itself with tendrils to the *Macrocystis* holdfast, allowing its single egg to develop inside while moored safely to home base.

These complex structures are the base of a vertical wonderland of an ecosystem. Understory kelp such as *Pterygophora* grow between the giant kelps, and all of the algae oxygenate the surrounding waters—they are photosynthesizing machines that use CO_2 to generate biomass and pump oxygen into the surrounding waters at a rate unknown in our terrestrial world. Fish hide amongst the giant kelp's fronds. Mollusks such as abalone and snails feed on kelp detritus that sloughs off, as do crabs and countless amphipods, isopods, and small crustaceans. Hydroids and bryozoan colonies take up residence on the giant kelp's broad blades and stem, and fish nibble at these delicacies. Urchins are the most voracious kelp herbivore, able to attack the forest in hordes, but they are often just one of the thousands of organisms that thrive in the complex system that is the amber forest.

The giant kelp plant can live six years or more, but the reproductive cycle is similar in some ways to the annual *Nereocystis*. Just above the holdfast, at the base of the rising amber giant, grows a cluster of specialized blades. These blades are smaller and thinner than their upper sisters and release trillions of microscopic spores into the surrounding ocean waters. The photosynthetic spores waft slowly in the water column to disperse and settle on the ocean floor and, with enough light—a tiny bit of blue light has been deduced in the laboratory to be all that's needed—develop into male or female gametophytes, microscopic organisms that produce either egg or sperm. Like the *Nereocystis*, a sperm follows a pheromone trail to find an egg, but we must remember scale here. Not only are these organisms tiny (microns big), but the female's perfume will be instantly diluted by the ocean surrounding her. The male and female microorganisms must be within a half millimeter away from each other for the pheromone attractor to work. Once fertilized, the egg can wait until the opportune time, perhaps up to eighteen months, before it begins to divide, with half growing downward into the holdfast and half growing

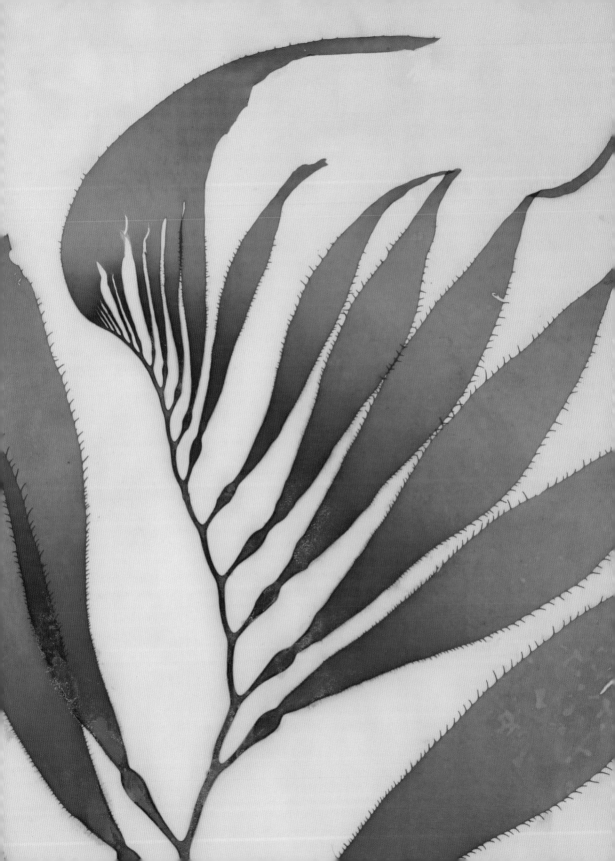

upward into a tiny, single-bladed sporophyte or baby kelp. This blade will split in two and then split again, eventually making the various strands of the giant kelp that reach for the surface and develop into the giant *Macrocystis*. All of these intricate steps have evolved to occur in concert with the ebb and flow of tide and current, a true miracle.

The tiny single-bladed baby is similar across many kelp species. Despite their incredible diversity of form as they age—think of *Egregia* to *Nereocystis* to *Macrocystis*—the young kelps all start off as a simple stipe with a single flat, heart-shaped blade. As the days lengthen in springtime, a carpet of juvenile *Macrocystis* blades emerges from the ocean floor, only some to grow to the great heights of maturity. One of the secrets of the giant kelp's speedy development—up to two feet a day—is that it can grow from any number of points. The very tip of the massive *Macrocystis* frond is called the apical scimitar, an apt descriptor of the initially singular flat, curved blade that splits into individual fronds. This is where new growth occurs, extending horizontally once the ocean surface has been reached. New fronds also grow farther down the plant, but these depend on the transfer of energy from the canopy for growth. The photosynthesizing blades at the ocean's surface distribute their products down the stipe for growth all along it. The natural rhythms of the ocean

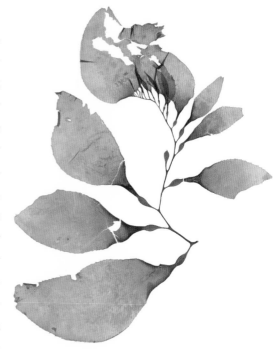

cause the top blades to slough off within months, and the younger blades then rise to the surface for more direct photosynthetic action. The entire giant kelp is a primary production conveyor belt. All parts of the organism, however, have the capacity to use the sun's energy for growth, even the outer portion of the hollow stipe. Unlike bull kelp, these multiple growth points mean that the giant kelp can lose, or have lopped off, its topmost vegetation and regrow with abundance. That is, if the oceans are healthy.

This page: *Macrocystis pyrifera*, collected by Hayden R. Williams, harbor master's dock, Newport Harbor, California, 1970. University Herbarium, University of California, Berkeley, no. 1602927. *Opposite*: *Macrocystis pyrifera*, collected by Gilbert M. Smith, Mussel Point, Monterey, California, 1941. University Herbarium, University of California, Berkeley, no. 2007983.

Like all seaweeds and kelps, *Macrocystis* houses phycocolloids in its cell walls—large polysaccharide, or sugar ring, molecules whose connections to hydrogen and oxygen (i.e., H_2O) form particular shapes that create gel networks, or viscous solutions. Phycocolloids are what make a seaweed goopy. These cell wall substances are essential for the longevity and success of all marine algae: they prevent a seaweed from drying out at low tide, and they allow a large kelp to remain supple and durable, able to bend and sway with the ocean current and wave action. Phycocolloids give the large kelps a modicum of structure in their cell walls, not enough to withstand the forces of gravity when pulled out of the ocean or thrust upon the beach, but enough to flourish when buoyed by the ocean itself.

The cell walls of brown, red, and green seaweeds all house their particular variation of this gooey substance. Algin is in the cell walls of kelps and brown seaweeds. Carrageenan is a similar emulsifier found in the cell walls of red seaweeds such as *Chondrus crispus*, or Irish moss. The algin constituent of *Macrocystis* has been measured to be about 2.5 percent of the entire organism. This considerable goo content, together with the giant kelp's ability to quickly regrow if only the top is harvested, has made *Macrocystis* one of the premier seaweeds for industrial use. When combined with fluids containing water, algin has the ability to control their flow characteristics. In 1929, the Kelco Company of San Diego started harvesting *Macrocystis* from the massive kelp beds off Point Loma and La Jolla to render algin as an emulsifier for industrial and household products. They developed ever bigger harvesting barges that would cut off the top few feet of the giant kelp, leaving the majority of the organism to regrow towards the ocean surface. Seven years later on the East Coast, two brothers set up the Algin Corporation factory in Rockland, Maine, to process that coast's ubiquitous *Ascophyllum nodosum* into algin. But the Atlantic rockweed could not compete with the West Coast kelp. *Ascophyllum* is slow growing, nothing like the massive beds of *Macrocystis*, so the Algin Corporation changed tack and began processing carrageenan from *Chondrus crispus* and eventually other red seaweeds and changed its name to Marine Colloids. Together these two companies were the source of seaweed derivatives that the American industrializing economy could not get enough of. The scientists at Kelco and Marine Colloids produced gelling, emulsifying, and smoothing agents to be mixed with paint, toothpaste, cosmetics, ice cream, cream cheese, salad dressing, and beer, among many other things.

These chemists, known as the pudding boys (pudding mixes being the iconic product using algin or carrageenan), sent their constantly revised seaweed derivatives to the test kitchens of Kraft, Unilever, Betty Crocker, and Sara Lee to be added to breads for shelf life, cheese for spreadability, and processed meats for convenience and to cake mixes and ready-made frostings. The postwar American processed-food diet relied heavily on these phycocolloids—whose genesis was the great beds of *Macrocystis* off the Southern California coast.

Kelco designed and built ever larger and more efficient kelp-harvesting ships to deliver massive tons of kelp to their Barrio Logan factory. They also understood the importance of sustaining their remarkable ocean resource. While they leased the kelp beds and were licensed and regulated by the California Department of Fish and Game (now Fish and Wildlife), they also hired a team of marine biologists associated with the Scripps Institution of Oceanography that came to know and love the kelp forest. This group of scientists and divers, particularly Ronald McPeak and Dale Glantz, spent their careers diving amongst the amber forest, doing extensive research and restoration projects. In the 1950s, pollution runoff as well as overharvesting of urchin predators such as sheephead fish and California spiny lobsters were the key factors in a major kelp die-off. Pollution controls were put in place, and the Kelco marine biologists devised systems to reseed juvenile kelp plants and use quicklime to eradicate urchins. Off Point Loma, kelp canopies increased from sixty to two thousand acres between 1967 and 1987, and off Palos Verdes, from two plants to a thousand acres. The scientists also understood the destructive cycles of El Niño for the kelp forests as well as the periodic waves of urchin infestation. They were in it for the long haul and were committed to sustaining this wild underwater wonderland.

But as the seaweed-derivatives industry kept getting bigger—Kelco had become a division of the pharmaceutical giant Merck in the late sixties—there were other environmental pitfalls. In 1989 a judge ruled that the kelp processing plant exceeded air pollution limits and was responsible for a third of the emissions of volatile organic compounds in its area. Merck settled with the Department of Justice and the Environmental Protection Agency for $1.8 million and installed new machines to reduce emissions. But this did not change the reality that processing thousands of tons of seaweed for its tiny colloidal component and discarding the remaining biomass was an

inefficient and hugely water-dependent process. In California, this is not sustainable. In 2004, San Diego instigated new water and sewage rates, and the company's costs more than doubled. After more than seventy-five years the factory closed and shifted its production to a factory in Scotland. Kelco has been swallowed many times over by globalized industrial giants, and today the name lives on as CP Kelco. The specialized kelp-harvesting ships no longer ply the *Macrocystis* beds—one retired kelp cutter named *El Rey* rests off of San Diego harbor deliberately sunk as an artificial reef—and the amber forest is no longer tended by a committed team of scientists and divers. Off San Diego the giant kelp forest is left to the natural rhythms of our warming ocean, and the unmarked factory in Rockland, Maine, also part of a large pharmaceutical company, remains the only seaweed phycocolloid processing plant on US soil.

The giant kelp's contributions to the health of our oceans cannot be overemphasized. *Macrocystis pyrifera* absorbs CO_2 and creates oxygen, creates habitat, and provides protection against coastal erosion. Its blades serve as the platter upon which herring serve their roe. Each spring the Haida and other First Nations peoples of British Columbia wait with anticipation for the great schools of herring to lay their roe on the broad blades of the *Macrocystis*. I took a workshop recently with a First Nations instructor on native uses of seaweeds in British Columbia and learned about the delicacy and value of *kaaw* (pronounced "gow"), as *Macrocystis* blades covered with roe are called. They are prized not only to eat fresh but to dry and trade. During the workshop we cooked and ate delicious seaweed stir-fries and seaweed-rice rollups, but I hope that someday I get to taste a blade of *kaaw*.

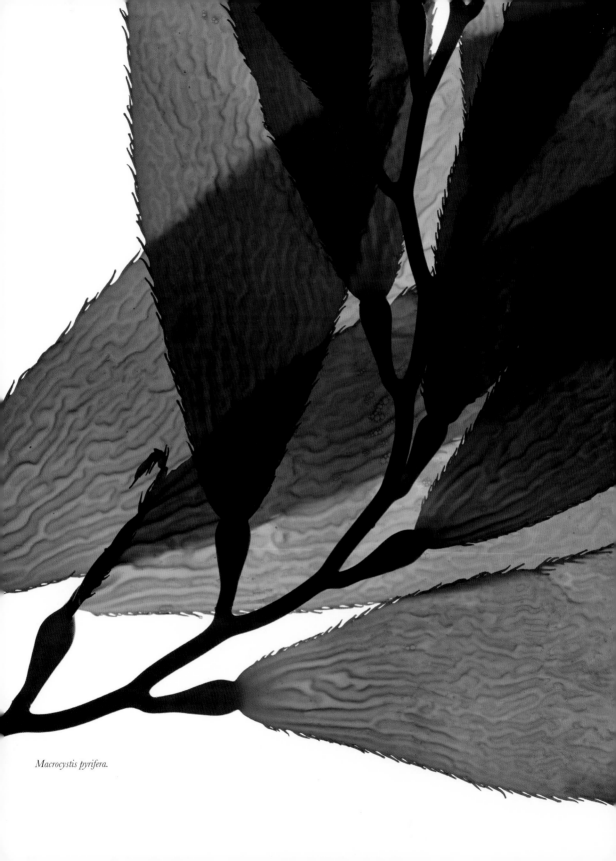

Macrocystis pyrifera.

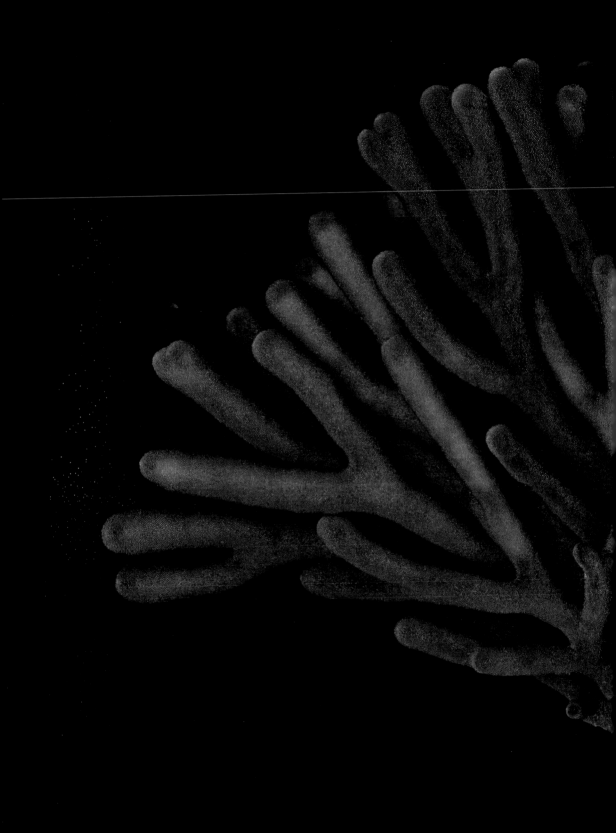

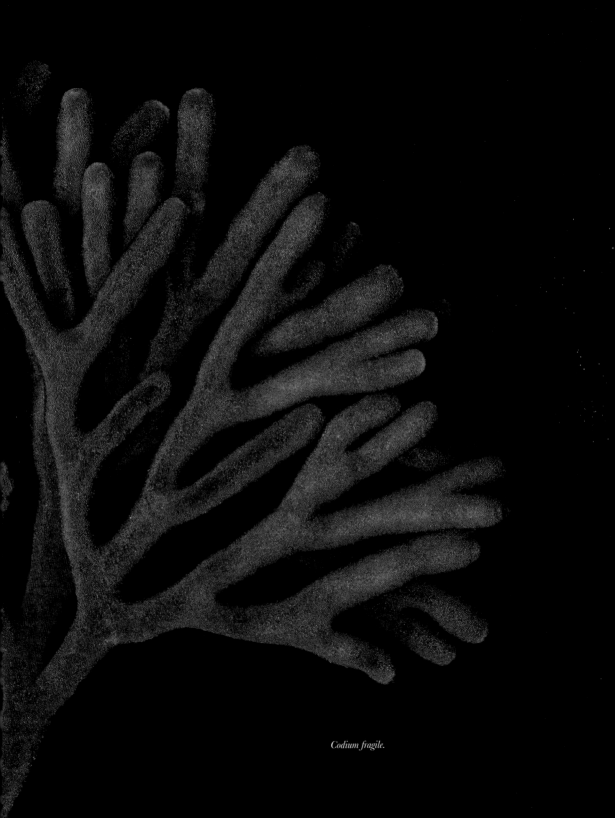

Codium fragile.

Codium fragile

Dead Man's Fingers

Codium is a dark, spongy seaweed. Although in the green category (division Chlorophyta), it reads as almost black. It does not have a stipe and blade, or any blades at all, but emerges from a small disc as a mass of textured, cylindrical branches with rounded ends, giving it the common epithet dead man's fingers. This is an apt descriptor. The uniform thickness of these soft branches gives *Codium* an inflated quality. Each cylindrical segment of *Codium* forks evenly in two, and then in two again (dichotomous growth), leading to a cluster of branches five to fifteen inches in length. With no rigidity at low tide, *Codium* lies prone on the rock waiting for the tide to buoy its digits upright. When covered by the tide, a fish or snorkeling onlooker might see *Codium* as dark gloved fingers reaching from the watery world up towards the realm of air.

Codium is a widespread genus with up to seventy species whose habitat can range from shallow intertidal to as deep as two hundred feet. Native to the Pacific and the Indian Ocean, *Codium fragile* is a common species found on the reefs of the California intertidal zone, nestled amongst the corallines and other reds. It grows along the Pacific Coast from Sitka, Alaska, to Baja California. *Codium fragile* has spread around the globe and has become a nuisance seaweed in the Atlantic and the Mediterranean, where it was inadvertently introduced during World War II. A marine lab on the French Mediterranean coast near Spain was bombed by the Allies, and the live sample of *Codium fragile* from California in safekeeping was released into nearby waters, initiating its spread as an invasive—another example of the reordering of our planet by *Homo sapiens*.

A fellow green algae, *Ulva*, is also widespread throughout the world's oceans. While *Ulva* and *Codium* both house chlorophyll for performing the task of photosynthesis, they take decidedly different approaches to collecting light. *Ulva* is brilliant Kelly green and transparent, only two cells thick, and acts like a solar panel: each cell on the flattened blades has a chloroplast ready to be ignited by a photon. *Codium* aggregates its chloroplasts into dense collections (thus its dark color) in the interior of the organism and

Opposite: Codium fragile.

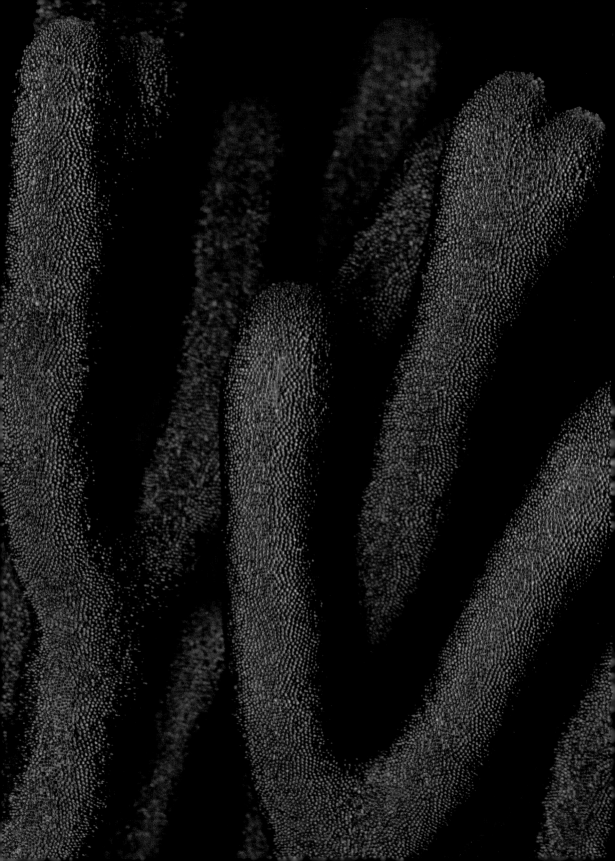

funnels light down tubes, or utricles, to strike these loads of pigment. The thallus of this alga is composed of long filaments wrapped together like a rope, with outward-facing, enlarged siphons or utricles. On many species these utricles have a minute, sharp point at the apical end, known as a mucron. Capturing a scan of *Codium* is tricky and takes a different strategy than scanning other seaweeds. It is opaque and on first glance the scan appears as a black-on-black shadow. But with careful inspection of the image,

Codium fragile cross section. Illustration by E. Yale Dawson from *Marine Botany: An Introduction* (1966). Shows the branched and interlaced central filaments and the peripheral layer of inflated utricles.

I notice that the entire surface of the fingerlike algal tube is covered with pinpricks of light. The end of each utricle has collected and reflected the light source from my scanner. The *Codium* becomes a mass of fireflies.

A cross section of a finger of *Codium fragile* reveals another remarkable aspect of this species and others in the genus: there are no cell walls. The circular array of siphons with a tangle of filaments on the interior is a single, multinucleated cell, a situation known as coenocytic. As the organism grows, the nucleus of the cell divides but the cell itself does not divide, resulting in a single enormous cell without walls. If cut or damaged, the *Codium* quickly repairs itself, constricting at the injured spot so as not to lose its cell sap.

The world's foremost authority on *Codium* was Paul Silva. He died in 2014, but he is still the acknowledged expert on this genus. William Albert Setchell, head of the botany department at the University of California at Berkeley from 1895 to 1934 and the father of California seaweed studies, left rich but unpublished investigations into *Codium*, and George Papenfuss, Setchell's successor at Berkeley, amassed a large collection of *Codium* from the species-rich coast of South Africa. All of this material was there for Silva when he arrived at UC Berkeley to begin work towards his Ph.D. in 1951, funneling him towards a lifelong quest to intimately know this group of spongy, dark seaweeds. Silva understood that the gross morphology of *Codium* was not enough to differentiate the species. He began to look at the utricles with a microscope to know their particular anatomy. Those funny-shaped, outward-facing light-catchers were, for Paul Silva, the key to species differentiation. He could see whether mucrons, the pointed utricle tips, were evident or not, and see where the reproductive parts were located on the utricle. In the tradition of William Henry Harvey and so many others, his concentrated looking begat delicate and precise pen-and-ink drawings. Silva got to know this genus of seaweed so well—to parse the minute differences in visible and microscopic characteristics—that his goal to differentiate, categorize, and name all of the world's *Codium* species in a global monograph seemed within reach. But as Silva pointed out, *Codium* is a prolific seaweed and one that has traveled the globe—attached to sailing and other vessels—almost from the outset of seafaring explorations from one ocean to another. New studies and collections of *Codium* kept arising. The global review never came to fruition.

E. Yale Dawson, a slightly older colleague, was also studying *Codium* among many other seaweeds and provides a counterpoint to Paul Silva's deliberate approach to seaweed naming and scientific publishing. He drowned while diving in the Red Sea in June 1966, just after taking a position at the Smithsonian in Washington. His papers remain there, and since I was intrigued by his various books and pamphlets on seaweeds from the 1950s—scrounged at used-book sales—I decided to visit the Smithsonian's archives over a few stormy days in January, hoping to discover more about this energetic phycological populist who died tragically and too young.

E. Yale Dawson published a lot. Between 1944, when he published his dissertation, and his premature death, he published 165 books and papers, ninety-six relating to marine algae. These ranged from scientific publications and a full-length textbook on marine botany to countless field guides and booklets with titles like *How to Know the Seaweeds* for the average shore visitor. He was, in fact, lined up as lead author of Abbott and Hollenberg's *Marine Algae of California* when he died so abruptly. While Paul Silva became immersed in nomenclature and taxonomy in the strictest sense, E. Yale Dawson tackled the ocean and its flora with a looser gesture and open heart. His facility with writing about the intertidal zone and the seaweeds is matched by the beguiling drawings he produced to go with each publication. He was a polymath, exuberant and overflowing with energy and curiosity and goodwill. Dawson's devotion to the algal world began in 1936 when he became Setchell's last, and perhaps most devoted, student. In January and February of 1940, his senior year at UC Berkeley, Dawson joined the marine biological expedition to the Gulf of California (the Sea of Cortez) on the *Valero III*, a research vessel sponsored by Captain Allan Hancock. He returned to the gulf in July that year to compare winter to summer seaweed collections from one remote outpost. In 1944 Dawson published the report of this research, with all the attendant species descriptions, as his dissertation and dedicated it to "Uncle Bill" Setchell, who had just died. Clearly there was a deep bond of intellectual curiosity between these two giants of California phycology.

Codium is well represented in Dawson's 1944 listing of species from the Gulf of California and brings to mind what was missing from the account of those other collectors on the same body of water—the flora. In *The Log from the Sea of Cortez*, John Steinbeck memorializes his and Ed Ricketts's trip to the Gulf of California to collect

invertebrates. How amazing to find that the *Western Flyer*, the purse seiner chartered by Steinbeck and Ricketts, entered the gulf in March 1940, just as the *Valero III* was leaving. This prompts me to pull my bedraggled copy of *The Log* from the shelf. As I reread it, I am, as always, floored by the clarity and quality of the writing. Nothing matches it. Steinbeck discusses their goals for the trip in the introduction: "We were determined not to let a passion for unassailable little truths draw in the horizons and crowd the sky down on us. We determined to go doubly open."

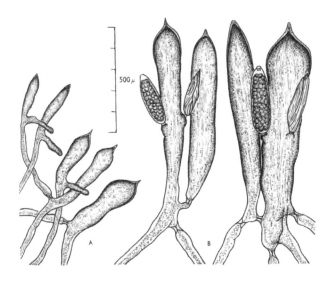

Utricle illustrations by Paul Silva, from
"The Dichotomous Species of Codium in Britain," 1955.

E. Yale Dawson was trained as a scientist to observe and record those unassailable little truths, but these did not keep him from being "doubly open." Throughout his career he took meticulous field notes and published voraciously on particular seaweed species while he kept a clear eye on the value of our ocean world to all of us. He saw the "stars in the tide pool"—to borrow Ed Ricketts's famous phrase from his book *Between Pacific Tides*. E. Yale Dawson went on to became the first phycologist to use scuba diving equipment to collect seaweeds from deeper waters, and he wrote an article in 1962 noting that the academic pipelines were lacking biologists adept at natural history—observing organisms in the field—a dismay voiced frequently today as well. My favorite book of his is for the children of Ecuador, beautifully designed and illustrated, with text in Spanish and English about the ocean creatures around the Galapagos Islands. Dawson's goal was to familiarize the younger generation with their remarkable archipelago, so they might in turn be good stewards of it.

While collecting in the Sea of Cortez in 1940, Dawson recorded many *Codium* specimens. He felt strongly that one cannot discuss this genus in particular without having

been in the intertidal zone with them. Because of their sponginess, their aspect changes altogether once they are dried, so determining differences between species is best done while fresh. Dawson emphasized the particulars of this unique body of water, choked off from the open ocean, with little wave action (so limited oxygenation) and yet with extreme tides and strong currents. These factors affect how *Codium* grows and the shape it takes—its morphology. Adding to information and collections made by Setchell in that same area in 1924, Dawson condensed two different *Codium* names into a single species. *Codium cuneatum* was written up again and confirmed, using utricle identification, by Paul Silva in 1951 as he was completing his Ph.D. at UC Berkeley. Since then, the systemics of *Codium* uses three criteria to determine a particular species: morphological differences, emphasized by Dawson; the microscopic study of utricle shape, emphasized by Paul Silva; and today molecular markers are used as well to sort, parse, catalog, and name the various *Codium* species from around the world.

Both Dawson and Silva loved the California coastal landscapes and marine flora, making frequent seaweed-collecting trips up and down the West Coast, but Dawson's correspondence reveals clear tension between the two friends. Silva went deep into nomenclature, setting international standards and creating a comprehensive catalogue of seaweed names and source material. He could easily find some detail to thwart completion of the paper or chapter to be written, whereas Dawson's typewriter never stopped. Dawson loved the microscope—it is what drew him to marine botany in the first place—but he seemed aware that taxonomy and the naming of species was a building process such that if there were discrepancies—slapdashery, if you will—these would be worked out over time by others. Each species recorded in *Marine Algae of California* has a string of names after it, and Dawson was aware that when naming a species, he would be but one, with more surely to follow.

In a lovely twist on the relationship between E. Yale Dawson and Paul Silva and the spongy, dark *Codium*, Silva submitted a paper at the age of ninety-one describing a new species of *Codium*. This new *Codium* was common "in the kelp forests of Southern California and Northern California, but previously confused with a species, *Codium cuneatum*, that occurs in the Gulf of California." Silva named this new species *Codium dawsonii* after his old friend, and the paper was published on the day Silva died.

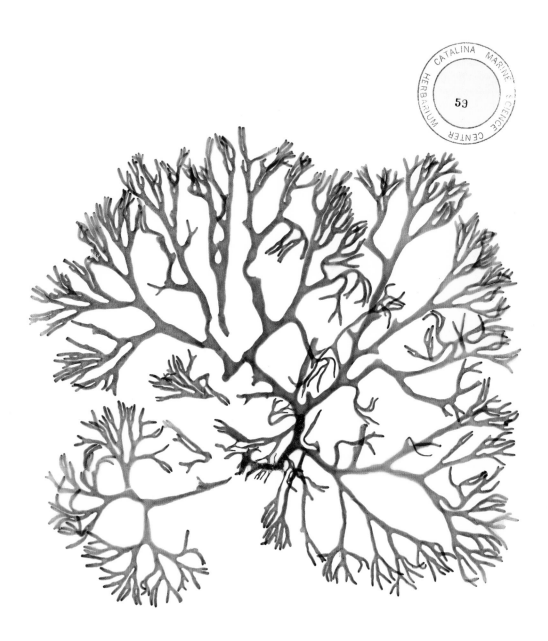

Codium cuneatum, renamed *Codium dawsonii*, collected by B. Hart and R. Given, Santa Catalina Island, California, 1976. University Herbarium, University of California, Berkeley, no. 1985389.

MARINE ALGAE OF ALASKA

Codium *fragile* (Suringar) Hariot

Det. W. A. Setchell

Southeastern Alaska. Hunter Bay. Two miles west of
Hunter Bay and southwest of the native village
Klinkwan.

R. B. Wylie 424 10.vi.1913
With: U.S. Bureau of Soils Kelp Expedition

HERBARIUM OF THE UNIVERSITY OF CALIFORNIA AT BERKELEY

318

MARINE ALGAE OF ALASKA

Codium *fragile* (Suringar) Hariot

Det. W. A. Setchell

Southeastern Alaska. Ratz Harbor. A small harbor
along a shore otherwise rather unindented. Shores of
rock and gravel with brackish water stream from a
lagoon.

R. B. Wylie 318 4.vi.1913
With: U.S. Bureau of Soils Kelp Expedition

HERBARIUM OF THE UNIVERSITY OF CALIFORNIA AT BERKELEY

This page: *Codium fragile*. Illustration by Jeanne Russell Janish from Smith, *Marine Algae of the Monterey Peninsula* ([1944] 1964). *Opposite*: *Codium fragile*. University Herbarium, University of California, Berkeley, no. 1516804.

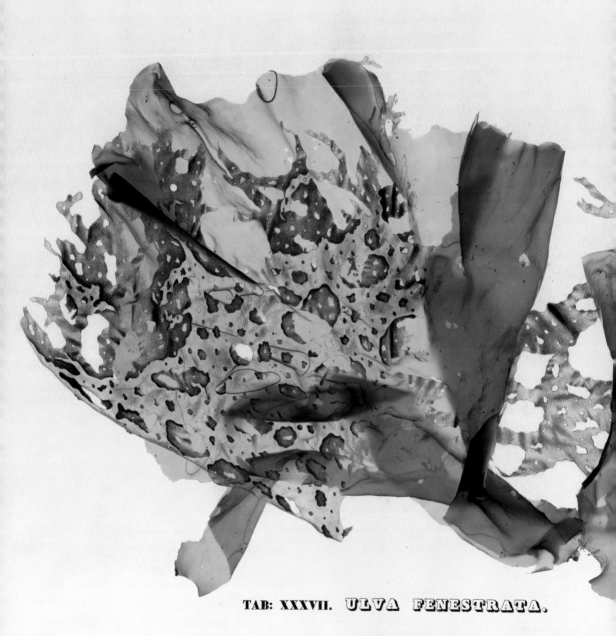

TAB: XXXVII. ULVA FENESTRATA.

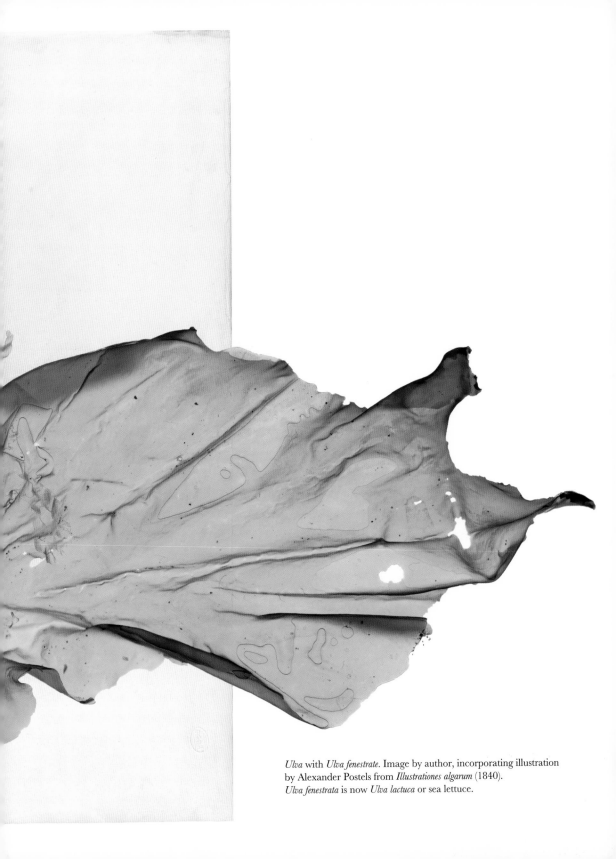

Ulva with *Ulva fenestrate*. Image by author, incorporating illustration by Alexander Postels from *Illustrationes algarum* (1840).
Ulva fenestrata is now *Ulva lactuca* or sea lettuce.

Ulva spp.

Sea Lettuce

When sunlight comes through the filmy blades of *Ulva lobata* or *Ulva lactuca*, both referred to as sea lettuce, it projects a purity of green we rarely experience in our terrestrial world. *Ulva* is a leafy seaweed, but nothing about our salad experiences prepares the eye for its translucent vibrancy. Conceptually we understand that green leaves and blades of grass absorb red wavelengths of light so the green is reflected back to our eyes, but none of these familiar encounters have the impact of the fundamental greenness that *Ulva* projects. I looked into this super greenness and found a new word that in the ancient Greek means "twice spread": a blade of *Ulva* is only two cells thick, or distromatic. Each of the cells spread across the two layers is identical in its function, undifferentiated, and each has the green pigments chlorophyll *a* and *b* in its chloroplasts. It is this consistent hit of chlorophyll across the entire seaweed tissue that makes *Ulva* so profoundly green. Photons can strike a cell on the first or second layer or just as easily pass right through. This combination of hit or miss creates the translucency that is so compelling.

My daughter recently moved to Vermont. Before she left I insisted we spend a last California day at the beach and she and I drove down the coast. We stopped at Martin's Beach in San Mateo, wandering down the road leading west off Highway 1. We emerged onto a spectacular golden beach with steep, untouched sand curving from vertical cliffs at the south end to spiked pinnacles to the north. We instinctively walked towards the cluster of rocks jutting skyward off the north end of the beach and found that they were accessible via a flat slab of reef. *Egregia* was growing in abundance in the slightly deeper water, but the initial slab of horizontal stone was covered exclusively with *Ulva*. Undaunted by the slippery seaweeds, my daughter immediately worked her way across the reef to a first rock outcrop to climb aboard and survey the great Pacific Ocean for a last time before her eastward migration. On the other side of the rock huge rollers crashed and surging spray filled the air. I noticed a cluster of *Postelsia* on the steep sides of one of the rocks farthest out, in the wave-trounced position that it loves. But

the reef I was standing on was protected from such turbulence, and while the beach itself was too sandy for any seaweeds to grab hold, *Ulva* had found its perfect spot on this particular expanse of hard substrate. The incoming tide was just beginning to lift the blades, revealing a hint of the Kelly green that characterizes sea lettuce. It is a green that does not veer towards the blue or the yellow and, as such, feels authentically green.

Ulva is the signature marine algae of a group of close to six thousand species in the green category, or division Chlorophyta, many of which are freshwater algae. Its simplicity of design and its cosmopolitan distribution—hundreds of species range throughout the world's oceans—make it a generalist of sorts. *Ulva* is able to succeed in

Ulva spp.

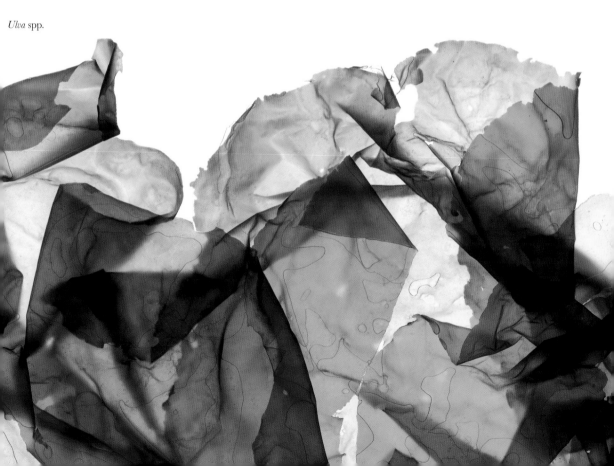

deep waters, but beachcombers find it most often in the tide zone closest to the top of the beach and around freshwater outlets. This proximity to the land reminds us that today's *Ulva* is a descendant of the green seaweeds of the Silurian era 450 million years ago, related to ones that migrated up from the shore onto drier land and evolved into the first plants, then diversified into the vast array of vegetation on land. So the algae came first. The chlorophyll that drives all the photosynthesis in the forests and fields of our continents is the chlorophyll of green algae.

But this begs the question. If plants on land evolved from the seaweeds in the oceans, how did the seaweeds evolve? The lineage of seaweeds is not linear and not simple. My friend Karina Nielsen, director of the Estuary and Ocean Science Center of San Francisco State University and a seaweed expert, characterizes the seaweeds as an evolutionary hodgepodge. Except for the coralline algae, seaweeds do not generally fossilize—they decompose too quickly—and without a robust fossil record it is difficult to put the evolutionary picture together. But by looking closely at the boundaries of plastids in the algal cells, molecular analysis, and the clever thinking of a scientific giant named Lynn Margulis, the evolutionary trajectory resulting in the pure greens, rosy reds, and golden browns of the three divisions of seaweeds originally set up by William Henry Harvey was determined to be three separate paths only connected at the very beginnings of life in the oceans.

As I pore over illustrations and attempt to understand the phylogenic relationships between the three groups of seaweeds—Chlorophyta, Rhodophyta, and Phaeophyta—I realize that each book I consult presents a different diagram. Some favor the branching tree that is familiar, another presents colored blobs around a common ancestor dot, and still others use the bracketing format favored by basketball tournaments. Most recent books on marine algae skip the notion of kingdom—the topmost grouping of organisms—because there does not seem to be consensus on how the kingdoms should be named or distributed, especially vis-à-vis the algae. While we *Homo sapiens* follow a neat pathway through the phylogeny from kingdom Animalia down through the phylum Chordata, class Mammalia, order Primates, and family Hominidae, seaweeds are persistent in their refusal to be easily classified. They remind us that they evolved in a most fecund and unruly place, the nearshore oceans, developing alongside algal neighbors they are not even related to. The seaweeds have consistently made

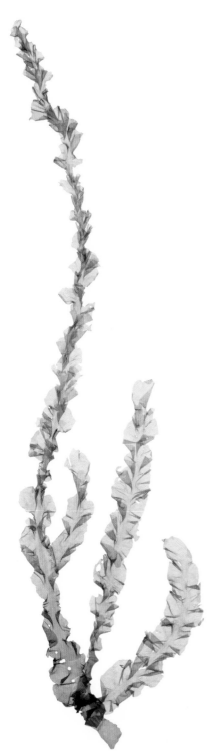

identification and classification an ongoing challenge for the phycologists and taxonomists of the world. The constant changing of seaweed names and groups reminds us that our understanding might never match the cleverness of the organisms themselves.

Seaweed evolution is the story of acquiring the ability to capture the energy of sunlight for self-generation and starts with the color blue-green, or cyan. Cyanobacteria are prokaryotes—tiny, unicellular organisms without nuclei. They have, since the beginning of time, used a bluish pigment called phycocyanin and the green chlorophyll enfolded in the cell membrane to translate sunlight into metabolic energy and to off-gas oxygen. About 2.5 billion years ago these single-celled bacteria were responsible for the oxygen revolution that generated our earth's atmosphere as we know it.

At some point in the primordial stew, an ancestral cyanobacterium was engulfed and enslaved by a higher-level organism, a eukaryote. The once free-living bacterium was transformed inside the larger cell into an organelle, the chloroplast, in which the chlorophyll and other light-grabbing pigments driving photosynthesis in green algae, such as *Ulva* and red algae, are found. Green and red multicellular algae evolved separately from this time on, with only the ancient cyanobacterium as a common connection. Later, a second round of enslavement occurred. A single-cell red algae was similarly engulfed by a eukaryote, its genes similarly hijacked

Ulva spp. Collected by a University of California–Santa Cruz marine botany class, 1967. Collection: California Academy of Sciences, San Francisco.

by the host's nucleus, its own nucleus reduced, and the whole single-celled alga converted into the chloroplast found in brown algae, which includes the kelps. When looking through a microscope at the chloroplasts in algal cells, one can see double and triple membranes surrounding them, holdovers from the various stages of engulfment. Bacteria dominated the oceans of early Earth. The process by which they were engulfed to endure inside other bacteria and later in higher-order cells is called symbiogenesis.

The evolution of green and red algae via symbiogenesis came first, in seaweeds on the evolutionary branch leading to the kingdom Plantae. The brown seaweeds evolved later—much later, millions of years later—and have recently been placed by some in a different kingdom, labeled Chromista. The reds and greens (such as *Ulva* and *Mazzaella*) are as distantly related to the browns (such as *Macrocystis*) as any three photosynthesizing organisms could possibly be.

"Symbiogenesis" as a term has the same root as "symbiosis" and "symbiotic." It implies togetherness versus individuality. The idea that algae of different color groups arose from a bumping together of different kinds of cells—that living together in tight quarters can lead to mutually beneficial relationships, leading to new species—irked scientists devoted to Darwinian concepts of evolution, which based change and species evolution on competition, not cooperation. Darwin's theories, however, explained how species evolved once they were in their environment but did not explain how they arose in the first place. In the 1960s, Lynn Margulis was the scientist who first proposed the theory of endosymbiosis, explaining the bacterial origin of the plastids and mitochondria in prehistoric algae and other cells. Her 1967 paper, "On the origin of mitosing cells," laid out a compelling scenario of bacteria and eukaryotic cells in the Precambrian brew bouncing off each other, engulfing each other and evolving interdependencies. The engulfed cyanobacteria became "obligately symbiotic plastids, retaining their characteristic photosynthetic pigments and pathways."

This was heretical to many and Lynn Margulis, who was not quite thirty years old in 1967, withstood withering criticism. But her theories stood up to close scrutiny and have been accepted over time. In my quest to understand the fundamentals of *Ulva* as a precursor to lettuce, I wanted to know more about this brilliant, tough-as-nails scientist who wrote so prolifically. I pulled a bunch of her books out of the library and finished *Symbiotic Planet: A New View of Evolution* in one sitting. Published in 1998, it is brash and

to the point, and I came away with a clear sense of the bacterial stew that dominated the first phase of life on our planet and that over time teamed up to create larger organisms. I also got a clearer sense of Lynn Margulis, a rigorous and well-read scientist, as well as a woman who loved having babies, preferred her children's company to that of grown-ups, and was determined to collect evidence from all the "dusty corners of biology" to prove her ideas. She was confident in them. She was a big and wide thinker. She was, in fact, one of those "men" that Steinbeck describes as tearing a seam in the box of conventional thought for us to look and then step through. Steinbeck, himself stuck in a box, couldn't conceive that such a person might actually be a woman. Over the decades since that first paper, as genetic mapping techniques were developed, the scientific community was able to confirm Margulis's assertions that chloroplasts had been cyanobacteria. These organelles have their own genes, separate and different from the DNA within the nucleus. When deciphered, these genes are found to be virtually identical to the genes of existing cyanobacteria, closer to their free-living single-celled cousins than to the genes in the nucleus of their own cell.

Margulis was continually puncturing conventional bubbles. In a chapter of *Symbiotic Planet* titled "The Name of the Vine," Margulis calls to the traditions of taxonomy confining and a deterrent to big ideas. Established taxonomy is built on the notion of the tree of life, a structure that continually branches outward. This, however, precludes the idea that lineages can come back together, that the tree can grow in on itself. Symbiosis is about new partnerships between previously evolved organisms—new unions forming stable new beings.

Another taxonomic diagram appears on page 53 of *Symbiotic Planet*. This one, designed by Margulis's son Dorion Sagan, is a wobbly, thin-lined drawing in the shape of a hand. This animated, evolution-oriented hand holds the earth between thumb and forefinger. The base of the palm is the region of the bacteria, the group from which all else arose. Resting on this base, the middle palm area of the diagram is the kingdom of Protoctista. This is a hard word, but Lynn Margulis is adamant about its proper use. It is the next evolutionary step whereby the bacteria have merged and formed higher-level organisms with nucleus, plastids (chloroplasts), mitochondria, and other cellular characteristics, but they are not yet plants or animals or fungi. These three groups each evolve to deserve their own named fingers or kingdoms. But way out

on the pinky finger, unnamed and still connected to the Protoctista grouping, is a tiny drawing of a seaweed. It is hard to distinguish what kind, but I think it is a rockweed, from the browns.

All three lines of algae—the greens, the reds, and the browns—are placed in the Protoctista kingdom, but they are nowhere near each other in terms of their evolutionary relationships. While the browns are out on the pinky finger, the greens, including our *Ulva*, are placed towards the middle knuckle of the index finger, which emerges as the plant kingdom, and the reds are off towards the base of the thumb. Despite our own observations of the seaweeds together in the intertidal zone, sharing the intimacies of their ecosystems, the three phyla of seaweeds share only the far-distant cyanobacteria as a common ancestor. They are simply not otherwise related.

But even Lynn Margulis, with an encyclopedic knowledge of evolutionary biology, genetics, microbial ecology, and geochemistry, with a lifetime of looking into the guts of termites and poking into the muddy shores of ponds and remote seas, emphasizes in *Symbiotic Planet* that any taxonomic scheme has problems: "Our classifications tend to blind us to the wildness of natural organization by supplying conceptual boxes to fit our preconceived ideas." Margulis might argue that the Linnaean legacy has played into our human inclination to sort and categorize, and the emphasis on Latin names and taxonomies—what organism goes in what group—has diverted us from other ways of thinking about ecological organization. Margulis makes us question whether the Linnaean system of binomial nomenclature is the right language to be speaking.

Ulva bears one of the few original algal genus names established by Linnaeus in 1753, but pretty quickly the genus *Enteromorpha* was also erected to encompass the green algae that are tubular in structure as opposed to leafy. *Enteromorpha* filled with hundreds of species—willowy, sheer green seaweeds. When perusing the herbaria for specimens of *Ulva*, the alternate name *Enteromorpha* arises consistently for what seem to be clearly *Ulva*-like green seaweeds. Books refer to *Enteromorpha* and *Ulva* almost interchangeably. In 2003, after much speculation that there was not a lot of difference between the *Ulva* and the *Enteromorpha* (the double layer of cells would often separate into a tubular form), DNA testing confirmed that these two groups were really the same genetically, and the two groups of seaweeds were collapsed. *Ulva* as a name came first, so it was retained.

This analysis was made by comparing a database of seaweed DNA that has been growing in a catalog called Barcode of Life Data (BOLD). The barcode is generated from a short chunk of DNA from a certain gene in the mitochondria of a cell extracted from a tiny snippet of an herbarium specimen. In this way algal collections housed in herbaria around the world are being labeled with barcodes. While the specimens of *Ulva* remain carefully pressed and cataloged in their special cabinets in the herbaria, the barcode database exists online.

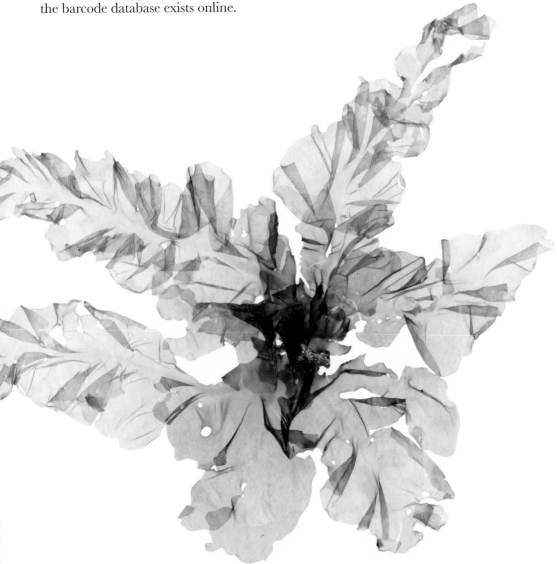

Ulva spp. Collected by a University of California–Santa Cruz marine botany class, 1967.
Collection: California Academy of Sciences, San Francisco.

159

This database is the next iteration in the efforts to compare and categorize the marine algae. Paul Silva created the *Index Nominum Algarum,* a card catalog of seaweed names and reference information. Some two hundred thousand typewritten index cards still reside in a wooden case in his office at UC Berkeley. In 1996, Michael and Wendy Guiry took over the idea of centralizing algal information and created the website AlgaeBase, which has grown to provide extensive information on all seaweeds, including publications and name changes. It is a remarkable repository of information. Efforts continue, and molecular and DNA studies of seaweeds abound, usually resulting in a shuffling of categories and names. The intensified focus on lab-based molecular and genetic study, however, has many scientists dismayed. They note the drop in enrollment of students in traditional natural history courses where field observations are the primary concern. E. Yale Dawson voiced a similar worry. While the microscopes were important, he believed, one could not describe and understand a particular species of seaweed without being in its world and seeing the full breadth of its community. The complexity of the connections and interactions within even the smallest tide pool, let alone whole coastal ecologies, are constantly being uncovered as crucial elements in understanding the algal world. Luckily, today's students have some fantastic teachers and opportunities to visit the intertidal zone and observe the brilliantly green *Ulva lactuca* and other colorful seaweeds of our Gaia organism, as Lynn Margulis called our planet in its messy, flamboyant workings.

Ulva lactuca and *Ulva intestinales* (formerly *Enteromorpha intestinales*).

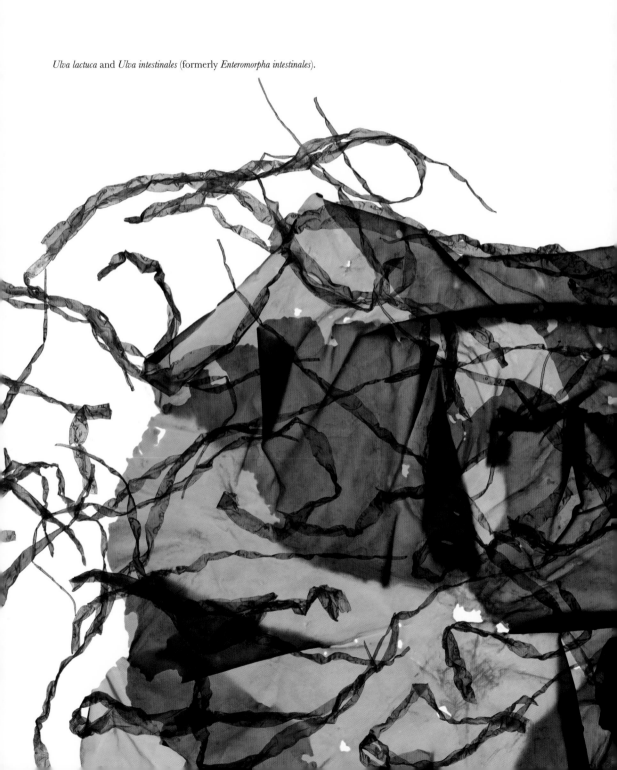

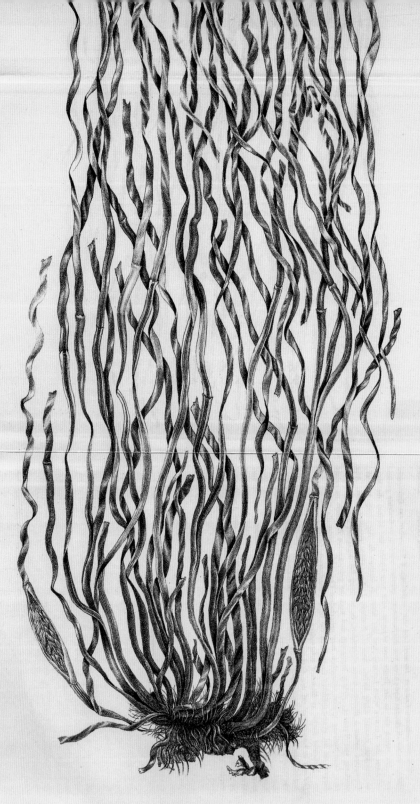

Phyllospadix Scouleri.

Pries fecit

Печ. М. Тюлева.

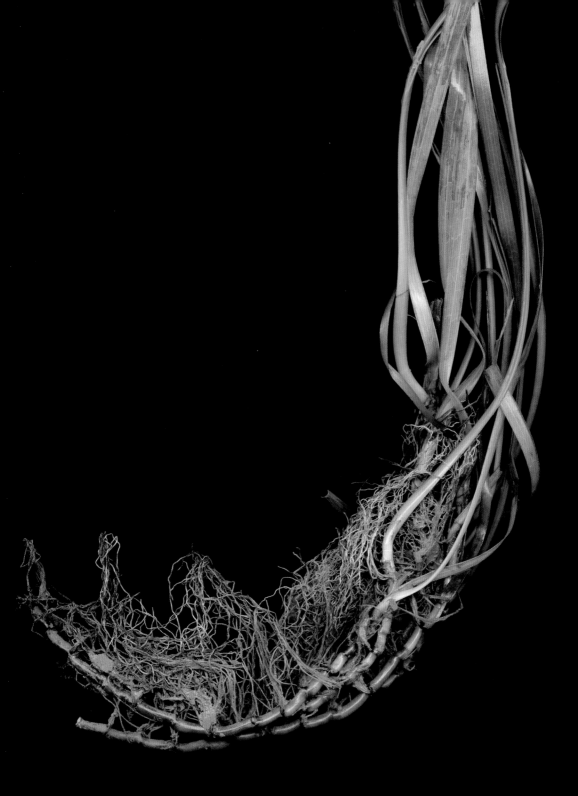

This page: Zostera marina. Opposite: Phyllospadix scouleri foldout plate from Ruprecht (1852, pl. I). Collection of Michael J. Wynne.

Phyllospadix scouleri and *Zostera marina*

Surfgrass and Eelgrass

I went across the bay to Keller Beach today and sat gazing at the sun-sparkled expanse of water reaching past Angel Island to the Golden Gate Bridge and beyond, waiting for the super-moon low tide. I wanted to see if the seagrasses emerging from the lowest region of the beach had any herring roe attached to them. The return of herring each year to bays up and down the west coast of North America is a sign that the ecological workings of the ocean are in sync. The great schools of these bottom-tier fish are elusive but the golden eggs encrusting the kelp, rockweed, and eelgrass near the shore are talismans of their presence and their persistence from year to year. I scramble over some slippery rocks to a cobbled inlet to wait, listening to kids screeching with delight, playing in the sand on a January afternoon. I watch the tide drag the waters farther down the shore, revealing larger rocks covered with brilliant green

Ulva and worn and gnarled, almost-black *Mastocarpus*, its reproductive papillae spent. The tide lowers and reveals brown and beaded *Sargassum* curving gracefully with the tiny waves like a true Victorian botanical, its elegance belying its presence as an unwanted invasive. I pick up a scrap of Turkish towel (*Chondracanthus*) and hold it up to the sky. This bit of detritus is the color of raspberry sorbet, an essence so remarkable it pales the late-afternoon scenery unfolding behind it. Finally the seagrasses are revealed over on the sandy beach, first furling and unfurling with the wavelets in the shallowing waters, and then lying prostrate but vibrantly green on the wet sand. I wander over hoping for a miracle— to see the silvered pearls of roe clinging to the green blades, a sign that schools of herring have come into

Smithora naiadum on *Phyllospadix scouleri.*

the bay to spawn as they have for millennia. The blades of *Zostera marina* are clean and bare, graduating from brilliant green to white where the rhizome begins just above the sand. There are no herring eggs here. I ask a local resident tending her garden at the beach's edge if she has noticed any and she says, "Not yet," but she is hoping in the next few weeks to notice either the eggs or the fish. She adds that often when the masses of eggs are laid the fish disappear without a trace.

The underwater mats of seagrass that we associate with tropical waters are just as widespread along the rough-and-tumble world of the Pacific Coast. The masses of brilliant green in surf channels of an exposed reef or in more protected waters of estuaries and bays are intuitively reassuring. Any coastside wanderer can guess that these adventurous plants are important. Seagrasses are truly plants—that have recolonized salty waters; they are not algae. They have real roots and rhizomes that hold them to the ocean floor, they grow blades that are, in fact, leaves, and they sport flowers that produce seeds, not spores. They are vascular plants—veins carry molecules around the plant—that have evolved an ability to thrive in salt water.

There are two types of marine grasses on the Pacific west coast. Eelgrass, or *Zostera marina*, like most seagrasses, is associated with calm bays and tranquil estuaries. They create essential habitat for a remarkably diverse community of animals from larval invertebrates, tube worms, and clams to young fish and birds. *Zostera* is one of the most common marine grasses, growing all over the northern hemisphere. Surfgrass, or *Phyllospadix scouleri*, like our coast in general, is anything but ordinary. As its common name suggests, it likes the surf. It flourishes on the reefs along the coast from Alaska to Baja California, where wave action is near constant.

Seagrasses recolonized the oceans after many millions of years as terrestrial plants, illustrating the unlikely trajectory that evolution can take. Extending one's mind's eye to deep time and the beginnings of life—when photosynthetic bacteria became chloroplasts in green algae, through billions of years to imagine primitive seaweeds evolving

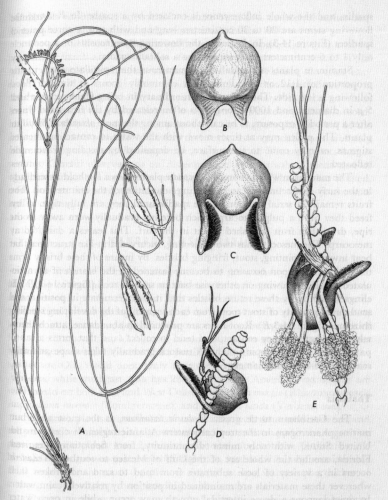

FIGURE 14–3. *Phyllospadix torreyi*: *A,* mature fruiting spadices; *B,* a young fruit; *C,* a mature fruit with exocarp worn away; *D,* germination of seed after attachment to a coralline; *E,* young plant with developing roots.

Sterile, leafy plants of *Phyllospadix* are usually encountered and are identified by leaf characters. *P. torreyi* has narrow, thick leaves 0.5 to 2 millimeters wide with inconspicuous nerves, while *P. scouleri* has broader, flat leaves 2 to 4 millimeters wide, with three distinct nerves.

Flowers are borne on dioecious plants in two rows on the side of a flattened

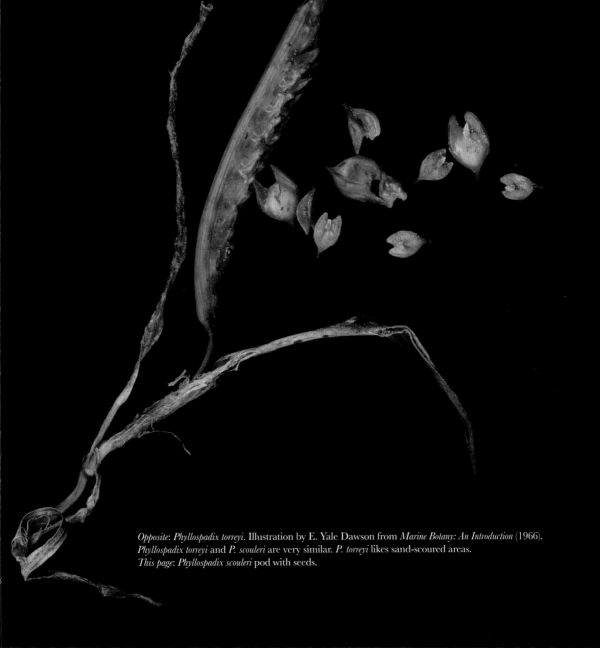

Opposite: *Phyllospadix torreyi*. Illustration by E. Yale Dawson from *Marine Botany: An Introduction* (1966). *Phyllospadix torreyi* and *P. scouleri* are very similar. *P. torreyi* likes sand-scoured areas. *This page*: *Phyllospadix scouleri* pod with seeds.

into the plant kingdom on land—seems within our imaginative abilities. If we continue our evolutionary time travel we can understand that some of these plants—lilies from freshwater ponds, perhaps—migrated back into the tranquil waters of marine bays and inlets where rivers merged with ocean. Seagrasses evolved techniques for holding salt substitutes in their system to overcome the stress of salt in the surrounding waters and to keep osmosis in balance. But now to imagine these green, bladed, flowering grasses migrating out onto the wave-pounded rocks of the open coast is where our capacity to visualize fails us. The wild and unprotected coast of California and north through Oregon, Washington, and British Columbia to Alaska is most often open to the entire Pacific Ocean, the waves breaking on the coast unhindered since they left Japan. This lovely strip of littoral wildness is constantly expanding our notions of life's potential. How would a flowering plant like *Phyllospadix scouleri* survive in this turbulent world of crashing surf and constantly rising or falling tide? How would it reproduce?

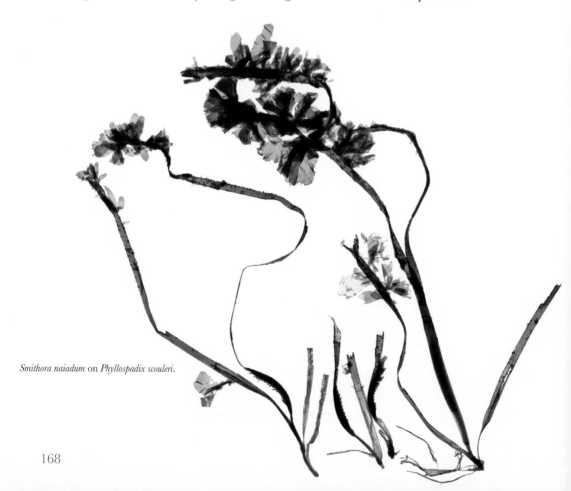

Smithora naiadum on *Phyllospadix scouleri.*

Phyllospadix can reproduce asexually, extending its rhizomes and roots laterally and shooting up green flattened leaves that stream out horizontally up to three feet in length. But to ensure its survival, *Phyllospadix* must also reproduce sexually—its flower must be pollinated to make seeds. No insects or bees to help out here: pollination happens underwater and is timed to the period of springtides. The male flower releases a long strand of sticky pollen, either underwater or on the surface if the tide is low, which floats about until it snags onto the stigma of the female flower. The fertilized seeds develop and, when released, reveal a hard interior kernel with tiny wings or "fish-hook-like prongs" that catch onto anything they can grab—often an upright bit of coralline algae. Once hooked, the seed has a chance to put down roots. Unlike a seaweed's holdfast, these really are roots that take up nutrients.

C. O. Rosendahl described the surfgrass along the rocky coast of Vancouver Island in the second yearbook published by Josephine Tilden and the Minnesota Seaside Station. In *Postelsia: The Year Book of the Minnesota Seaside Station* (1906), Rosendahl wrote of *Phyllospadix scouleri*:

> It occurs in great abundance over the jagged sandstone rocks exposed only at low tide, and in most of the numerous tide pools along the shore. Mixed with various species of algae it forms in some places a distinct zone covering the rocks. The zone varies in width with the slant of the shore, for in no case is the plant found in very deep water. Where it occurs in tide pools, it is found mostly as a fringe along the edge and the long blades float upon the water in such a manner and quantities as to completely obscure the surface. The wanderer upon the beach at low tide must pick his way with care, for it is extremely difficult to tell whether the eel grass [*sic*; surfgrass] lies upon a flat rock surface or is spread out over some deep tide pool.

I experienced firsthand the care one must take when stalking the seaweeds of Botanical Beach to avoid stumbling deep into a tide pool camouflaged by the surfgrass.

Great mats of green surfgrass are also found just as described in the channels out on Duxbury Reef, near Bolinas in Northern California. At low tide this is the zone where

a heron can be spotted stalking, its long, backward-bending legs disappearing into the partially submerged grasses, jabbing its dangerous beak into the tangled green to arise with a speared fish. In late springtime, a brown film darkens the intense green of the flattened *Phyllospadix* leaves. This brown muck is actually a red seaweed epiphyte named *Smithora naiadum*. It is common to see certain seaweeds associated with others in this interdependent, nonparasitic relationship—space on a given rock is limited, and many seaweeds and sea creatures solve the real-estate crunch by growing on top of each other—but the classic epiphyte on the Pacific reefs is the beautiful and delicate *Smithora naiadum*. It grows exclusively on *Phyllospadix* and *Zostera*, surfgrass and eelgrass. When the grasses arise with the tide and sway with the current in their underwater meadow, the *Smithora*'s thin blades will unfurl into lavender wings. *Smithora*, the delicate algae, is always associated with *Phyllospadix* or *Zostera*, the tough seagrasses; the algae's sticky spores will cling only to a blade of seagrass—not on seaweeds, not on rock. It is named after Gilbert Smith, who died in 1959 just as the genus *Smithora* was being erected in his honor.

Another associate of surfgrass is the chaffy limpet, dedicated to living its life exclusively along the narrow strip of green blade, grazing on the grass's outer cuticle layer and its nutritious microalgal coating. This small limpet is five or six times longer than it is wide, growing only as wide as the blade it inhabits. Ed Ricketts wonders in *Between Pacific Tides* how this tiny mollusk can cling to its blade of surfgrass given the considerable surf, but remarks: "Perhaps the feat is not as difficult as might be supposed, since the flexible grass streams out in the water, offering a minimum of resistance." A limpet cousin, *Discurria incessa*, lives a similar life solely along the midrib of the feather boa kelp, growing nearby.

The leaves of *Zostera marina* eelgrass are a slightly wider ribbon of green than those of *Phyllospadix scouleri*. Eelgrass grows in muddy or sandy bottoms of sheltered areas and creates underwater patches of hyperproductive habitat. It is well adapted to low light levels, but it too stays in shallower waters to photosynthesize efficiently. One square meter of seagrass has been estimated to produce up to ten liters of oxygen every day. This is an enormous rate of primary production as well as nutrient cycling for the surrounding area. Eelgrass is often referred to as the "lungs of the sea." *Zostera* is also considered an ecosystem engineer. It modifies its surroundings to make coastal

habitats more amenable not only to itself but to countless other organisms. Besides preventing erosion—its roots and rhizomes allow sand and mud to accumulate—entire rafts of invertebrates survive in and amongst the blades of *Zostera* leaves and others in tubes built in the sand around its roots: shrimp, crabs, worms, copepods, isopods, and amphipods. The sea hare *Phyllaplysia taylori* is particularly adept at cleaning the eelgrass blades, keeping them clear of algal epiphytes so they can continue to photosynthesize efficiently. These smaller organisms are, in turn, a food source to larger invertebrates, like Dungeness crabs, larger fish, and birds. Pacific herring roe attach to *Zostera* blades, making it an essential nursery for the herring fishery.

Estuaries and bays inhabited by *Zostera* are often adjacent to farmland and thus susceptible to agricultural runoff and other human effluent that cause over-nutrification. The increase in nitrogen and phosphates from fertilizer or detergent runoff causes out-of-control growth of algae on eelgrass. These algae are not like the beautiful *Smithora*. They create a muck that can smother the green blades, not allowing them to photosynthesize. There are, however, algal grazers—amphipods, isopods, and sea hares—that keep the muck in control. They systematically eat the algae off the eelgrass blades, which can then produce the oxygen needed for these tiny respirators to keep up their enterprising work as algal vacuums. This delicate balance between oxygenators and respirators is

Zostera marina, grown in the laboratory of K. Boyer, Estuary and Ocean Science Center, San Francisco State University, Tiburon, California.

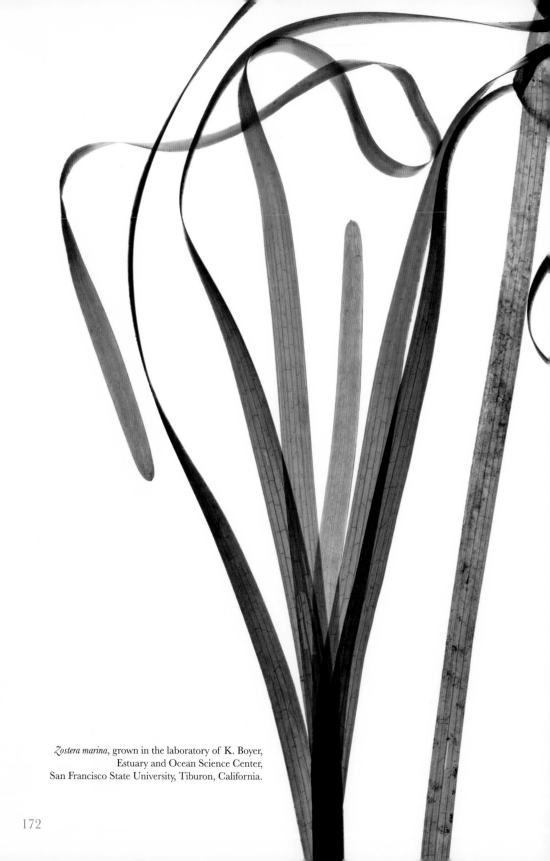

Zostera marina, grown in the laboratory of K. Boyer,
Estuary and Ocean Science Center,
San Francisco State University, Tiburon, California.

just that—delicate. It can be thrown off by any number of factors, with agricultural runoff being a major one. Another is the presence or absence of crabs that eat the grazers. If the crab population gets too high, the eelgrass vacuuming project starts to fail and the seagrass blades, starved for sunlight by the coating of muck, can no longer sustain themselves.

One particular estuary in California, however, has shown the power of top preda-tors to keep this balance in balance, despite being adjacent to aggressively farmed land. Elkhorn Slough, centered between Santa Cruz and Monterey, is home to eelgrass beds that have rebounded despite the near constant fertilizer runoff from adjacent fields. The eelgrass in the slough has shown a surprising resilience, expanding in coverage and density since sea otters reentered the slough and took up residence in this extensive marine estuary.

Any photograph of Elkhorn Slough usually shows the smokestacks of a power plant in the distance, just beyond the protected marshland, and anyone who has driven State Route One south from San Francisco and around Monterey Bay knows the beauty of pumpkins, strawberries, and artichokes growing in some of the darkest soil in the coun-try. The fields flow right to the cliffs' edge with the great Pacific Ocean as backdrop. It is a stunning drive despite this being some of the most productive agricultural land in the country. The effects of land use make Elkhorn Slough "highly nutrient loaded and eutrophic," a situation that elsewhere has led to the collapse of eelgrass beds across the northern hemisphere, especially in San Francisco Bay as well as Chesapeake and Nar-ragansett Bays. From 1965 to 1984, with algae suffocating the blades, Elkhorn Slough eelgrass beds mirrored the demise of these marine meadows across the globe, with the beds reaching an all-time low in 1984.

But in the 1980s, a few male sea otters from the growing population around the Monterey Peninsula entered the slough and were followed by females over the next decade. A healthy population of otters has been in Elkhorn Slough since then, with one precipitous drop, from 2000 to 2004, steadfastly counted by Bob Scoles, a retired sher-iff's deputy, and Ron Eby, a retired naval officer. Unlike in other bays, the eelgrass beds in Elkhorn Slough have expanded and exhibited healthy growth since 1984 despite the overnutrification. The seagrass abundance experienced one setback over the past decades, from 2000 to 2004, exactly in parallel to the drop in the otter population.

Cancer entennarius and *Cancer productus* are two common crab species in the slough that dine on snails and limpets and other algae eaters. It turns out that the colonizing otters love to eat these crabs. Otters are adaptable as to what they prefer to eat, and while the otters in the open ocean tend to eat sea urchins, the otters in Elkhorn Slough dine on crab. Their spectacular metabolism means the otters act as a significant player in the trophic cascade of the slough, keeping crab populations in check, which in turn allows the mesograzers to keep the algal muck in control so the eelgrass, or *Zostera marina*, the primary producer and bedrock of the entire system, can do its job of processing CO_2, producing oxygen, and building habitat. In 2007, Elkhorn Slough was designated a Marine Protected Area and crab harvesting was outlawed there. This coincided with a decline in natural crab predators such as nurse sharks and rays. An overpopulation of crabs could have spelled disaster for the seagrasses and the overall health and biodiversity of the estuary, just as the urchin hordes spell disaster for kelp forests offshore. But the otters have proven their worth at the top of these complex ecological webs. The difference is that in the estuary there is an added layer within the trophic cascade. From otter to crab to mesograzer to algal epiphyte makes a four-tiered system as opposed to the three tiers—otter to urchin to kelp—within the kelp forest.

While the story of Elkhorn Slough stems from a unique situation, the potential implications of the otters' effects on eelgrass recovery are not lost on Kathy Boyer, a professor of biology at the Estuary and Ocean Science Center at San Francisco State University, and the scientist most involved in eelgrass recovery in San Francisco Bay. Infectiously energetic, she runs a busy and fun-loving lab that experiments in seagrass restoration techniques. But restoring nuanced ecological systems can be complicated by all sorts of factors, especially in a place as ecologically and historically complex as San Francisco Bay. While nutrient loading is not such a problem in the bay, there is an invasive snail abundant in certain places that drills into native Olympia oysters, making their recovery all but impossible in those areas. Oyster restoration efforts often go hand in hand with eelgrass recovery, and Boyer has wondered if otter were reintroduced into San Francisco Bay, might they eat the invasive snails, allowing better oyster recovery? But she reiterates that each bay and estuary is unique in its multilayered interactions, and there is no real way to translate the eelgrass successes of Elkhorn Slough to San Francisco Bay.

Boyer's large tubs of eelgrass at the Estuary and Ocean Sciences Center sit on the side of the Tiburon Peninsula looking east across the bay towards Richmond and Berkeley, home to the University of California botany department where William Albert Setchell presided at the beginning of the twentieth century. In the 1920s Setchell was the first to seriously study the *Zostera marina* of San Francisco Bay, and he had two eelgrass observation sites on the Tiburon Peninsula, very close to Boyer's current lab.

Setchell's research led to an understanding of how water temperature plays a role in the growth and reproductive flowering of the eelgrass. Over the course of the year, eelgrass cycles from cold stress in winter into a phase of rapid growth and reproduction as water temperatures warm and then to heat stress as temperatures get too high. As water temperatures cool in the fall, the eelgrass goes dormant, to start the cycle anew the following year. Setchell was able to pinpoint the exact temperatures at which these various events would occur. But *Zostera marina* on this coast ranges from Alaska to as far south as the Sea of Cortez, so research abounds on questions of how it adapts to differing ocean temperatures, important questions given our warming world.

Two exciting facets of eelgrass research illustrate its role as a fundamental player in ecological understanding of marshes and estuaries throughout the world. The genome of *Zostera marina* was sequenced in 2016—a first for marine plants. Phylogenic dating suggest that the emergence of *Zostera* back into the oceans happened around the time of the Cretaceous-Palaeogene extinctions 72 to 64 million years ago. The extinctions opened up new ecological opportunities, and seagrasses adapted to fill empty niches. The genome also illustrates how *Zostera* lost genes typical of plants on land that it no longer needed and gained genes to help it survive in the salty ocean.

The second line of research is a multinational project known as the Zostera Experimental Network, or ZEN. *Zostera marina* is a global player occurring in abundance throughout the northern hemisphere—in bays and estuaries from high-latitude arctic waters to warmer marine climates nearer the equator. The resilience exhibited by this single species flourishing in a wide range of ocean temperatures offers a unique opportunity for study. Groups of scientists in twenty-five eelgrass-rich locations across fifteen countries, from Korea and Japan to Ireland, Norway, and Finland, with multiple locations on both coasts of the United States and Canada, are performing the same experiments to discover food web and other biological mechanisms at work in eelgrass

beds around the globe. This collaborative approach among ecologists is inspiring, especially when seagrass beds are disappearing as human endeavors, rising sea levels, and ocean warming attack these particularly vulnerable troves of biodiversity. ZEN's goal is to gain new ecological knowledge that can inform conservation efforts for coastal habitats.

One of the ZEN partners is a team of scientists working on the western side of the Baja Peninsula in Mexico. Led by the duo of Clara Hereau and Pablo Jorgensen, they are studying some of the most southerly beds of eelgrasses found on the west coast of North America. In 1940, flowering eelgrass was also found on the eastern side of the Baja Peninsula in the Sea of Cortez, by none other than John Steinbeck, Ed Ricketts, and the gang from the *Western Flyer* expedition. This was their first encounter with the

grasses, and they brought back a sample for identification to E. Yale Dawson, the newly minted Ph.D. botanist at the University of California, who identified it as "the true *Zostera marina*" and remarked that "it had not been reported previously so far south." He had just finished his own extensive flora of the Sea of Cortez, on the expedition aboard the *Valero III*, so he would know. I cannot help but chuckle over the meeting of these minds—Dawson, Steinbeck, and Ricketts—over a specimen of eelgrass, a specimen rich in signifying the health of the oceans. These southerly samples of eelgrass are important indicators of success in warming oceans, and the interactions of seagrasses, sea otters, and our intent and empathetic observations can provide a template for restoration and health in our coastal bays and waters.

Zostera marina, grown in the laboratory of K. Boyer, Estuary and Ocean Science Center, San Francisco State University, Tiburon, California.

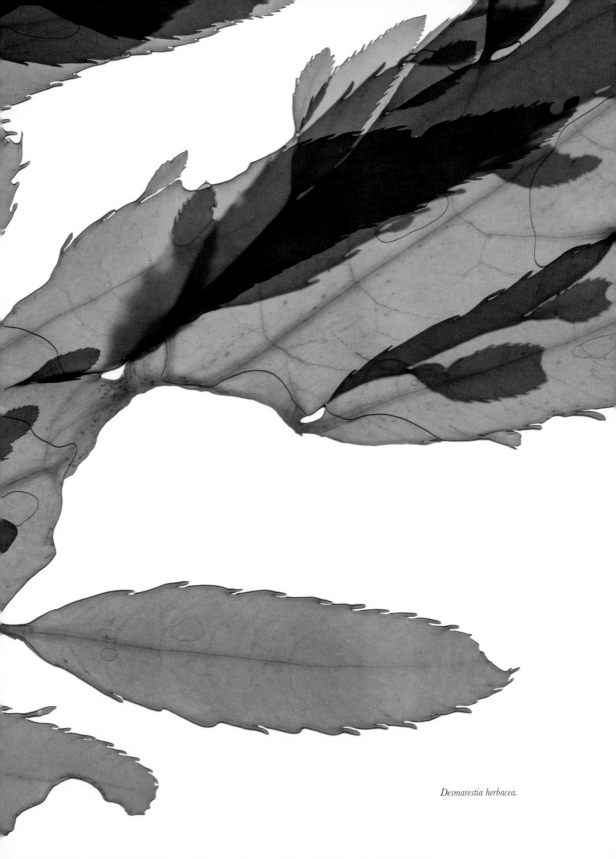

Desmarestia herbacea.

Desmarestia herbacea

Acid Kelp

Sulfuric acid is not a substance we generally want to fool around with. It is easy to find videos demonstrating its ability to eat away a piece of meat or destroy an egg. How surprising then to find a common seaweed, a kelp in the brown family, that is full of sulfuric acid. *Desmarestia herbacea* is a flattened seaweed that grows in great clumps on the ocean floor. Its coloring can range from butterscotch to a pale greenish yellow. Each cell of *Desmarestia herbacea*—called acid weed or acid kelp—holds a tiny pocket, or vacuole, filled with sulfuric acid. If the seaweed is disturbed in any way, the cavities release their acid. This seems a formidable strategy against being nibbled upon. An acid kelp's internal pH level can be as low as .5 to .8, the range of human gastric juices, and one can only imagine the effect of this acidity on a scavenging limpet or snail, or on the voracious teeth of a sea urchin.

Algæ Exsic. Am. Bor. Farlow, Anderson, & Eaton.

166. **Desmarestia ligulata** Lamx.

Santa Cruz, Cal. Leg. C. L. Anderson.

This superb defense against herbivory can result in some large and beautiful *Desmarestia herbacea* washed up on the beach or residing below the waves. My first encounter with this species was along the wrack line of Princeton-by-the-Sea on the San Mateo coast after a winter storm. I collected a mass of mixed-up seaweeds and untangled them back home on my kitchen counter. I was lucky that the acid kelp had not ruined the other specimens, or itself. Seaweed collectors are often warned to put acid kelp in a separate bucket as it will bleach out whatever it touches. This effect on proximal flora gives the acid kelp an added advantage. Its acid-bearing fronds inhibit neighboring growth, leaving it to claim its space along the ocean bottom with less competition for sunlight.

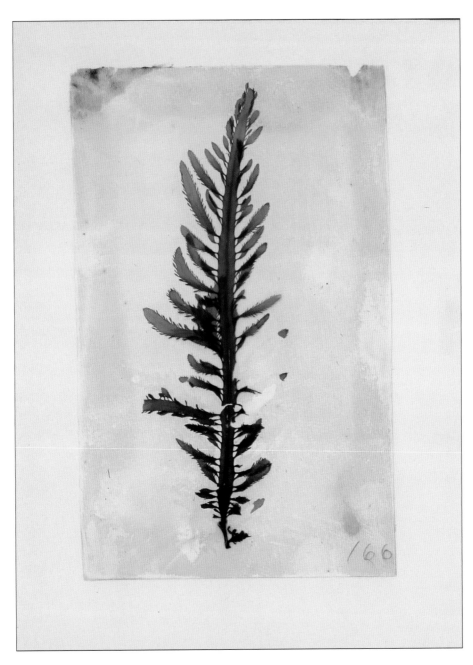

This page and *opposite*: *Desmarestia ligulata* (now *herbacea*), collected by C. L. Anderson, Santa Cruz, California, 1925. University Herbarium, University of California, Berkeley, no. 687994.

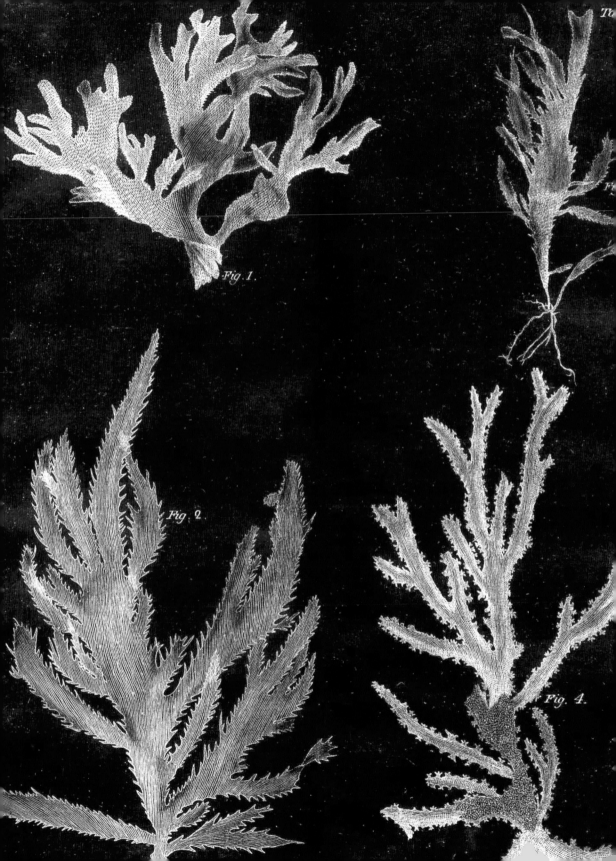

Fig. 1.

F

Fig. 2

Fig. 4.

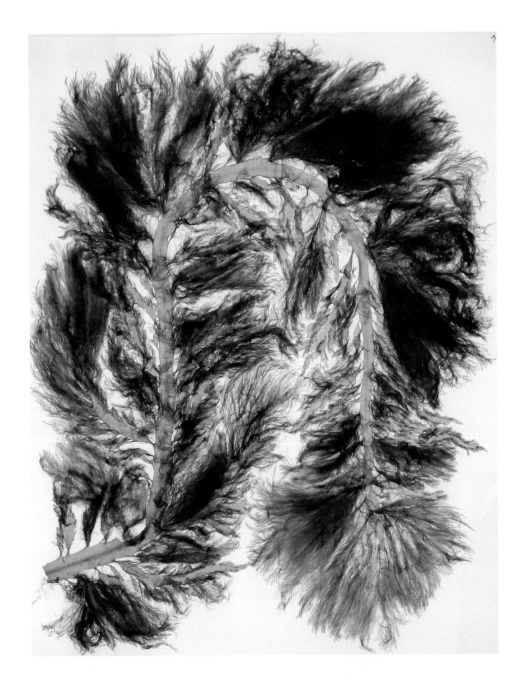

This page: *Desmarestia ligulata* (now *herbacea*) covered with *Schizymenia*, collected on the Monterey Peninsula, no date. University Herbarium, University of California, Berkeley, no. 1974294. *Opposite*: *Fucus ligulatus* (now *Desmarestia ligulata*) collected from the Mediterranean Sea. Illustration by Gmelin from *Historia fucorum* (1768, pl. XXI, fig. 3), recolored. 183

Back at my kitchen counter I floated the pale-olive *Desmarestia* in a puddle on a sheet of clear acetate and teased out the delicate blades, each with tiny serrations and delicate but surprisingly tough joints connecting them to the main strap. I was entranced by the unfolding complexity. I have since encountered acid kelp countless times in the intertidal, usually as a piece of flotsam washed ashore from deeper waters. I was nonetheless surprised to find it growing as great bushes below me when snorkeling at Van Damme State Park in Mendocino, where at first I did not recognize the massive, billowing understory shrub of algae. The individual strands of acid kelp found on the beach are so flat and two-dimensional that the dynamic volume of aggregated and wafting fronds felt unfamiliar. I was struck by how limited our specimen pressings are in communicating the dimensionality and perpetual motion of the seaweeds in their undersea world and how the lid of the tide covers and obscures most of their reality to us.

My initial delight at discovering the branching pattern of acid kelp was amplified by the poetry of the Latin name I first knew for it. It tripped off my tongue: *Desmarestia ligulata*. "Ligulate" means "straplike"—the flattened aspect of the thallus of this *Desmarestia* apparently inspired this perfect combination of vowels and consonants as its species appellation. Just as I was priding myself on *knowing* the name of this seemingly obscure member of the marine algal family, I was informed that *Desmarestia herbacea*, also lovely—indicating a herbaceous, not woody nature—is the correct name for this particular acid kelp found along the California and Pacific Northwest coast. Name changes are common for those studying the seaweeds and must be accepted with a nod towards our inherent desire—and the continuous work—to get things taxonomically sorted out. But for *Desmarestia ligulata* or *D. herbacea*, I can find no consensus in the literature on which is what.

Acid kelp is also found in waters off of Europe. In Britain it is known as sea sorrel, likewise in France, as *oseille de mer*. Gmelin, looking at a Mediterranean sample, describes *Desmarestia* in his 1768 *Historia fucorum* using the latinized *ligulatus* as an epithet to the then general algal genus *Fucus*. He includes a small but distinct drawing. Archibald Menzies, as naturalist to Vancouver's expedition, provided a specimen from our "North West Coast" to Dawson Turner, which seems a feat not only of attentive specimen preservation, since acid kelp tends to degenerate easily, but also of the spirit. Relations between Menzies and his captain were strained and bitter throughout the

four-year voyage. George Vancouver was, by all accounts, a tyrant, a psychopath, and a manic-depressive. He could not leave the constrained British hierarchies of thought and society behind, needing to prove his position as captain by constant and belligerent confrontation. He preferred the world of astronomy and numbers, and his skills at celestial navigation were unparalleled. Menzies, on the other hand, was cheerful and positive in outlook and constantly awed by the new wonders they encountered as the expedition's smaller boats surveyed bays and coastlines from Alaska south to California. Every attempt by Vancouver to exert his dominion and control was shrugged off by Menzies. He was outside the official chain of command, which further infuriated the captain. At one point (either before or after he kidnapped Menzies's assistant and sent him before the mast as a common sailor), Vancouver insisted that Menzies stay within musketshot of the anchored ship *Discovery*. This constraint would have kept Menzies along the shoreline of Puget Sound or the inland waters east of Vancouver Island to explore the marine algal riches of the area, rather than venturing into the deep forests. Dawson Turner described the specimen of *Fucus ligulata* collected by Menzies from these waters, and in 1852 in *Nerei Boreali-Americana* William Henry Harvey cited the same specimen, his description alluringly replete with the alliterative language of Turner when describing *Desmarestia ligulata*: "stem as thick as a crow's quill" and "margins serrated with small, spiniform, rather remote teeth." And "colour: grass green with a faint tinge of brown, transparent. Substance: membranaceous, extremely thin and tender."

Jean Vincent Félix Lamouroux and the English botanist John Stackhouse in 1809 recognized that the enormous diversity of forms encountered among marine algae deserved more than the desultory three or four groups (*Fucus* and *Ulva* being the major ones) designated by Linnaeus and Turner. Lamouroux was lucky to inspect the same sample of acid weed collected by Menzies described above, but he gave it its own genus name. These two men opened the taxonomic floodgates by authoring the genus name *Desmarestia* and many additional genera for seaweeds.

The distinction between *Desmarestia herbacea* and *Desmarestia ligulata* to this day is confusing. It might be distinguished according to the width of its blades (*ligulata* narrow, *herbacea* wider) or the ocean it inhabits (Atlantic versus Pacific). William Henry Harvey acknowledges the confusion, mentioning that he supports uniting the broad- and the

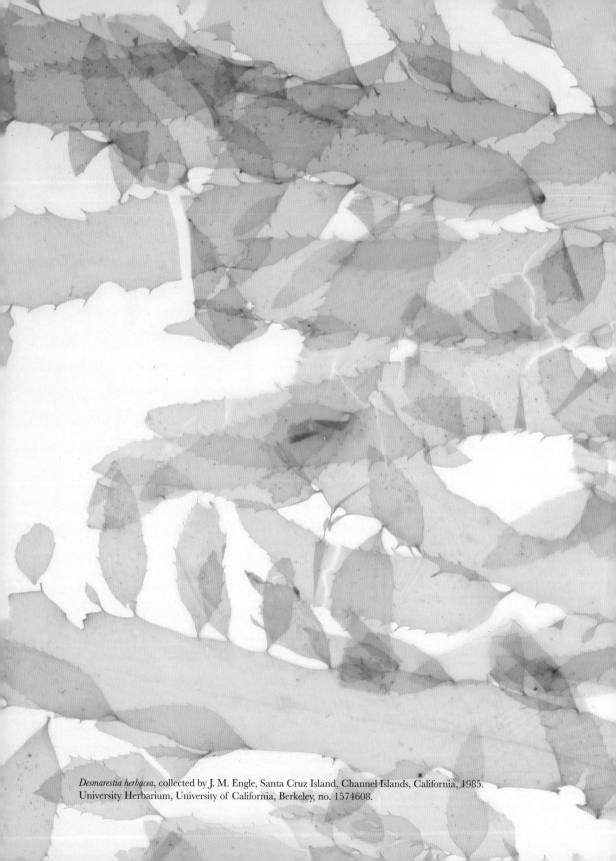

Desmarestia herbacea, collected by J. M. Engle, Santa Cruz Island, Channel Islands, California, 1985.
University Herbarium, University of California, Berkeley, no. 1574608.

narrow-leaved forms into one species. But we do know that this particularly flat, trans-lucently yellow kelp, singly or doubly named, has a toxic secret within it. Its ability to store and secrete sulfuric acid has allowed the acid kelp to flourish beneath the tides as understory foliage in the nearshore subtidal zone, the poetry of its name reflected in the lyrical beauty of its form.

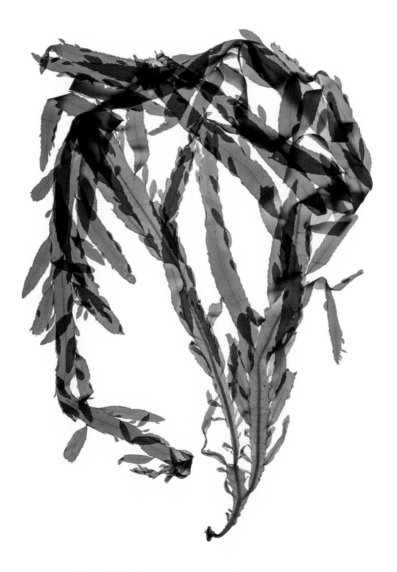

This page: *Desmarestia herbacea*. *Opposite*: *Desmarestia ligulata* (now *herbacea*), collected by W. A. Setchell, Duxbury Reef, Marin County, California, 1896. University Herbarium, University of California, Berkeley, no. 111827.

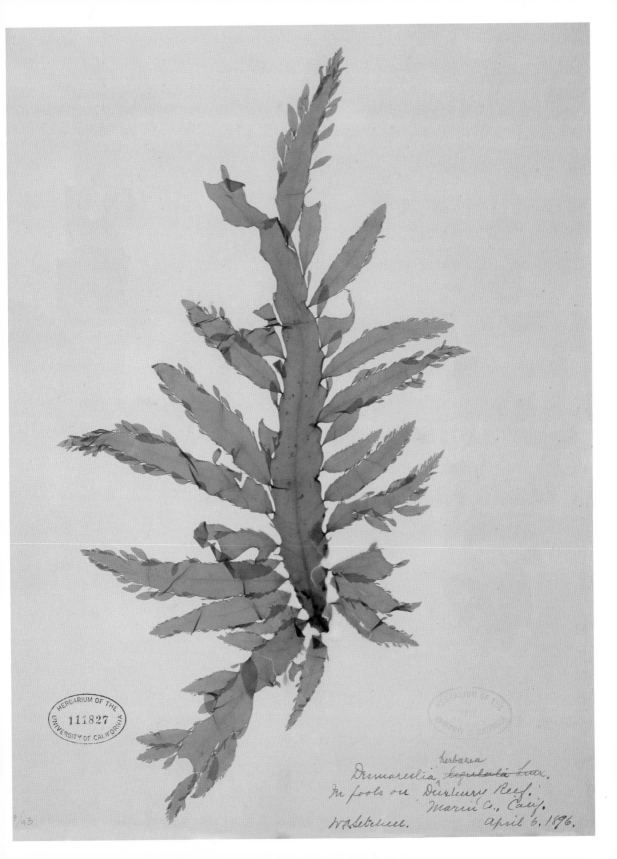

herbaria
Desmarestia ligulata Lamx.
In pools on Duxbury Reef,
Marin Co., Calif.
W. A. Setchell. April 6. 1896.

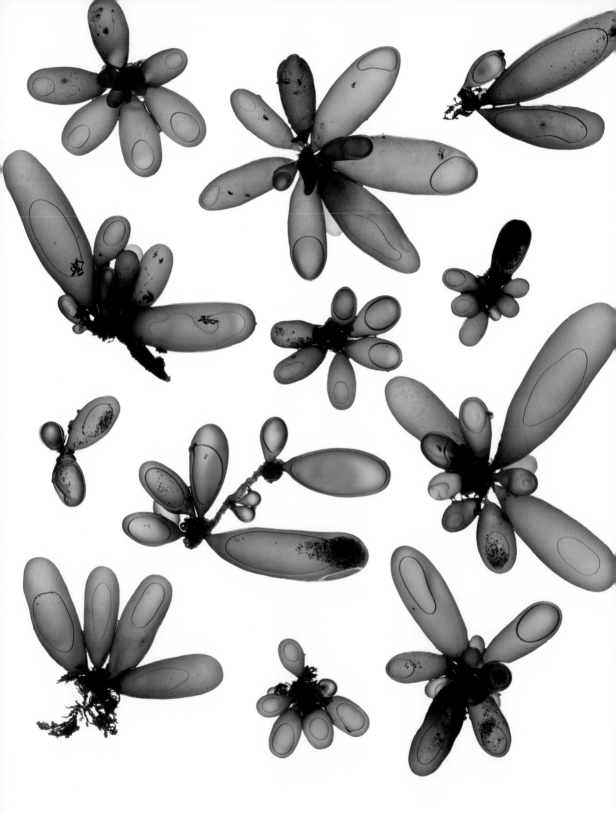

This page: *Halosaccion glandiforme*. *Opposite*: *Botryocladia pseudodichotoma*. Both are in the red group of seaweeds.

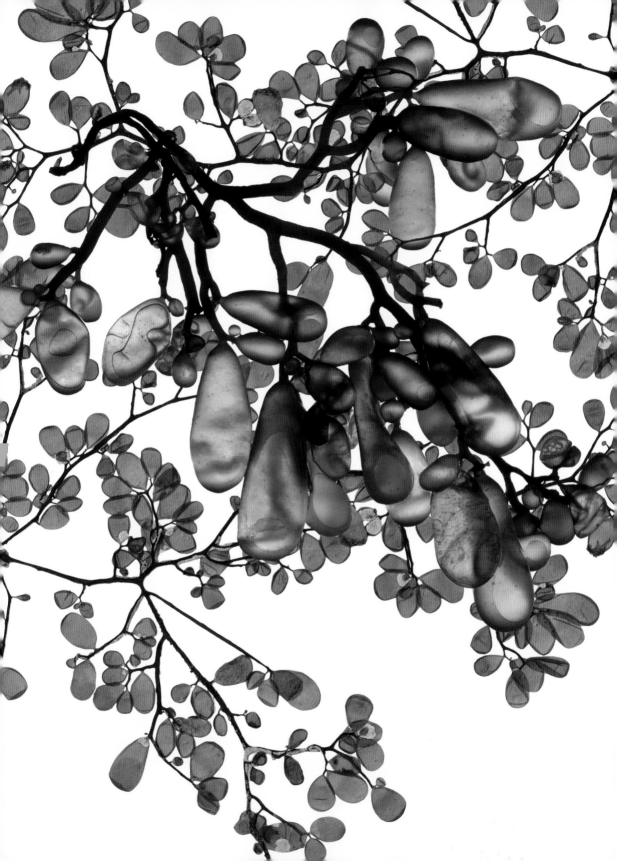

Sea Sacs and Sea Grapes

Every once in a while there is a *Halosaccion* day at Fort Funston in San Francisco. On such a morning, I climb down the cliff and arrive onto the water-wiped sand to find thousands of celadon-green algal fingers scattered across the beach. *Halosaccion glandiforme* are better known as sea sacs, a red seaweed (division Rhodophyta) that can be vibrantly green. They are elongated sacs, as their common name suggests, as opposed to bladed, leafy seaweeds. They grow from a tiny holdfast at the base of the sac and emerge either as a single digit pointing skyward or as a starburst of four or five thumbs of varying length. *Halosaccion glandiforme* emerges in early spring as a carpet of algal bubbles on the flat reefs to the north of San Francisco. The bubbles grow into the longer sacs but never get more than about six inches long and might take eight months or so to grow. By late fall or during the winter a storm event will wrench the sea sacs off the rock and drive them southward onto the beach at Fort Funston. There have been only two or three occasions when I have encountered the beach littered with hundreds of *Halosaccion*, and it is a magical moment.

Despite their turbulent journey, most of the sacs are intact, inflated by a combination of seawater and trapped gas. A single sac lies prostrate on the sand like a tiny beached whale and on close inspection it is easy to see a world of amphipods and nematodes inside, trapped in a microuniverse they cannot escape. These microfauna inhabiting this tiny ocean are well protected until the sea sac dislodges and decomposes, releasing its animal population to the larger world.

Halosaccion glandiforme is the only species in this genus and is not hard to find in the mid-tidal zone from Alaska to Point Conception on the Santa Barbara coast in California. Its range extends across the Aleutian Islands: its type locality is the Kamchatka Peninsula in Russia.

Halosaccion glandiforme.

Right next to *Halosaccion* in the seaweed listings of Abbott and Hollenberg's *Marine Algae of California* is a cousin named *Botryocladia pseudodichotoma*, or sea grapes. Sea grapes are equally fascinating and extraordinarily beautiful. They reside in somewhat deeper water, on the rocky edges of Vancouver Island south to Magdalena Island in Baja California, Mexico, only occasionally exposed at low tide. As its name suggests, it looks like a bunch of grapes, with rosy, rounded miniature balloons clustering off stiff branches. The sea grapes are filled with a mucilage that is more structurally solid than the surrounding water in their deeper habitat. They are common around Monterey and can be found in the drift. *Botryocladia*'s type locality is Santa Cruz, California.

The complexities of existence when the basic fabric of life is wrenched away and comes flooding back twice a day has given rise to an enormous number of strategies for survival in the rocky intertidal zone. Withstanding the desiccating hours when the tide is out, when sun and wind can dry it to a crisp, is one of a seaweed's chief challenges. *Halosaccion* and *Botryocladia* have evolved a similar response to this challenge: hydrate from within. Most seaweeds have hydrating substances, phycocolloids, in their cell walls, but the sea sacs simply keep water within them. *Halosaccion* have tiny pores in their skin that allow water to seep out slowly when the tide is out and refill when they are once again submerged. On a low-tide reef excursion one can find *Halosaccion* inflated and standing upright amongst the prostrate blades of *Ulva* and *Pyropia*. On discovering a loosened but full sea sac, a gentle squeeze will force water to jet out through the pores at its tip, sprinkler fashion. The Haida name for *Halosaccion* means "nipple," and as a mom who has breastfed three babies, this seems particularly apt.

Besides desiccation, surviving the dynamic conditions presented along the edge of the continent,

Botryocladia pseudodichotoma.

between the land and the open ocean, is another seaweed task. The torpedo shape of *Halosaccion* stands out as a different approach than its bladed neighbors. This shape clearly has a streamlining effect, decreasing the drag of the incoming or outgoing tide, allowing the sea sac's small holdfast to do its job of keeping it attached to the rock.

A grove of bulbous and torpedo-shaped sea sacs are beguiling in their outward nonconformity but equally beguiling when we come to understand that the group of cheerfully erect sea sacs is a mix of generations, some diploid sporophytes mixed together with haploid individuals—all male. There are no girls in the group. *Halosaccion glandiforme* is part of the order Palmariales, which includes the leafy and delicious red seaweed known as dulce: *Palmaria palmata* or *P. mollis*. The details of their life cycle, including both haploid and diploid generations, are what define them as a group. Like all red algae the Palmariales create sperm that are nonmotile—the sperm have no flagella—so they can only float, and the life cycle evolves to accommodate. A mature *Halosaccion* releases spores from tiny sori patches along its sac. These grow into an equal number of two-celled males and females. The male organism will take eight months to grow to maturity and looks just like the spore-producing (sporophyte) diploid plant beside it. The tiny female remains a prostrate disc and becomes fertile immediately. A mature male sea sac from the previous generation—her brothers are too young yet—

This page: *Halosaccion glandiforme*. Illustration by E. Yale Dawson from Abbott and Dawson, *How to Know the Seaweeds* ([1958] 1978). *Opposite*: *Dumontia*: various. Illustration by Alexander Postels from *Illustrationes algarum* (1840, pl. XXXV). A, C, E, and D are now *Halosaccion*.

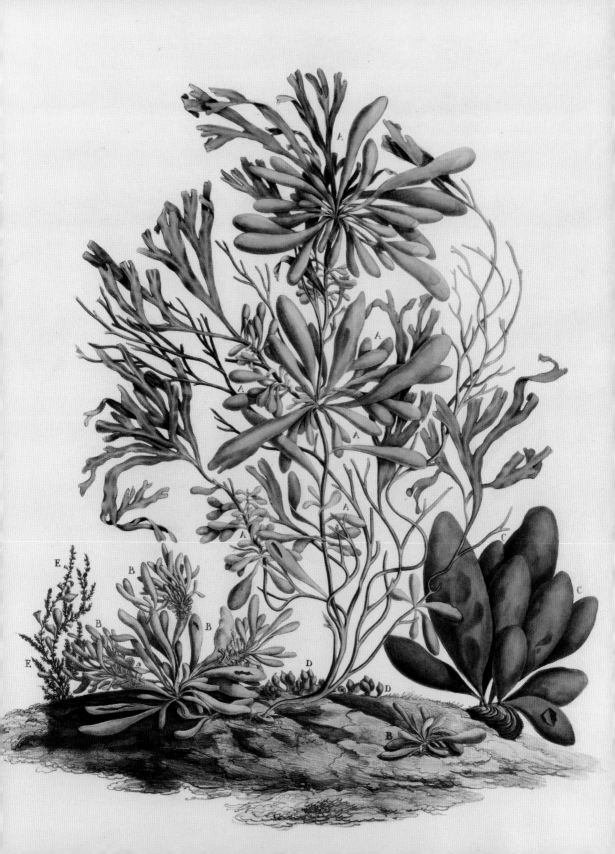

produces sperm in a long strand of slime. Tidal washing helps increase the possibility of encountering the flattened but ready female below. If fertilized, the new sea sac sporophyte, with a full set of chromosomes, will grow directly from the tiny female, obliterating it, and will eventually look identical to the males growing nearby. If the female does not get fertilized, she aborts and washes away after a few months.

The *Halosaccion*'s form and reproductive techniques take us into a world we are challenged to genuinely grasp. We need to get down on our knees and slither into the nearshore waters, become as thin as a wave, and slide over the rocks to really understand this world and its evolutionary forces.

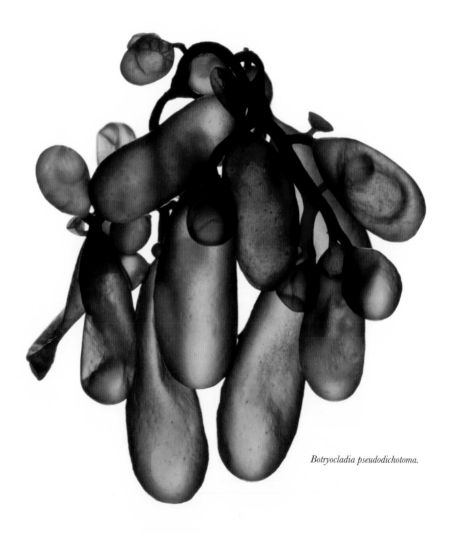

Botryocladia pseudodichotoma.

Halosaccion glandiforme.

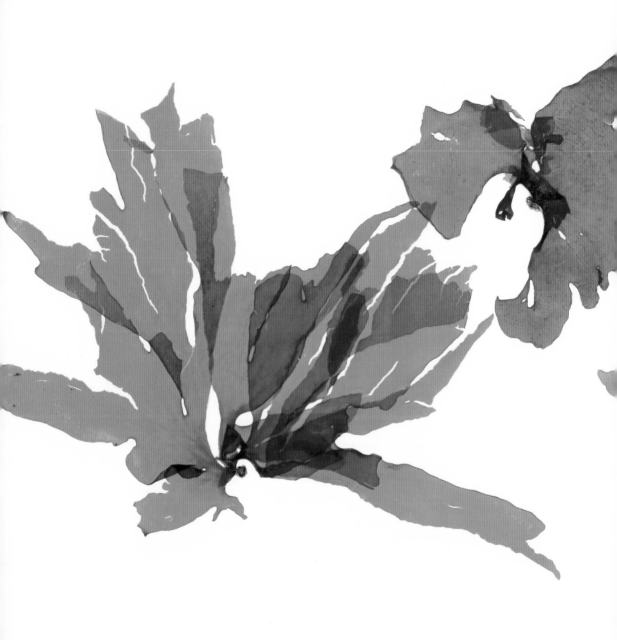

Weeksia reticulata. University Herbarium,
University of California, Berkeley, no. 1883542.

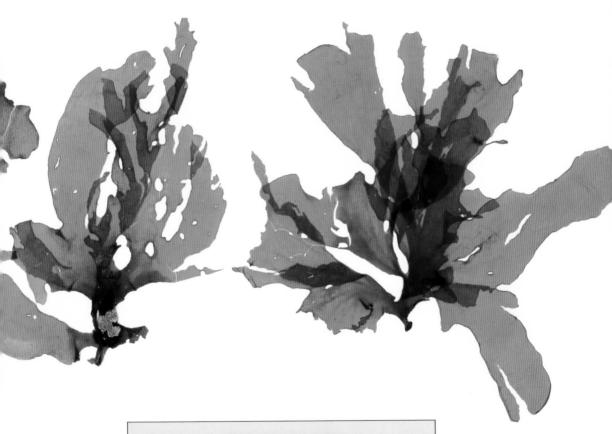

Weeksia reticulata

In October 1948 Isabella Abbott typed a letter to E. Yale Dawson asking if she could borrow a specimen of *Weeksia reticulata*, a beautiful leafy red seaweed she hoped Dawson had in formalin (preserved in a bottle) and as a pressing. A few months later in January 1949 she reiterated her request, promising, "Dear Yale,…I'll be your friend for life. I probably will be anyway, but I'd love to see the reprint and the material very much. Sincerely, Izzie."

Izzie Abbott and E. Yale Dawson *were* friends for life, although unfortunately one life was cut short when E. Yale Dawson died while collecting algae in 1966 at age forty-eight. Their correspondence, usually prompted by specimen trading, attests to a deep and abiding affection for one another, with much sisterly cajoling on Izzie's part. Isabella Abbott's letters to E. Yale Dawson evoke a feisty, confident woman who was comfortable being the boss, "shooting the bull," and wrangling a group of sniping men to make big things happen.

Isabella Abbott died in 2010 at the age of ninety-one. Considered one of the preeminent phycologists of her day, her knowledge of California and other West Coast marine algae was unparalleled in her time. She was the prime author of *Marine Algae of California*, published in 1976, ever since then the bible for all who study the seaweeds of this coast. She was also a beloved professor at Stanford's Hopkins Marine Station in Monterey from 1960 until 1982, where she imbued undergraduates with her love for the *limu*, as seaweed is called in her native Hawai'i, and she mentored countless graduate students and postdoctoral fellows in advanced algal research. She was the first Hawaiian woman to be awarded a Ph.D. in science, and the first woman and the first minority (she was native Hawaiian and Chinese) in the biology department at Stanford.

The specimen of *Weeksia reticulata* exchanged with E. Yale Dawson in 1948 was probably collected from one of the beaches around Monterey or Pacific Grove, where Isabella Abbott lived and worked for so many years. This is its type locality. The type specimen was found tossed up on a Carmel-area beach sometime before 1901 by

another intrepid woman obsessed with seaweed, Mrs. J. M. Weeks. She supplied the type specimen to William Albert Setchell, who named the seaweed in her honor.

Mrs. J. M. Weeks was a serious and focused seaweed collector who explored the fecund beaches and shorelines of the Monterey Peninsula, wearing long skirts and leather boots, three generations before Izzie Abbott did the same thing, albeit in pants and rubber boots. We know of Mrs. Weeks by her enormous record of collected specimens, and we have her correspondence with Setchell from 1886 to 1904 in the archives of his papers. She is mentioned in numerous scholarly papers and histories of the study of seaweed, as she supplied Setchell and the herbarium at the University of California at Berkeley with so many specimens, and she has a genus of rosy-red, smoothly lobed, foliose seaweed named after her. But like the seaweed itself, which grows deep in the subtidal zone and can only be found when dislodged and thrown upon the shore, Mrs.

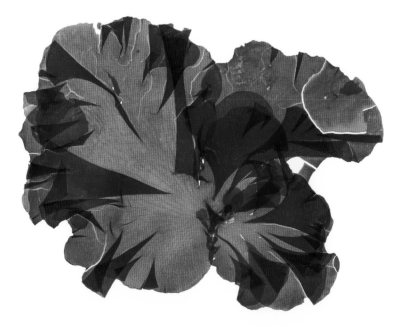

Weeksia reticulata, S.E. Farallon Islands, California, 1997. University Herbarium, no. 1935142. Found at fifty-five-foot depth.

J. M. Weeks is a bit of a mystery. The most important tidbit of information to be found is that the initials are her own, not her husband's. She was Mrs. Jane M. Weeks.

I do know, however, that like many of us she fell under the spell of the exuberant and rich algal flora of Carmel, Pacific Grove, and Monterey and would spend as much time among the "weeds" as she could. On March 20, 1896, she concluded a letter to Setchell: "I was in the surf about three hours yesterday and my fingers don't seem to want to write," and on June 22, 1901, she broke from her formal listing of seaweeds found and sent—packed in coal oil cans and sent up the coast by "Fargo Express"—to write from her winter home in Martinez:

> Dear Friend, I should have been very glad to have been in the Grove, with old Lottie and the phaeton while you were collecting and working in the Laboratory. I should have certainly begged the privilege of bringing my microscope and working in my slow way and so catching glimpses of your discoveries. I am intensely interested in all light thrown upon the growth and forms of Algae....
>
> How I have wanted to go out in a boat on Monterey bay on such a day and explore from Chinatown down to the wharf. The broad-leafed banded *Dictyoneuron* grows in some ten ft. of water near Chinatown (Saunders said) then there are so many other things near the wharf I'd like to see growing...the many varieties of red membranes that must grow between Seal Rock and the Chinese quarters possibly as far down as the central point of Moss Beach. They come in quantities there in Sept. I should like to be aquatic for a season to solve some of these mysteries.
>
> I am very cordially yours J. M. Weeks

Setchell captured Weeks's intense curiosity regarding the red leafy seaweeds by naming some of them after his steadfast collector. He tried to name one of the many *Callophyllis* species *Callophyllis weeksii*, but in 1896, Weeks wrote to Setchell and stated forcefully, "I think you will change the name of *C. weeksii* to gratify me." In his 1901 paper "Notes on Algae," Setchell described a number of diverse and interesting foliose

Opposite: *Weeksia reticulata*, collected by J. M. Weeks, "cast ashore," Pacific Grove, California, 1896
University Herbarium, University of California, Berkeley, no. 96498

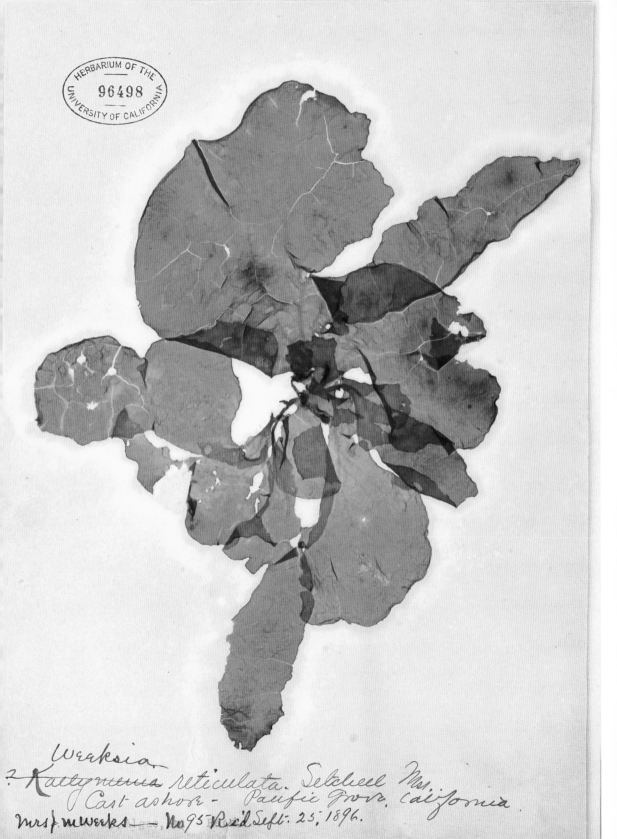

Weeksia
? *Kallymenia reticulata.* Setchell M.
Cast ashore — Pacific Grove. California.
Mrs. J. M. Weeks — No 95 Rec'd Sept. 25, 1896.

Constantinea simplex. Illustration by E. Yale Dawson from Abbott and Dawson, *How to Know the Seaweeds* ([1958] 1978). Common name is cup and saucer seaweed.

red seaweeds of the Pacific Coast, including *Dilsea* with its scimitar-shaped blades; *Constantinea simplex*, the intriguing cup and saucer seaweed that sits atop a stalk; *Callophyllis*, the group of flat-bladed, densely branching, elegant reds; and *Schizymenia*, a brownish, slippery-to-the-touch seaweed that looks as if it is torn. In his paper Setchell erects a new genus named *Weeksia*, for the delicate, petaled algae similar to the others, but particularly beautiful and intense in its redness. As per Setchell, the *Weeksia* genus is "named in honor of the Mrs. J. M. Weeks, an indefatigable and discriminate collector of our algae, who first collected and insisted upon the distinctness of the only species: *Weeksia reticulata*," which he describes with "frond ample, broadly reniform [kidney bean–shaped], up to 30 cm in diameter, of a rose pink to dark red color, soft and fleshy, adhering well to paper when drying, with many radiating broad indistinct veins.... A rather rare plant cast ashore from deep water on several beaches near Pacific Grove."

The explosion of life in the deep, rich waters of Monterey Bay and along the shores of the Monterey Peninsula creates a power of place that was, historically, multifaceted in its orientation towards the ocean. Chinese families moved to Monterey to create a community of fishermen on one particular beach, dubbed China Beach after many years. J. M. Weeks remarks in her letters that the seaweeds around "Chinatown" are plentiful and interesting. The Chautauqua nature study movement chose Pacific Grove for its West Coast assemblies, teaching botany and zoology (both terrestrial and marine) for the general public starting in 1879. Ed Ricketts explored the local tide pools and published *Between Pacific Tides* in 1939, introducing ideas of ecology that were not yet being taught within the universities. Gilbert Smith, E. Yale Dawson's mentor through his graduate studies, published *Marine Algae of the Monterey Peninsula* in 1944, the first floristic study of California seaweeds. This book became a touchstone for many students of marine botany exploring the California coast and beyond. Its illustrations were

lovingly inked, many from Smith's original drawings, by Jeanne Russell Janish and have been used over and over by fellow phycologists.

Gilbert Smith retired from teaching at Hopkins Marine Station in 1952, just when Izzie Abbott and her husband, Don Abbott, were taking up residence on the peninsula. Isabella Abbott would come to Pacific Grove and study the same red algae found on the same beaches J. M. Weeks had collected from Abbott. She approached the group of foliose red algae that had attracted Weeks as the ultimate challenge, stating in 1967, "The 'foliose reds' are the most systematically difficult group of algae remaining to be studied on the Pacific Coast of North America." How should they be organized—by shape, by reproductive behavior, by microscopic structure? In 1968 Isabella Abbott published a paper establishing a new family to hold four different *Weeksia* species and their close cousin, the curious cup and saucer seaweed, *Constantinea simplex*, her solution to this taxonomic vexation. She named the new family *Weeksiaceae*, a continuing tribute to a woman similarly captivated by the life stories of the marine algae presented along the ragged coast, from Point Lobos at the south, around Carmel Bay and Point Pinos, past Lovers Point to the wharves of Monterey.

E. Yale Dawson and Isabella Abbott solidified their algal friendship as she established herself at Hopkins Marine Station and forged ahead in the world of research and taxonomy, and also made every attempt to bring to the general public the beauty and fascination they found in the botanical world between the tides. Izzie Abbott was an enthusiastic and renowned teacher of undergraduate and graduate students. She rapidly became a full tenured professor and gained a loyal following as a guide to the younger generation into the intertidal world of marine flora. E. Yale Dawson was a prolific writer, and in 1965 the two were tapped by Stanford University Press to write a supplement to Gilbert Smith's *Marine Algae of the Monterey Peninsula*, to bring it up to date. This project was only a precursor to the much larger project of a complete flora of the state, to be called *The Marine Algae of California*. E. Yale Dawson, newly situated in Washington DC, was lined up as the main author of the book but wrote to Izzie Abbott, "I am especially interested in working on this *Marine Algae of California* conveniently from this new point of view. Perhaps the situation calls for joint authorship here. Would you be favorably disposed to such?" In early March 1965, Dawson met with Abbott in Pacific Grove and they strategized on the project, agreeing to ask George

Hollenberg to join them in writing up the dizzying number of species that would make up the 744 pages of descriptions. Eventually Paul Silva was asked to join the duo, and the troika divvied up the green, brown, and red seaweeds according to their expertise. Abbott held onto the foliose reds, those groups that include *Weeksia*. Paul Silva eventually dropped out of the project and his greens were taken on by Izzie Abbott and E. Yale Dawson.

In January 1966, Dawson had already finished his groups of browns. He wrote to Abbott that he had the funding in place to go to two international science conferences, one in Moscow and the other in Tokyo. He and his wife, Maxine, sold their property in Santa Ynez, California, to allow Maxine and their daughter Renée to join in the trip around the world from May through the end of the summer. Dawson's handwritten itinerary had the days of each month carefully planned, listing Cairo, Beirut, Bombay, Madras, Sydney, Wellington, Auckland, Manila, Tokyo, and Nagasaki—an epic trip of a lifetime. After the Moscow Congress in June, Dawson met his daughter in Cairo and they headed to El Ghardaqa (Hurghada), an Egyptian resort on the Red Sea. They were to spend three days collecting algae. On the third day, before their scheduled bus return to Cairo, E. Yale Dawson drowned in the Red Sea. No information was forthcoming out of Egypt as to the details of his death.

Isabella Abbott must have been profoundly grief-stricken when she learned the news of Dawson's death. She and Dawson shared a collegial and collaborative spirit, both working at the height of their intellectual capacities in this obscure corner of the marine sciences. This bond instantly and unexpectedly disappeared. Abbott wrote a beautiful and personal obituary for Dawson, and she immediately took up the projects he had left behind unfinished. True to her feisty tone in her letters to him ("I shall have to come down and give you a lecture," she berated at one point), she handled the clutch of "boys" and willed Big MAC, as Abbott and Hollenberg's taxonomic tome *Marine Algae of California* became known, to completion. It was published in 1976. It is dedicated "in admiration and affection to Gilbert Morgan Smith and Elmer Yale Dawson."

Weeksiaceae is included in *Marine Algae of California* as the family within the phylum Rhodophyta that contains *Weeksia reticulata* and its cousins, as named by Abbott in 1968. But the advent of DNA barcoding has allowed the vagaries of this red algal group to

Opposite: *Weeksia reticulata*, collected by J. M. Weeks, Pacific Grove, 1896. University Herbarium, University of California, Berkeley, no. 96501.

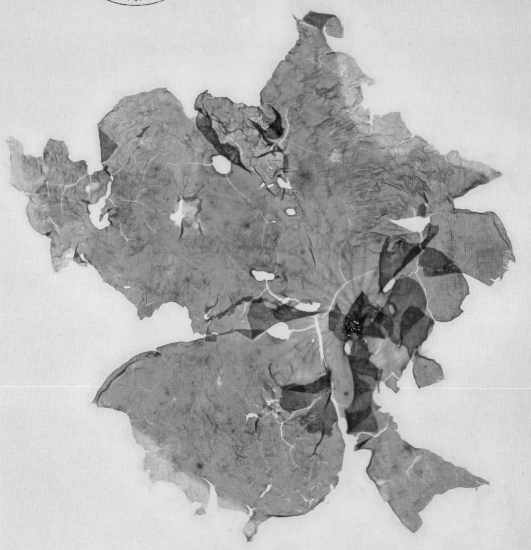

Werksia reticulata Setchell
Pacific Grove. Calif.

Mrs J. M. Werks, algae No 95. Recd Sept. 25, 1896. Mrs J. M. Werks.

be revisited. In 2008 the *Weeksia* genus on the west coast of North America was recombined into the order Gigartinales, family *Dumontiaceae*, and reduced to two species, the most common remaining *Weeksia reticulata*—the original seaweed named by William Albert Setchell from the specimens found by Weeks.

As I pull my copy of Big MAC from the shelf for the thousandth time, I notice that the illustration of *Weeksia reticulata*, showing the delicate veins running up its wide-lobed blades, gets pride of place on the back cover. This must have been at Isabella Abbott's insistence, in recognition of an algal sisterhood. The connection these seaweeds create across time and space is profound. I am now determined to go to Pacific Grove or to Monastery Beach nearby, wary of the dangerous waters there but in hopes of finding a sample of *Weeksia reticulata* washed from the deep Monterey Canyon onto the sandy shore.

This page: Schizymenia pacifica. Opposite: Weeksia reticulata.
University Herbarium, University of California, Berkeley, no. 1574747.

ALGAE OF THE CALIFORNIA CHANNEL ISLANDS

Weeksia *reticulata* Setchell

**Santa Rosa Island. Wreck of the freighter
Chickasaw.** Exposed kelp bed east of the
wreck, with low - to medium-relief sandstor
reefs with fine sand and coarser sand in
channels. Lush algae.

Growing on rock. Common. Depth: 12-13 m

Det. K.A. Miller
Leg. K.A. Miller 1283 22.x.1986
 Channel Islands Research Program

209

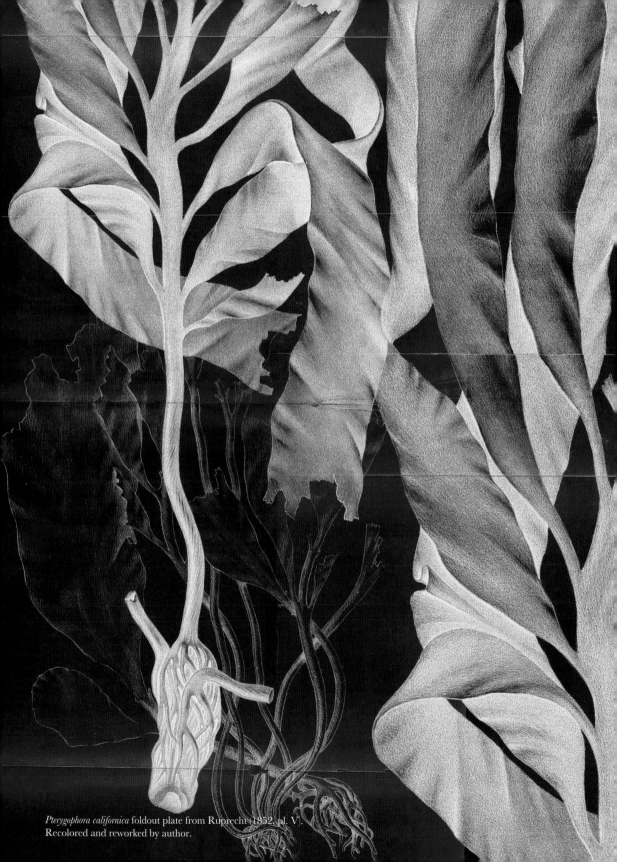

Pterygophora californica foldout plate from Ruprecht (1852, pl. V).
Recolored and reworked by author.

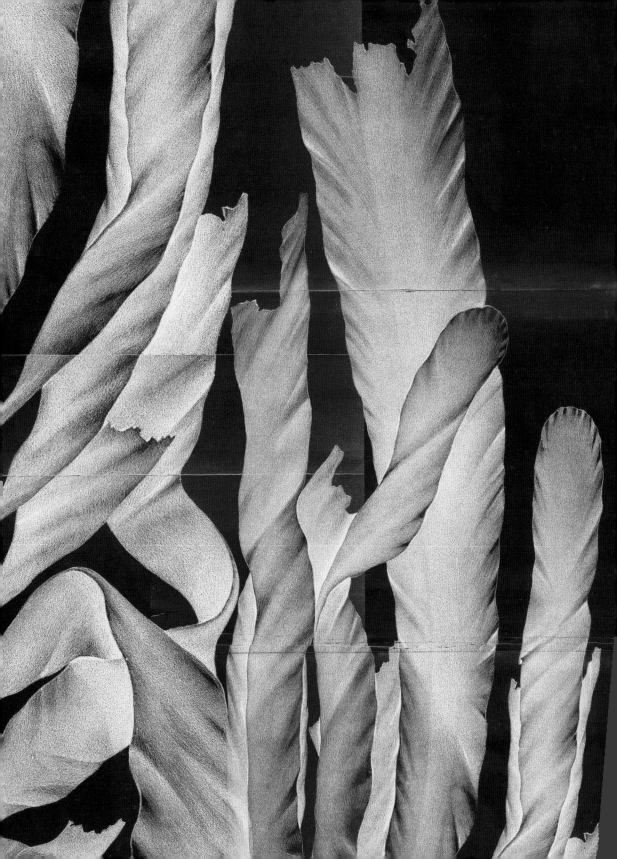

Pterygophora californica

Walking Kelp

Can we conclude our accounting of iconic Pacific Coast seaweeds and seagrass without including *Pterygophora californica*? The answer is that we cannot—it must be chapter sixteen.

Pterygophora is a kelp that can be easily overlooked. It is a perennial kelp that is as important to our kelp forests as *Nereocystis luetkeana* or *Macrocystis pyrifera*, and yet when these foundational habitats are discussed, it is rarely mentioned. *Pterygophora californica* often makes up the understory of the *Nereocystis* and *Macrocystis* forests. It is the chaparral to the larger kelps' oaks or redwoods (to borrow a phrase from my friend Larry Knowles). Its dark-brown blades are thick and leathery and grow straight out horizontally from its stipe, like wings—thus the prefix *ptera*—with one oblong blade growing straight up off the stipe's end. It does not turn up on aerial surveys of coastal kelp because it rarely reaches the ocean surface, but it is, in fact, the old-growth forest of the seas. *Pterygophora* has a rigid, woody stipe—the stiffest among kelps. When cut in cross section, the stipe reveals growth rings that can be counted. This kelp, in ideal conditions, can live for fifteen to twenty years. Some have been found to be twenty-five years old, a true anachronism in the algal realm.

As a beachcomber I love encountering the *Pterygophora* stipes amongst the beach wrack. Easily mistaken for a piece of driftwood, the stipe is identified by the worn knob of the holdfast on one end and a flattening on the other. A wavy, corrugated edge where the blades have been stripped off, and often bleached white while the rest is dark brown or black, is the telltale sign that this stick is algal in origin. Indigenous peoples of the Pacific Northwest described *Pterygophora* as "walking kelp," and this became its common English name. Its holdfast can attach to a cobble or stone heavy enough to keep the organism rooted to the ocean bottom, but as the kelp grows, it becomes vulnerable to wave action and surf. The cobbles with their attached kelp bounce around in the surf, creating the effect of "walking" around the shallower waters. First Nations peoples

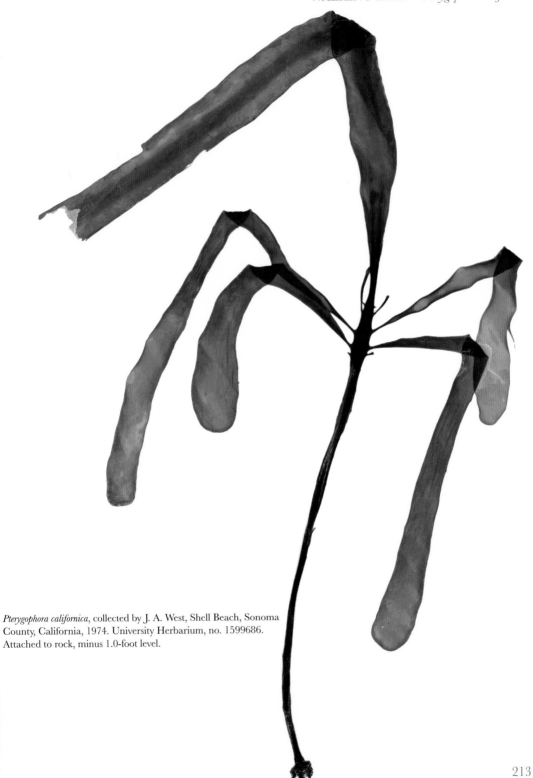

Pterygophora californica, collected by J. A. West, Shell Beach, Sonoma County, California, 1974. University Herbarium, no. 1599686. Attached to rock, minus 1.0-foot level.

would use this movability to their advantage by arranging the *Pterygophora*—with their attached cobbles—into rows, creating a funnel to deflect salmon into their fish traps. Ingenious!

Pterygophora is also referred to as old-growth kelp. A typical *Pterygophora*, surrounded by bull kelp, bladder chain wrack, feather boa, and other algae swaying in the ocean currents, would be the oldest kelp in the underwater woods. Most disturbing, then, is that the *Pterygophora* along the northern coast of California is disappearing. Without sunflower stars (*Pycnopodia*) to keep them in check, hordes of urchins have swept through the deeper subtidal rocky reef, eating all the kelp they can find. On their first pass the urchins eat the *Pterygophora* blades, leaving the unbending stipes denuded, standing like upright walking sticks. Then on a second pass the starving urchins will graze down the tough stipes to nothing. While the decline of bull kelp can be seen at the ocean surface and tends to get the attention, the loss of *Pterygophora* is seen only by divers and snorkelers. More importantly, its loss is felt by the rockfish, lingcod, greenlings, and other fish that should shelter among its blades, by the young salmon who rest in the kelp forest on their way out into the ocean, by the invertebrate larvae who depend on the kelp beds to calm the water so they can grow to maturity, by the abalone that feed on the kelp's sloughed debris, and by the clams, barnacles, and mussels that filter-feed off the more minute pieces of algal detritus broken down by the action of the waves. The urchins themselves will in turn become impoverished once they have eaten down the fleshier kelps and have turned to the tougher *Pterygophora* and its stipes.

Along some of the coast of British Columbia where sea otters were reintroduced in the 1970s, the situation is different. The otters control the urchin population, and *Pterygophora* is thriving. In one spot, paradoxically, one can see the *Pterygophora*-otter story by looking up in the air rather than down into the sea. In February 2015 a researcher noticed an eagle's nest in a lone tree on Gosling Rocks, a remote archipelago on British Columbia's central coast. A close-up photograph of the nest shows a hodgepodge of what at first looks like driftwood. On close inspection, however, the flattened ends, corrugated edges, and worn knobs of holdfasts identify the sticks as stipes of walking kelp. The recent return of otters to that area of coastline has led to dramatic rejuvenation of the kelp forest, with fish returning to abundance. The eagles are thriving off the fish and able to forage for nest material close by along the beach. This rejuvenated food

chain takes pressure off other shorebirds, an eagle's prey in lean times. The kelp washed ashore also provides nutrients and hiding places for shore creatures and an influx of nitrogen to shore ecologies. The nest on Gosling Rocks has been noted since the 1990s, but until the otters' return, it was made of wood. The transition to kelp construction marks a rich and intertwined web of life from ocean to air.

It is believed that until the beginning of the fur trade in the mid-1700s and the subsequent slaughter of sea otters, over three hundred thousand otters (*Enhydra lutris*) ranged from northern Japan along the northern edge of the Pacific Ocean all the way south to Baja California. This coastal marine mammal shared with the seaweeds the same slender band of temperate ocean that hugs the North American continent and Aleutian Islands. By 1911, when the US Congress joined an international ban outlawing the killing of sea otters, there were less than two thousand left along their entire range. The last sea otter seen in British Columbia was shot in 1929. The few remnant and isolated populations declined. They were considered extinct in California until the small Big Sur colony was rediscovered in 1938. By the 1960s biologists were searching for suitable habitat to reintroduce the sea otter, and they chose a remote section of Vancouver Island's west coast just to the north of Nootka Sound, that waypoint for eighteenth-century exploratory expeditions (including Malaspina and Vancouver), where Europeans first traded for sea otter pelts with the Mowachaht people and the fur trade began. From 1969 to 1972 eighty-nine otters were translocated from remnant populations in the Aleutian Islands and Prince William Sound, Alaska, to this rocky coast south of the Brooks Peninsula.

This ocean-facing coast was a beneficent home to the otter, with bountiful red sea urchins (*Strongylocentrotus franciscanus*) to feed on, and protected bays and islets. The sea otter populations grew steadily and expanded their range. We know generally that when otters are present, kelp forests and the widespread web of contingent organisms thrive, and when otters are absent, an alternate regime dominated by urchin barrens persists. But this correlation had not been quantified.

The return of otters to the northwest coast of Vancouver Island gave a young researcher named Jane Watson the opportunity to carefully inspect the ecological effect of sea otters foraging as they returned to these habitats. *Pterygophora* was one of the major players in her study, and she spent many years—twenty-three years of data are

This blade 127 cm. long
?

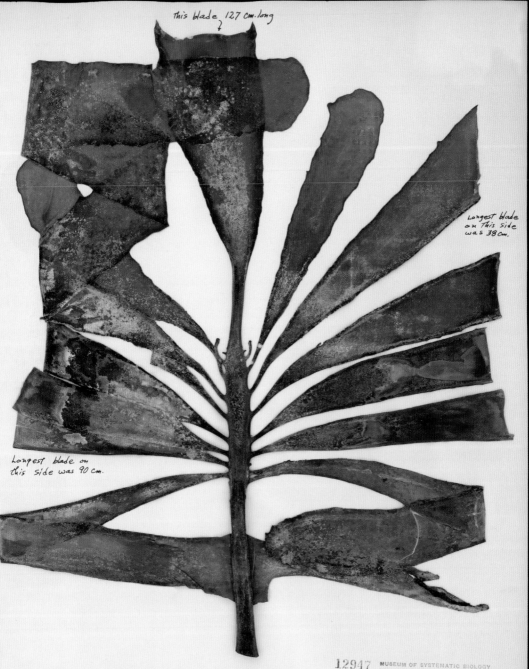

Longest blade
on this side
was 38 cm.

Longest blade on
this side was 90 cm.

12947 MUSEUM OF SYSTEMATIC BIOLOGY
UNIVERSITY OF CALIFORNIA, IRVINE

stipe was
broken from
plant.

green

HERBARIUM OF H. R. WILLIAMS

Binomial *Pterygophora californica Ruprecht*

Classification *Laminariales; Alariaceae*

Coll. *H. R. Williams* Det *HRW*

LOCATION
Location *Eagle Glen Canyon, 4.6 miles West of the
Santa Cruz, California city limits, Cast ashore*

DATE
Date *July 10, 1964*

PHOTO.
ALBRI.

included in her published papers—donning her dive gear and becoming part of the ocean itself to tease out the story of such long-lived algae with and without otter. In 2019, Watson is in her thirty-third year of looking at kelp and sea otter. Just as Edna Fisher had repeatedly observed and recorded the interplay of sea otter and *Nereocystis luetkeana*, or bull kelp, Jane Watson, over her long-term study, records the fascinating life story of the tough-stalked *Pterygophora* in the zones where otter were returning as top predator and clearing space on the reef of the ubiquitous, kelp-eating red sea urchin.

In 1987, Watson established dive sites at various locations along the west coast of Vancouver Island—some where otters had been present for ten years, some where otters were just moving into the area, and some where no otters had been since their extirpation in the 1800s. Watson was counting urchins and algae in quadrats laid down in waters twenty-four to thirty-six feet deep, the typical depth sea otters dive to find their prey. *Pterygophora* also grows in the sublittoral fringe, closer to shore, but Watson was most interested in the deeper stands where both urchin and otter had the major impact. She was able to confirm that those places with otters consistently present were kelp-dominated ecologies with persistent stands of *Pterygophora* being the most common brown algae (kelp) observed, while those sites with no otters were urchin barrens with little to no brown algae whatsoever. But there were four sites where otters entered the system while she was recording her data. She witnessed the regime shift from urchin to algal-dominated ecosystems. The algal mix she recorded was different from site to site and initially depended on what time of year the otters began their urchin feeding. Most often kelp annuals *Nereocystis* (bull kelp) and *Desmarestia* (acid kelp) initially recolonized these sites, but over time, the perennial *Pterygophora* and some *Laminaria* would replace the annuals. Once established, the *Pterygophora* maintained an age-class of individuals that survived and persisted as a group. Survival of the mature kelps was very high, so younger recruits were shaded out and did not grow.

Watson figured this out by doing something I have always wanted to do: tag kelp. Tagging animals is a mainstay of wildlife studies, but tagging marine flora is a bit more obscure. Watson placed PVC tags around the *Pterygophora* stipes large enough to keep them attached. She retagged if they were lost and at one point had 97 percent of an entire deep-water stand of walking kelp tagged. The tagged kelp proved just how sturdy and long-lived an individual *Pterygophora* can be and also how stable their

Opposite: Pterygophora californica.
University Herbarium, University of California, Berkeley, no. 1713021.

217

population was. At a site where otter presence allowed a grove of *Pterygophora* to take hold, she recorded a 95 percent survival rate of the kelp over three years. She was also able to age the plants by counting the rings of their stipes and found that the deep clusters of *Pterygophora* were of a similar age range. They had established together when space had been opened up by otter predation. Watson realized she could even reverse the process and date the return of otter to an area by the age of the *Pterygophora* there.

And the study continued. Watson kept diving and observing and counting. For ten years the *Pterygophora* remained unchanged at her sites with continuous otter presence. Then, suddenly, the *Pterygophora* died off as a group. At seventeen years old (a ripe old age for a kelp), the deep stands of walking kelp senesced. Vast collections of *Pterygophora* stipes washed ashore, building material for more eagle nests. Observing and recording this pulsed senescence was a remarkable feat.

And the algal mix shifted. In the space newly opened by the dying *Pterygophora*, great bushes of *Desmarestia* or acid kelp occupied the plot and were abundant until the study ended in 2009. And each plot had a slightly different algal mix. Some included players like *Nereocystis* and *Macrocystis*. Watson emphasizes that although there was a highly predictable association of algal abundance with otters present, the make-up of the algal community varied from site to site. *Pterygophora* was an overall solid community builder, but the story of algal succession once the *Pterygophora* died out was complex and unpredictable.

Ecological succession, the process by which the structure of a biological community evolves, comes to mind more frequently in our new era of increased forest fires; what grows back is not necessarily what burned. But kelp forest succession happens on a timescale and in a place that are both remote, beneath the reflective surface of the ocean. In the Atlantic Ocean, lower seaweed species diversity makes kelp bed succession relatively predictable. But on the Pacific Coast, the remarkable number of kinds of marine algae combines with the geography of place to make highly dynamic nearshore communities with countless factors affecting which seaweeds recruit and survive. Is there shade from other kelps? Is there wave action? Are there herbivores? Warm water events? On the West Coast, succession from one generation of kelp forest to the next is not so predictable.

Jane Watson caught a glimpse of long-term ecological processes in one region of

the ocean along a particular section of the varied Pacific Coast. Each coastal region along the eastern edge of the Pacific presents its own set of factors putting different kelps and algae into play. Adding otters to the mix in British Columbia has allowed the rebound of the long-lived *Pterygophora*, but it doesn't necessarily allow us to predict algal succession or other ecosystem questions in other places. Otters have rebounded in British Columbia, parts of Alaska, along the central coast of California, but the intense variability from place to place makes it hard to predict what would arise if otters were reintroduced in other places.

Sea otter and kelp forest recovery on the coast of British Columbia does, however, shed particular light on our human relationship with these nearshore ecosystems. The time period of Jane Watson's study, continuing up to the present, is a period in which ecologists have learned the long-term effects of otters not only on the health of a coastal area's kelp forest but also on that area's populations of invertebrate otter prey. In 1987, when Watson began, the First Nations peoples of the Kyuquot area of Vancouver Island had not yet felt the sting of competition for the shellfish they relied upon. Sea otters had been missing from the landscape for so long that, while remaining an important cultural figure, their role in the food-web narrative had been sidelined. Until the 1990s the intertidal ecology without them, replete with clams, abalone, urchins, and crabs, sustained and nurtured the coastal indigenous communities and, like elsewhere along the Pacific Coast from Alaska to San Diego, came to be understood as a "natural" state. Up and down the West Coast, fisheries, economies, lifestyles, and expectations of coastal communities of all sorts arose from the abundance of shellfish in the absence of otters.

But these invertebrate riches came from an unnatural act—the wholesale killing of the top predator in these waters—a detail that is often forgotten or overlooked. This lack of historicity leads to a false sense of what is the natural state of an ecosystem, a "shifted baseline," if you will. The shifting baseline syndrome plagues scientists, policymakers, fisheries experts, and community stakeholders alike. It has been at play for years and even manifests in our Marine Protected Areas that claim to restore sections of coastal intertidal ecologies to their natural settings.

First Nations elders and historians in British Columbia are, however, working past this. As they insist on having a voice in otter management and ecosystem restoration

policy, they are asking the real question: "Restore to what?" They are reaching back into deep history, tapping elders' memories, the history in shell middens, and archeological data to find clues to the relationship between humans and otters before Europeans descended upon the west coast of North America for fur to plunder. Certainly otters were hunted and their pelts used for warmth, trade, ceremony, or as a sign of chiefly status by indigenous populations all along the otter range. Ka:'yu:'k't'h' (Kyuquot) and Che:k'tles7et'h' (Checleseht) First Nations members and their ancestors have lived for thousands of years on the section of Vancouver Island where otters were first reintroduced and where Jane Watson set her dive sites. Indigenous leaders as well as archeologists, biologists, and a range of different knowledge holders are piecing together ancient traditions and strategies for sharing the bounty of the kelp forest with the otter. Their long-term memory and far-forward thinking balance the need for food sources such as plentiful urchins and productive clam flats with respect for the health of the kelp forest and system as a whole. Acknowledging that humans have been part of the ecology of this section of the Pacific Coast for thousands of years is a start. How were the otter populations both revered and controlled at the same time?

Prehistoric ancestors followed the kelp highway down this beneficent but rugged coast. We all need the *Pterygophora californica*, or walking kelp, to continue bouncing along the intertidal on its cobblestone and to grow in old-growth stands in the deeper waters—but we cannot deny that we as humans have been part of the system for a long, long time. How do we learn from our deep past?

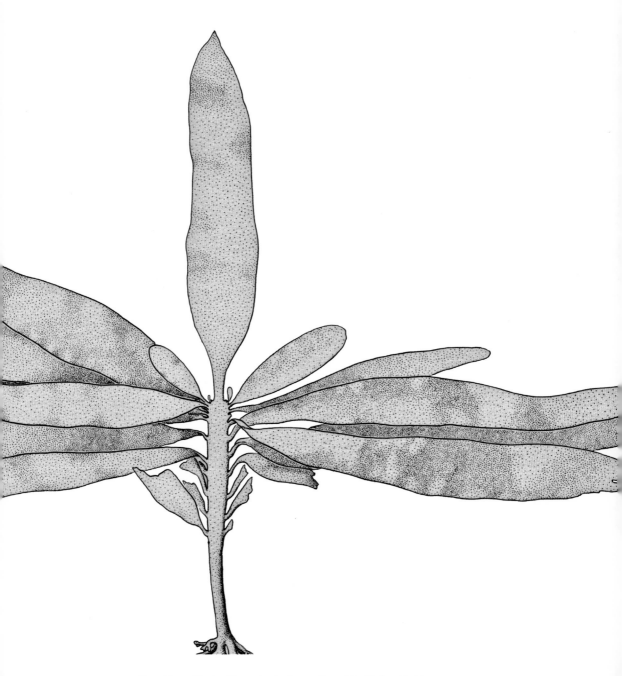

Pterygophora californica. Illustration by Jeanne Russell Janish from Smith, Marine Algae of the Monterey Peninsula ([1944] 1964).

Microcladia coulteri. University Herbarium,
University of California, Berkeley, no. 1572102.

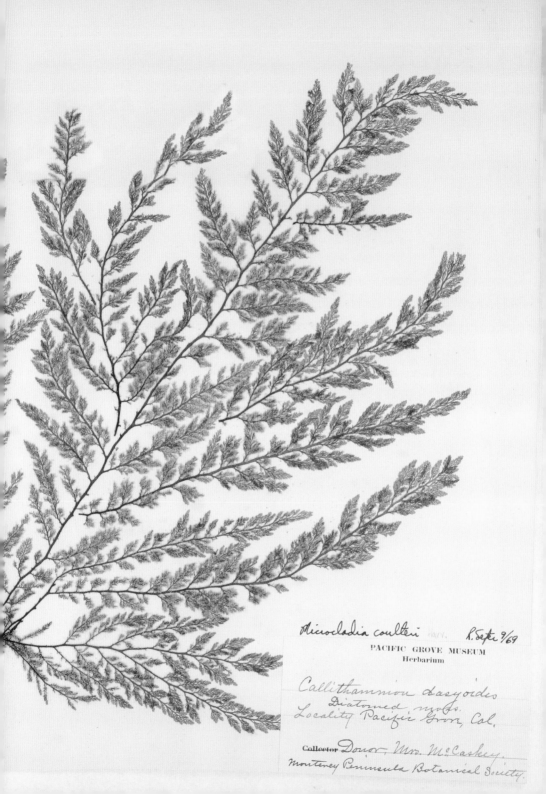

Microcladia coulteri L. Sept 9/69

Callithamnion dasyoides
Diatomed, n.gen.

Locality Pacific Grove, Cal.

Collector Donor Mrs. McCaskey.
Monterey Peninsula Botanical Society

AFTERWORD

Erythrophyllum delesserioides.

My friend Lina called me a few weeks ago to report she had found an odd bull kelp on the beach. She saved it in a baggy in her refrigerator and gave it to me to scan a few days later. Two bladders seemed to have fused together, forming a single heart-shaped pneumatocyst on this mid-sized specimen. She had not seen anything like that in her many years of bull kelp collecting. I mentioned this to my friend Tom Mumford, a bull kelp expert at Friday Harbor Laboratories, and he remarked that there is a First Nations story about such kelps as guides to an undersea source of wisdom.

The Pacific Coast—from the Baja Peninsula to the westward thrust of Alaska—has many more than sixteen seaweeds with stories to tell and wisdom to share. There is the astounding *Erythrophyllum*, or feather weed, whose deep rose color and flouncing, notched blades, like the feather of some magnificent underwater bird, make it easy to identify amidst the algal turmoil on the reef. There is the red genus *Callophyllis*, whose numerous fanlike species are notoriously difficult to tell apart, but are all characteristically flat. They dry into beautiful seaweed pressings that recall the Victorian passion for this pastime. There are two lacy red genuses we haven't discussed. *Plocamium*, or sea comb, appears in the literature as far back as Gmelin. *Microcladia borealis* is an algal filigree with a distinct handedness—the branching pattern is one-sided—that sets it on a spiraling trajectory. At low tide it is encountered as a dark clump inelegantly draped over the rocks, but when spread and carefully pressed, it curls and loops across the page. *Microcladia coulteri* is symmetrical in stature. It is most often found growing as an epiphyte on other algae.

Chondracanthus exasperatus, or Turkish towel, is a seaweed that often sports *Microcladia coulteri* as a ride-along. How can this classic of the intertidal zone be overlooked? Turkish towel is one of the few common names of algae that visitors to the shoreline remember. The fleshy blades of *C. exasperatus* are covered with nubs called papillae that recall the pile of a bath towel. All of the various versions of *Chondracanthus*, some of which have wildly irregular shapes, dry to a deep and striking fuschia. Before the 1990s, *Chondracanthus* was known as *Gigartina*. William Henry Harvey describes various *Gigartina* specimens collected from Puget Sound and the California coast in his 1853 opus on North American seaweeds. In 1933, William Albert Setchell and Nathaniel Gardner named a species of *Gigartina* after Harvey, the good-natured Irishman who devoted himself to the seaweeds. *Chondracanthus harveyanus* grows in elongated pairs of nubbly blades.

There are also green seaweeds I have not mentioned, including pincushion-like *Cladophora* or ropelike *Acrosiphonia*. There is the beautiful and abundant brown seaweed *Alaria*, or winged kelp, also known on our west coast as wakame. But I will leave those for the reader to discover and to learn from while inspecting wrack on the beach or venturing out onto the rocky reef at low tide.

The ingenuity of the kelp and seaweeds is fundamental to their stories. As I piece together the narratives of the seaweeds, I have been astonished and delighted by the array of naturalists, scientists, explorers, ecologists, and taxonomists who have collected them, named them, revealed their life histories, uncovered their role in a given habitat or food web, and nurtured our under-

Chondracanthus exasperatus.

225

standing of these profound yet elusive organisms. The spectacular herbarium samples they so carefully made of their collections are the continuing legacy of this work. Dawson Turner, Archibald Menzies, and Tadeo Haenke were beguiled by this corner of the natural world. William Henry Harvey, William Albert Setchell, E. Yale Dawson, and Paul Silva provided intuitive intelligence and scholarship to illuminate the largely unseen world of the marine algae specifically of the coast of California and on up into Oregon, Washington, British Columbia, and Alaska.

But most inspiring to me has been the lineage of brilliant women that I have

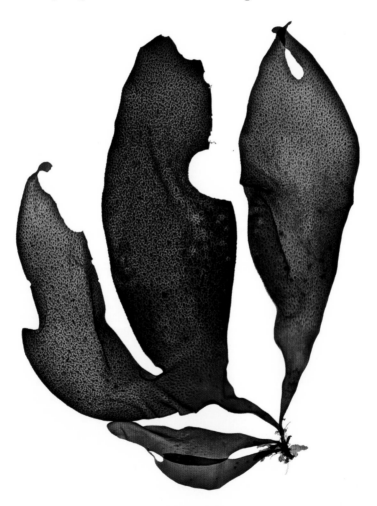

This page: *Chondracanthus exasperatus*. *Opposite*: *Gigartina microphylla* and *Gigartina spinosa*. Illustration by Harvey from *Nereis Boreali-Americana, Part II—Rhodospermeae* (1853, pl. XXVIII). *Gigartina* is now *Chondracanthus*.

Pl. XXVIII.

A.

B.

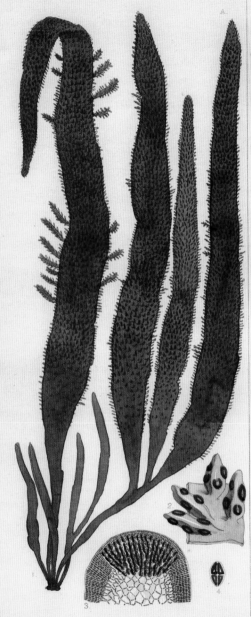

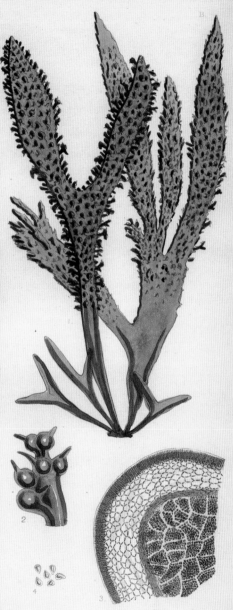

W.H.H. del. et lith.

Rad & West, Lithographers, 54, Hatton Garden.

encountered on this seaweed journey. These women have combined a passion and compassion for the marine algae with trained and sustained observation and analysis. They have created a body of knowledge around the seaweeds that can act as a beacon when addressing ecological issues like preservation of biodiversity in our nearshore ocean environments or restoration of coastal habitats. They are models for younger ocean lovers and beachcombers and burgeoning scientists and ecologists. The legacy includes Mary Turner, working alongside her husband Dawson Turner on his opus of 1808; Margaret Gatty and Anna Atkins, polymath artists of Victorian England; and J. M. Weeks, who collected seaweeds in Pacific Grove, California. Josephine Tilden traveled from Minnesota to Vancouver Island at the turn of the twentieth century, and Edna Fisher observed sea otters at Big Sur in the 1930s. Kathleen Mary Drew-Baker decoded *Porphyra* in mid-twentieth-century Manchester, England. Isabella Abbott was an algal leader amongst her male contemporaries in the 1970s and 1980s, and Lynn Margulis fearlessly cracked preconceived notions of evolution. Jane Watson stayed with it over the long term on the rocky coast of Vancouver Island. This rich heritage continues today with many women in the field of contemporary phycology leading current research on the kelps, seaweeds, and seagrasses of our Pacific Ocean. I could not have written this book without many of them. And while taxonomy and nomenclature continue as a concern, current algal research more often studies ocean change and the stresses associated with our warming planet.

One of the stressors being studied—the corollary to ocean warming—is ocean acidification. The increased CO_2 absorbed by oceans is decreasing pH levels, and this acidification has disastrous effects on coral, mollusks, and larval invertebrates of all kinds, as well as microalgae, some of whom build intricate calcified structures. The seaweeds, kelps, and seagrasses are appreciated as carbon sinks and oxygen producers. Macroalgae of all kinds mitigate acidification, at least locally and during the day when they are photosynthesizing. In January 2018, the California Ocean Science Trust and its advisory team of scientists lead by Karina Nielsen produced a report discussing ways that seaweeds and seagrasses in particular can ameliorate ocean acidification. It outlines questions to ask regarding what we know and what we still need to study about restoring these primary producers and why these efforts will be important not only to California fisheries and the economies they support but also to the coastal ecologies

generally. Kelp and seaweed farms are also being examined as acidification mitigators. As young oysters find it harder and harder to calcify their shells, experiments are proliferating with farming kelp and seaweed nearby to oxygenate the local waters, thus lifting the pH enough for the young oysters to get a start. Seaweeds, kelps, and seagrasses, as habitat engineers, are acknowledged as the foundational organisms they are, organisms that we might rely on to climb out of the corrosive environmental situation we humans have created in our oceans.

And yet, is that their job? The extraordinariness of marine botanicals, the vast array of red, green, and brown algae as well as the seagrasses, must be recognized, cherished, and revered fundamentally, not as a lifeboat to our solipsistic notion of the planet, but in and of themselves. This is hard when our human impacts on the planet are inescapable. Even the most wild and untamable of the Pacific Coast seaweeds—the giant bull kelp and the old-growth *Pterygophora*—get entangled in the economies of man. But looking way back to look forward gives us hope. Otter, kelp, abalone, and urchin evolved together in the ribbon of ocean that traces the edge of the North American continent, performing a choreographed dance that invariably had cycles of more and less but, overall, engendered a resilience that the *Nereocystis* and *Pterygophora* of Fort Bragg and the Mendocino coast are sorely missing in these times of environmental stress. The otters have been gone for so long that their story dropped out of the profile of that region's kelp forest. Only recently, as the complete trophic cascade is recognized as important to the health of the kelp forest *and* the abalone, has the mention of otters started creeping back into the kelp forest narrative around those abalone-diving communities.

And alongside the chronicles of *Nereocystis* and *Egregia*, *Mazzaella* and *Halosaccion*—why they are shaped the way they are, who found them and named them—are the pressings and scans and images made as part of the process of discovery. Per-

Callophyllis spp.

haps the magic of the seaweeds is better told by the visual elements of the story. The combination of historical lithographs and pressed specimens with my contemporary portraits made in my studio is the engine that drives this seaweed odyssey. My hope is that the visual elements offer surprising shapes and colors, forms that feel unfamiliar and yet alluring, clues to people and places—and that they illustrate organisms that feel foreign yet familiar. Seeing is an alternative to our verbal narrative, a reminder to reorient our perceptions, abandon our land-based point of view, and be more fluid in our thinking about seaweeds. The images are a reminder to shift perspectives while the tide is high enough to raise the thin blades of *Pyropia* and *Ulva*, with the sun filtering through the shallow water and bouncing in metallic blues and greens off the *Mazzaella* and pushing through the glowing rose blades of *Erythrophyllum*. Celadon digits of *Halosaccion* proudly grasp the rock with tiny but powerful spots of adherence, claiming their space amidst their fellow algae. They are a reminder to leave the algae alone to do their own thing, heal our oceans as they can, and let them be, as the profound ecological engineers that they are, not another resource for us to figure out how to manage. I know this is naïve thinking on my part, but it is what I feel in my heart.

I pore over the detailed interaction, pixel by pixel, between a scan of *Fucus distichus*, or bladderwrack, made on my scanner in 2012, and the remarkable lithograph by Alexander Postels published in 1840. (Bladderwrack has recently been divided into the East Coast variant *F. vesiculosus* and on the West Coast, *F. distichus*.) I understand viscerally that the building of empathy for the seaweeds starts with the sheer wonder of form, an attraction towards the beautiful and the strange. It is then built upon by a lineage of learning across time to create complex portraits that describe the algae as unique and intricate organisms. And this empathy is then expanded when scientists remind us of the countless interactions between the seaweeds and the creatures and dynamic forces of their world. To know the scientists that shared that empathy and built our knowledge base reignites our wonder and makes it a driving force.

My attitude towards the taxonomist as scientist has shifted over the course of this project. My initial pragmatism, or perhaps my artist's instincts, could not grasp the passion or commitment to phylogeny or precise naming and placing. I love and appreciate the concept put forward by the artist Robert Irwin and author Lawrence Wechsler, that "seeing is forgetting the name of the thing that one sees." But as I notice the speed

with which our American appreciation for seaweeds is evolving from "green and slimy" to celebrated, farmed, hailed, harvested, integrated, sold, and foraged, I now see the taxonomist as the scientist most interested in the algae for itself, understanding the mechanisms of its growth and its relationship to its algal cousins, not as a commodity for our use. The taxonomists are accumulating the knowledge base that increases our empathy for *Egregia menziesii* in particular, or perhaps it is *Mazzaella splendens*, or *Weeksia reticulata*. The names themselves, rendered in Latin, spill off as poetry, the syllables of genus and species rolling off the tongue in a lyrical cadence.

The Phycological Society of America's yearly conference brings together a remarkable group of phycologists, ecologists, ethnobotanists, naturalists, and other scientists deeply committed to learning about the world of the seaweeds. They have been generous and gracious in welcoming an artist among them. The feeling of generosity and opportunity springs not only from their subject matter, the seaweeds themselves, but from a shared sense of history. Knowing the faces and names of those who came before, who studied these same seaweeds out on the same reefs, with hobnailed leather shoes instead of rubber boots, diving in the same shallows, builds a bond of empathy across time for individual organisms and inspires all of us, scientists, artists, and storytellers, to continue striving to understand a world apart from our own.

Alaria marginata, or winged kelp, is often used in cooking as North American wakame.

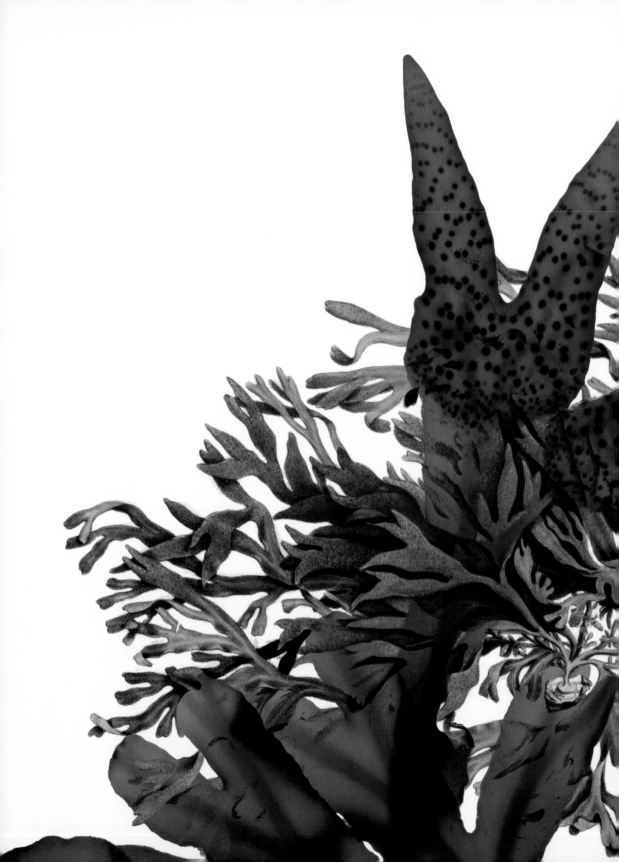

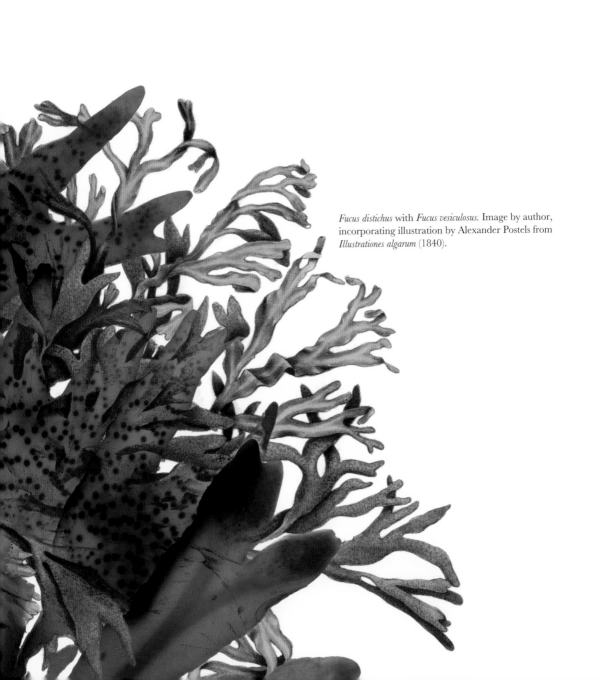

Fucus distichus with *Fucus vesiculosus*. Image by author, incorporating illustration by Alexander Postels from *Illustrationes algarum* (1840).

ACKNOWLEDGMENTS

I must first thank the Phycological Society of America for being such an inclusive and generous group of seaweed scientists. They have welcomed me into their midst, been patient with my questions, and appreciative of art as an alternative way into the science of marine algae. Thank you to Kirsten Müller in particular for reading the manuscript and assuring me that the science is sound and for giving invaluable feedback. A special thank you goes to Michael and Wendy Guiry for their website, AlgaeBase, an up-to-date taxonomic repository for all things seaweed. I return again and again to AlgaeBase, and if questions linger, Mike is always at the other end of the line. Michael Wynne, thank you for your writings on the characters behind the science of seaweed and for delving into your own library for some crucial imagery.

The collections of the University and Jepson Herbaria at the University of California, Berkeley, are the source for many of the specimens that tell the story of a collected seaweed. Thank you to Kathy Ann Miller, the curator of algae there, and to all the students and others who spent countless hours digitizing the collection. My seaweed education began and continues through the extraordinary seaweed workshops Kathy Ann runs through the Jepson Herbarium. I must thank Karina Nielsen for all her support, both spiritual and practical, and Kathy Boyer, Jane Watson, and Jenn Burt for being scientific sounding boards. Many thanks extend to Lindsie Bear for encouraging me first to begin and then to keep at it. I am grateful for the San Francisco Public Library and the special collections of the University of Southern California, both superb resources I have depended upon.

The San Francisco Arts Commission generously supported my years of research and writing with an Individual Artist Commission, deciding that yes, it is worthwhile to bring the communities of art and science together. Heyday and especially Gayle Wattawa have championed these seaweed stories over the long run, for which I am so very grateful. Thank you to Deborah Bruce-Hostler for her spectacular copyediting, to Ashley Ingram, who understood my design ideas and made them shine, and to Emily

Grossman for grantwriting. My buddies Lina Prairie, Julie Motz, and Larry Knowles continue to be vital coconspirators, constantly pushing me to return to the beach or into the ocean to pry open more seaweed and otter stories. Finally, my husband, Ken Pearce, and my three children, Eliza, Dee, and Andrew, have all delighted over the years in my deep dive into the world of seaweed. For this I can never hug them enough.

Chondracanthus exasperatus.

BIBLIOGRAPHY AND SOURCES

General Bibliography

Abbott, Isabella A. and E. Yale Dawson. *How to Know the Seaweeds*. 2nd ed. Dubuque, Iowa: W.C. Brown Co., [1958] 1978.

Abbott, Isabella A., and George J. Hollenberg, eds. *Marine Algae of California*. Stanford: Stanford University Press, 1976.

Carson, Rachel. *The Edge of the Sea*. New York: Mariner, [1955] 1998.

Dawson, E. Yale. Correspondence and papers. Washington DC: Smithsonian Institution Archives, Record Unit 7079.

Dawson, E. Yale. *Marine Botany: An Introduction*. New York: Holt, Reinhart and Winston, 1966.

Denny, Mark, and Steven Gaines, eds. *Encyclopedia of Tidepools and Rocky Shores*. Berkeley: University of California Press, 2007.

Druehl, Louis D., and Bridgette E. Clarkston. *Pacific Seaweeds: A Guide to Common Seaweeds of the West Coast*. 2nd ed. Madeira Park, BC: Harbour, 2016.

Estes, James A. *Serendipity: An Ecologist's Quest to Understand Nature*. Oakland: University of California Press, 2016.

Garbary, David, and Michael J. Wynne, eds. *Prominent Phycologists of the 20th Century*. Hantsport, Nova Scotia: Lancelot, 1996.

Guiry, M. D., and G. M. Guiry. AlgaeBase website. National University of Ireland, Galway. http://www.algaebase.org.

Harvey, William Henry. *Nerei Boreali-Americana: Contributions to a History of the Marine Algae of North America*. Washington, DC: Smithsonian Institution, *Part I.—Melanospermeae*, 1852. *Part II.—Rhodospermeae*, 1853.

Iselin, Josie. *An Ocean Garden: The Secret Life of Seaweed*. New York: Abrams, 2014.

Lindeberg, Mandy R., and Sandra C. Lindstrom. *Field Guide to Seaweeds of Alaska*. Fairbanks: Alaska Sea Grant College Program, 2015.

Mondragon, Jennifer, and Jeff Mondragon. *Seaweeds of the Pacific Coast: Common Marine Algae from Alaska to Baja California*. Monterey, CA: Sea Challengers, 2003.

Niesen, Thomas M. *The Marine Biology Coloring Book*. 2nd ed. New York: Harper Collins, [1982] 2000.

Pappenfuss, George F. "Landmarks in Pacific North American Phycology." In I. A. Abbott and G. J. Hollenberg, eds., *Marine Algae of California*. Stanford: Stanford University Press, 1976.

Postels, Alexander, and Franz Ruprecht. *Illustrationes algarum*. St. Petersburg: Eduardi Pratz, 1840.

Ricketts, Edward F., and Jack Calvin. *Between Pacific Tides*. 3rd ed. Stanford: Stanford University Press, [1939] 1952.

Rigby, Nigel, Pieter van der Merwe, and Glyn Williams. *Pioneers of the Pacific: Voyages of Exploration 1787–1810*. Fairbanks: University of Alaska Press, 2005.

Ruprecht, Franz Josef. "New or incompletely known plants from the northern part of the Pacific Ocean." *Mémoires de l'Académie Impériale des Sciences*, sixième série, Sciences Naturelles. St. Petersburg: 1852.

Salomon, Ann, Henry Huntington, and Nick Tanape Sr., *Imam Cimiucia: Our Changing Sea*. Fairbanks: Alaska Sea Grant College Program, 2011.

Scagel, Robert F. *Guide to Common Seaweeds of British Columbia*. Victoria, BC: British Columbia Provincial Museum, 1972.

Smith, Gilbert M. *Marine Algae of the Monterey Peninsula*. Stanford: Stanford University Press, [1944] 1964.

Stolzenburg, William. *Where the Wild Things Were: Life, Death, and Ecological Wreckage in a Land of Vanishing Predators*. New York: Bloomsbury, 2008.

Tilden, Josephine. *The Algae and their Life Relations, Fundamentals of Phycology*. Minneapolis: University of Minnesota Press, 1935.

Tilden, Josephine, ed. *Postelsia: The Year Book of the Minnesota Seaside Station*. Minneapolis: University of Minnesota, 1901 and 1906.

Turner, Dawson. *Fuci, or Colored figures and descriptions of the plants referred by botanists to the genus Fucus*. London: J. M'Creery, 1808.

Wynne, Michael J. "Marine Algae and Early Explorations in the Upper North Pacific and Bering Sea." *Algae*, 24(1): 1–29, 2009.

Wynne, Michael J. *Phycological Trailblazer* series. Phycological Society of America. www.psaalgae.org/trailblazers.

Wynne, Michael J. *Portraits of Marine Algae: An Historical Perspective*. Ann Arbor: University of Michigan Herbarium, 2006.

SOURCES FOR EACH CHAPTER DO NOT REPEAT THOSE GIVEN IN THE GENERAL BIBLIOGRAPHY.

Egregia menziesii

Newcombe, C. F., ed. *Menzies' Journal of Vancouver's Voyage April–October 1792*. Victoria, BC: William H. Cullin, 1923.

Raban, Jonathan. *Passage to Juneau: A Sea and Its Meaning*. New York: Pantheon, 1999.

Nereocystis luetkeana

Amsler, Charles D., and Michael Neushul. "Diel Periodicity of spore release from the kelp *Nereocystis luetkeana*." *Journal of Experimental Marine Biology and Ecology* 134(2): 117–127 1989.

Braje, Todd J. *Shellfish for the Celestial Empire: The Rise and Fall of Commercial Abalone Fishing in California*. Salt Lake City: University of Utah Press, 2016.

Callahan, Mary. "Collapse of Kelp Forest Imperils North Coast Ocean Ecosystem." *Santa Rosa Press Democrat*, April 16, 2016.

Catton, Cynthia. "Perfect Storm Decimates Northern California Kelp Forests." California Department of Fish and Wildlife, *Marine Management News*, 2016.

Edna M. Fisher Archive, 1930–1967. San Francisco State University Archives. J. Paul Leonard Library.

Johnson, William Weber. *The Story of Sea Otter*. New York: Random House, 1973.

Mertens, Henry (naturalist on board the *Siniavin*). "Two Scientific Botanical Notices." In W. J. Hooker, *Botanical Miscellany*. London: John Murray, 1833. Written at Kamchatka, 1827.

Ogden, Adele. *The California Sea Otter Trade 1784–1848*. Berkeley: University of California Press, 1941.

Springer, Y., C. Hayes, M. Carr, and M. Mackey. *Ecology and Management of the Bull Kelp, Nereocystis Luetkeana: A Synthesis with Recommendations for Future Research*. Santa Cruz: A report prepared by the University of California, Santa Cruz and Lenfest Ocean Program, 2007.

ZoBell, Claude E. and E. Yale Dawson. *The Seaweed Story*. California Department of Fish and Game, 1954.

Stephanocystis osmundacea

Cutter, Donald. *Malaspina in California*. San Francisco: John Howell, 1960.

Cutter, D. F., R. Polese, and M. Weber. *The Malaspina Expedition: In the Pursuit of Knowledge*. Santa Fe: Museum of New Mexico Press, 1977.

David, A., F. Fernandez-Armesto, C. Novi, and G. Williams, eds. *The Malaspina Expedition 1789–1794: The Journal of the Voyage of Alejandro Malaspina*. Madrid: The Hakluyt Society in association with the Museo Naval, 2003.

Gunnill, F. C. *Demography of* Cystoseira osmundacea *and* Halidrys dioica *at La Jolla, California*. San Diego: San Diego Natural History Museum, 1986.

Higueras Rodríguez, María Dolores. *Critical Catalog of the Malaspina Expedition 1789–1794*. Madrid: Museo Naval, 1985.

Silva, Paul C. "California Seaweeds Collected by the Malaspina Expedition, Especially *Pelvetia* (Fucales, Phaeophyceae)." *Madroño* 43(3): 345–354, 1996.

Vaughan, Thomas, E. A. P. Crownhart-Vaughan, and Mercedes Palau Baquero. *Voyages of Enlightenment: Malaspina on the Northwest Coast 1791/1792*. Portland: Oregon Historical Society, 1977.

Williams, Glyn. *Naturalists at Sea: Scientific Travellers from Dampier to Darwin*. New Haven and London: Yale University Press, 2013.

Mazzaella splendens

Armstrong, Carol, and Catherine de Zegher, eds. *Ocean Flowers: Impressions from Nature*. New York: The Drawing Center; Princeton: Princeton University Press, 2004.

Atkins, Anna. *Photographs of British Algae: Cyanotype Impressions*. 1843.

Gaines, Steven D. "Herbivory and Between-Habitat Diversity: The Differential Effectiveness of Defenses in a Marine Plant." *Ecology* 66(2): 473–485 1985.

Gerwick, W. H., and N. J. Lang. "Structural, chemical and ecological studies on iridescence in Iridaea (Rhodophyta)." *Journal of Phycology* 13(2): 121–127, 1977.

Moorhead, Joanna. "Blooming Marvellous: The World's First Female Photographer—and Her Botanical Beauties," *The Guardian,* June 23, 2017.

Corallina vancouveriensis

Fisher, K., and P. T. Martone. "Field study of growth and calcification rates of three species of articulated coralline algae in British Columbia, Canada." *Biological Bulletin* 226(2): 121–130, 2014.

Hansen, Gayle I. "Josephine Elizabeth Tilden (1869–1957)." In D. Garbary and M. Wynne, eds., *Prominent Phycologists of the 20th Century*. Hantsburg, Nova Scotia: Lancelot, 1996.

Horsfield, Margaret. "The Enduring Legacy of Josephine Tilden." *Hakai Magazine,* June 13, 2016. https://www.hakaimagazine.com/features/enduring-legacy-josephine-tilden/

Mason, A., G. More, and J. Isabella. *Out of This World: The Minnesota Seaside Station*. [Video file] *Hakai Magazine*, 2016. https://www.hakaimagazine.com/videos-visuals/out-world-minnesota -seaside-station/

Steneck, R. S., and P. T. Martone. "Calcified Algae." In M. W. Denny and S. D. Gaines, eds., *Encyclopedia of Tidepools*. Berkeley: University of California Press, 2007.

Yendo, Kichisaburo. "Corallinae verae of Port Renfrew." In Conway MacMillan, ed., *Minnesota Botanical Studies*, vol. II: 711–722. Minneapolis: Geological and Natural History Survey of Minnesota, 1898–1902.

Agarum spp.

Boo, G H, et al. "Taxonomy and Biogeography of *Agarum* and *Thalassiophyllum*…based on sequences of nuclear, mitochondrial, and plastid markers." *Taxon* 60(3): 831–840, 2011.

Clayborough, Stephen H. "Profiles in Natural History: Georg Wilhelm Steller and the Ape in the Sea." Popular Social Science July 2013. https://web.archive.org/web/20131127180041/http://www .popularsocialscience.com/2013/07/02/profiles-in-natural-history-georg-wilhelm-steller-and-the -ape-in-the-sea/

Ford, Corey. *Where the Sea Breaks Its Back: The Epic Story of a Pioneer Naturalist and the Discovery of Alaska*. Boston: Little, Brown, 1966.

Gmelin, Samuel Gottlieb. *Historia fucorum*. St. Petersburg: Petropoli, 1768.

Gmelin, Samuel Gottlieb. *Travels through Northern Persia 1744–1774*. Willem Floor translation and annotation. Washington DC: Mage, 2007. Biographical preface to the 1784 edition by Peter Simon Pallas.

Golder, F. A., ed. *Bering's Voyages: An Account of the Efforts of the Russians to Determine the Relation of Asia and America. Vol. II. Steller's Journal of the Sea Voyage from Kamchatka to America and Return on the Second Expedition, 1741–1742*. Leonhard Stejneger translation and annotation. New York: American Geographical Society, 1925. Appendix B: Steller's letter to J. G. Gmelin about the voyage.

Steinberg, Peter D., James A. Estes, and Frank C. Winter. "Evolutionary Consequences of Food Chain Length in Kelp Forest Communities." *Proceedings of the National Academy of Sciences* 92(18): 8145–48. August 29, 1995.

Wulf, Andrea. *The Transit of Venus: The Race to Measure the Heavens*. London: Windmill, 2012.

Pyropia spp.

Brawley, Susan, Juliet Brodie, Nicolas A. Blouin, Arthur C. Grossman, and Pu Xu. "Porphyra: A marine crop shaped by stress." *Trends in Plant Science*, 16(1): 29–37, January 2011.

Demmig-Adams, Barbara, and William W. Adams. "The role of xanthophyll cycle carotenoids in the protection of photosynthesis." *Trends in Plant Science*, 1(1): 21–26, January 1996.

Drew, K. M. "Conchocelis-phase in the life-history of *Porphyra umbilicalis*." *Nature* 164: 748–749, 1949.

Inglis-Arkell, Esther. "How an unpaid UK researcher saved the Japanese seaweed industry." *Ars technica*, 2017. https://arstechnica.com/science/2017/11/how-an-unpaid-uk-researcher-saved-the-japanese-seaweed-industry/

Sutherland, J., et al. "A New Look at an Ancient Order: Generic Revision of the Bangiales (Rhodophyta)." *Journal of Phycology* 47: 1131–51, 2011.

Turner, Nancy J. "We give them seaweed: Social economic exchange and resilience in Northwestern North America." *Indian Journal of Traditional Knowledge* 15(1): 5–15, 2016.

Postelsia palmaeformis

Callaghan, Catherine A. *Bodega Miwok Dictionary*. Berkeley: University of California Press, 1970.

Collier, Mary Trumbull, and Sylvia Barker Thalman, eds. *Interviews with Tom Smith and Maria Copa: Isabel Kelly's Ethnographic Notes on the Coast Miwok Indians of Marin and Southern Sonoma Counties, California*. San Rafael, CA: Miwok Archaeological Preserve of Marin, 1991.

Estes, James A., et al. "Sea otters, kelp forests, and the extinction of Steller's sea cow." *Proceedings of the National Academy of Sciences* 113(4): 880–85. January 26, 2016.

Setchell, W. A., and N. L. Gardner. *Marine Algae of the Pacific Coast of North America*. Berkeley: University of California Publications in Botany, University of California Press, vol. VIII, parts I and II, 1919–1920.

Silva, Paul C. "Seaweeds Tell Their Stories." *Fremontia* 32(1): 3–9, 2004.

Starko, Samuel, and Patrick T. Martone. "An empirical test of 'universal' biomass scaling relationships in kelps: Evidence of convergence with seed plants." *New Phytologist,* 212(3): 719–729, 2016.

Macrocystis pyrifera

Lahaye, Marc. "Chemistry and Physico-Chemistry of Phycocolloids." *Cahiers de Biologie Marine* 42: 137–57, 2001.

McHugh, Denis J. *A Guide to the Seaweed Industry*. FAO Fisheries Technical Paper no. 441, 2003.

McMahon, Shannon. "Good-Bye to a Sea Giant." *San Diego Union-Tribune,* June 9, 2005.

McPeak, Ronald, Dale Glantz, and Carole R. Shaw. *The Amber Forest: Beauty and Biology of California's Submarine Forests*. San Diego: Watersport, 1988.

Perissinotto, Renzo, and Christopher D. McQuaid. "Deep Occurrence of the Giant Kelp *Macrocystis Laevis* in the Southern Ocean." *Marine Ecology Progress Series* 81(1): 89–95, 1992.

Schiel, David R., and Michael S. Foster. *The Biology and Ecology of Giant Kelp Forests*. Oakland: University of California Press, 2015.

Codium fragile

Abbott, Isabella A. "Elmer Yale Dawson (1918–1966)." *Journal of Phycology* 2: 129–132, 1966.

Dawson, E. Yale. "Cactus at the Water's Edge." *Desert Plant Life* 21: 51–52, 1949.

Dawson, E. Yale. *Marine Algae of the Gulf of California*. Los Angeles: University of Southern California Press, 1944.

Dawson, E. Yale. *On the Supply of Teaching Materials for Marine Biology Classes*. Santa Ynez, CA: Baudette Foundation Newsletter, January 1962.

DeWreede, Robert. "Biomechanical Properties of Coenocytic Algae (Chlorophyta, Cauler-pales)." *Science Asia* 32 (Supplement 1): 57–62, 2006.

Hawkes, Michael. "In Search of Cacti and Seaweeds on Desert Shores: E. Yale Dawson, 1918–1966, Botanist." *Haseltonia* 11: 126–37, 2005.

Moe, Richard. "Paul Claude Silva (1922–2014)." *Phycologia* 54 (1): 89–94, 2014.

Norris, James. *Marine Algae of the Northern Gulf of California, Chlorophyta and Phaeopyceae*. Washington DC: Smithsonian Institution Scholarly Press, 2010.

Setchell, William Albert, and Nathaniel Lyon Gardner. "XXIX Expedition of the California Academy of Sciences to the Gulf of California in 1921: The Marine Algae." *Proceedings of the California Academy of Sciences*. Fourth Series, 12(29): 695–697, 705–73, May 13, 1924.

Silva, Paul C. "The Dichotomous Species of Codium in Britain." *Journal of the Marine Biological Association of the United Kingdom*: 565–577 1955.

Silva, Paul C. "E. Yale Dawson (1918–1966)." *Phycologia* 6(4): 218–236, 1967.

Silva, P. C., F. F. Pedroche, M. E. Chacana, and K. A. Miller. "Validation of the names of two new species of *Codium* (Chlorophyta, Bryopsidales) from Isla Guadalupe and Rocas Alijos, Pacific Mexico and the southern California Channel Islands, with some remarks on insular endemism." *Botanica Marina* 57(4): 243–250 2014.

Ulva spp.

Hayden, H., P. C. Silva, et al. "Linnaeus was right all along: *Ulva* and *Enteromorpha* are not distinct genera." *European Journal of Phycology* 38(3): 277–294, 2003.

Margulis, Lynn. *Symbiotic Planet: A New View of Evolution*. New York: Basic Books, 1998.

Margulis, Lynn, and Karlene V. Schwartz. *Five Kingdoms: An Illustrated Guide to the Phyla of Life on Earth*. 3rd ed. New York: W. H. Freeman, 2000.

Sagan, Dorian, ed. *Lynn Margulis: The Life and Legacy of a Scientific Rebel*. White River Junction, VT: Chelsea Green, 2012.

Sagan, Lynn [Margulis]. "On the origin of mitosing cells." *Journal of Theoretical Biology* 14(3): 225–274, 1967.

Phyllospadix scouleri and *Zostera marina*

Hollenberg, G. J. *Smithora: An Interesting New Algal Genus in the Erythropeltidaceae*. Solvang, CA: Pacific Naturalist: Contributions from the Baudette Foundation for Biological Research, 1959.

Hughes, B. B., R. Eby, E. Van Dyke, M. T. Tinker, C. I. Marks, K. S. Johnson, and K. Wasson. "Recovery of a top predator mediates negative eutrophic effects on seagrass." *Proceedings of the National Academy of Sciences*, 110(38): 15313–15318, 2013.

Larkum, A. W. D., R. J. Orth, and C. Duarte, eds. *Seagrasses: Biology, Ecology and Conservation*. Dordrecht, Netherlands: Springer, 2006.

Olsen, J. L., G. Procaccini, T. Reuschm, and Y. Van de Peer. "The genome of the seagrass *Zostera marina* reveals angiosperm adaptation to the sea." *Nature* 530(7590):331–335 2016.

Rosendahl, C. O. "Observations on Plant Distribution in Renfrew District of Vancouver Island." In Josephine Tilden, ed. *Postelsia: The Year Book of the Minnesota Seaside Station*. Minneapolis: University of Minnesota, 1906.

Schmalz, David. "How two volunteers changed our understanding of sea otters." *Monterey County Weekly*, March 31, 2016.

Wyllie-Echeverria, Sandy, and Mark Fonseca. *Eelgrass* (Zostera marina L.) *Research in San Francisco Bay, California, from 1920 to the Present*. National Centers for Coastal Ocean Science, 2003.

Desmarestia herbacea

Pelletreau, K. N., and G. Muller-Parker. "Sulfuric acid in phaeophyte alga *Desmarestia munda* deters feeding by sea urchin *Strongylocentrotus droebachiensis*." *Marine Biology* 141(1): 1–9, 2002.

Halosaccion glandiforme and *Botryocladia pseudodichotoma*

Mitman, Grant G., and Harry K. Phinney. "The development and reproductive morphology of *Halosaccion americanum*." *Journal of Phycology*, 21(4): 578–584, 1985.

Weeksia reticulata

Abbott, Isabella A. "Studies in some foliose red algae of the Pacific Coast. III. Dumontiaceae, Weeksiaceae, Kallymeniaceae." *Journal of Phycology* 4(3): 180–198, 1968.

Saunders, Gary. "A DNA barcode examination of the red algal family Dumontiaceae in Canadian waters reveals substantial cryptic species diversity. 1. The foliose *Dilsea-Neodilsea* complex and *Weeksia.*" *Botany*, 86(7): 773–789, 2008.

Setchell, William Albert. "Notes on Algae." *Zoe*, 5(6): 121–129, 1901.

Setchell, William Albert. Papers. University and Jepson Herbaria Archives, University of California, Berkeley. Letters from J. M. Weeks transcribed by Kathy Ann Miller.

Pterygophora californica

Hume, Mark. "The remarkable comeback of sea otters to the B.C. coast." *Globe and Mail*, May 11, 2018.

Lee, L., J. Watson, R. Trebilco, and A. Salomon. "Indirect effects and prey behavior mediate interactions between an endangered prey and recovering predator." *Ecosphere* 7(12): e01–604, 2016.

MacMillan, Conway. "Observations on Pterygophora." In Conway MacMillan, ed., *Minnesota Botanical Studies*, vol. II. Minneapolis: Geological and Natural History Survey of Minnesota, 1898–1902, 723–41.

Pollon, Christopher. "Eagles Deck Out Their Nest with Kelp: Thanks, Sea Otters." *Hakai Magazine*, May 25, 2018.

Salomon, Anne K., J. M. Burt, I. Herb, Kii'iljuus B. Wilson, Hup-in-Yook T. Happynook, Skil-Hilans A. Davidson, Wigvilhba Wakas H. Humchitt, Wii-tst-koom A. Mack, Gitkinjuuaas R. Wilson, N. Tanape Sr., and L. Wood. *Coastal Voices*: "Our ancestors had a way of managing our relationship with the sea otters." www.coastalvoices.net.

Salomon, Anne K., with Kii'iljuus Barb J. Wilson, Xanius Elroy White, Nick Tanape Sr., and Tom Mexsis Happynook. *First Nations Perspectives on Sea Otter Conservation in British Columbia and Alaska: Insights into Coupled Human-Ocean Systems*. Academic Press, 2015.

Watson, Jane. "The Effects of Sea Otter (*Enhydra lutris*) Foraging on Shallow Rocky Communities off Northwestern Vancouver Island, British Columbia." Dissertation, University of California, Santa Cruz, 1993.

Watson, Jane and James Estes. "Stability, resilience, and phase shifts in rocky subtidal communities along the west coast of Vancouver Island, Canada." *Ecological Monographs* 81(2): 215–239, 2011.

Afterword

Nielsen, Karina, et al. *Emerging understanding of seagrass and kelp as an ocean acidification management tool in California*. Ocean Protection Council Science Advisory Team and California Ocean Science Trust, 2018.

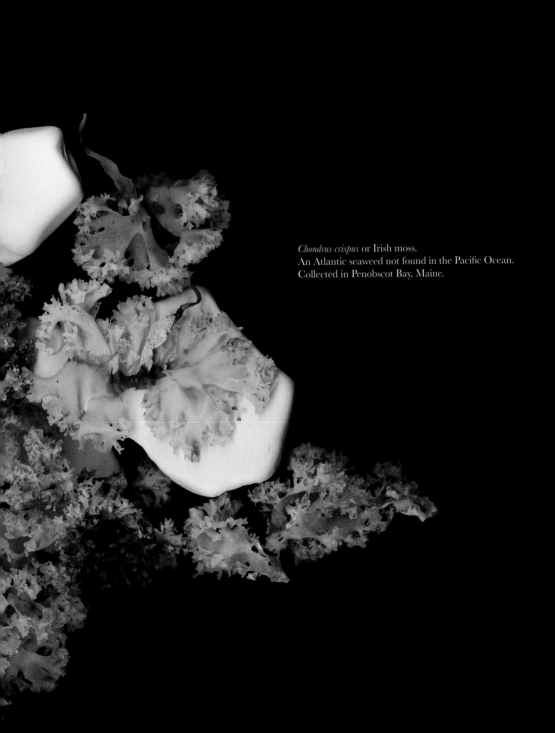

Chondrus crispus or Irish moss.
An Atlantic seaweed not found in the Pacific Ocean.
Collected in Penobscot Bay, Maine.

INDEX

Note: Entries in bold refer to images.

Abbott, Isabella, 6, 53, 56, 200, 201, 205, 206, 228
acid kelp. See *Desmarestia herbacea* and *Desmarestia ligulata*
Agardh, Carl Adolph, 62
Agardh, Jacob, 62
Agarum (colander kelp), 90–101; *A. clathratum*, 90, **91**, 93, **94**, **99**, **101**; *A. clathrus*, **95**, 97, **100**; *A. fimbriatum*, **88–89**, 92, 93, 97, 101
Alaria marginata (winged kelp), **231**
Alaska, 39, 94, 96, 97, 101
AlgaeBase, 160
Algin Corporation, 134
Ascophyllum nodosum, 134
Atkins, Anna, 72, 73, 228

Banks, Joseph, 21, 22
Barcode of Life Data (BOLD), 159
Bering, Vitus, and expedition, 94, 95, 101
Between Pacific Tides (Ricketts), 145, 170, 204
Big MAC, 6, 206, 208. See also *Marine Algae of California*
black seaweed (*Pyropia abbottiae*), 112. See also *Pyropia* (nori)
bladder chain wrack (*Stephanocystis osmundacea*), **ii**, 32, **48–49**, 50–63, **50**, **51**, **52–53**, **54–55**, **57**, **61**, **63**, 214
bladderwrack (*Fucus distichus*), 52, 230, **232–233**
blob (spot of warm ocean water), 21, 35, 36, 116
Bodega Bay, 122, 123, 125
BOLD (Barcode of Life Data), 159
Bory de Saint-Vincent, Jean Baptiste de, 70
Bossiella (coralline algae), **80**
Botanical Beach, 84, 85, 86, 169
Botryocladia pseudodichotoma (sea grapes), **191**, 192–197, **193**, **196**
Botryoglossum platycarpum, **4**
Boyer, Kathy, 174, 175
British Columbia, 214, 215, 219
British Phycological Society, 111

bull kelp (*Nereocystis luetkeana*), **30–31**, 32–47, **33**, **35**, **38**, **41**, **42**, **43**, **46–47**, 50, 81, 98, 107, 108, **110**, 118, 124, 128, 131, 133, 212, 214, 217, 218, 229

California native peoples. See indigenous peoples
Calliarthron (coralline algae), 6, **80**. See also red coralline algae
Callophyllis, 202, 204, 224, **229**; *C. flabellulata*, **7**
cat's tongue (*Mastocarpus papillatus*), 108, 117, 164
Chondracanthus, 53, 225, **227**; *C. exasperatus* (Turkish towel), 164, 225, **225**, **226**, **235**; *C. harveyanus*, 225
Chondrus crispus (Irish moss), 134, **246–247**
Codium, 140–149, **145**; *C. cuneatum*, 146, **147**; *C. dawsonii*, 146, **147**; *C. fragile* (dead man's fingers), **138–139**, 140–149, **141**, **142**, **148**, **149**
colander kelp. See *Agarum*
Colnett, James, 21, 38
Comtechal, Tomás (Tom Smith), 122
Connor, Judith, 52
Constantinea simplex (cup and saucer seaweed), 204, **204**, 205
Corallina vancouveriensis (red coralline algae), **76–77**, 78–87, **80**, **82**, **83**, **87**, 117, 140, 154, 169
coralline algae, 6, **80**. See also red coralline algae
Costaria costata, **i**, **252**
CP Kelco. See Kelco Company
Cryptopleura, **4**
cup and saucer seaweed (*Constantinea simplex*), 204, **204**, 205
Cystoseira osmundacea, 50, 53, **57**, 62. See also *Stephanocystis osmundacea*

Dawson, E. Yale, vii, 144, 145, 146, 160, 177, 200, 204, 205, 206
dead man's fingers (*Codium fragile*), **138–139**, 140–149, **141**, **142**, **148**, **149**
Delesseria, **4**
Desmarestia herbacea (acid kelp or acid weed), **178–179**, 180–189, **180**, **181**, **182**, **183**, **186–187**, **188**, **189**, 217, 218
Desmarestia ligulata, **180**, **181**, **182**, **183**, 184, 185, **189**. See also *Desmarestia herbacea*

Dictyoneurum californicum, **i**, 202
Dilsea, 204
Discovery (ship), 21, 56, 185. See also Vancouver,
 George, and expedition
Dumontia, **195**

eelgrass (*Zostera marina*), **163**, 164–177, **171**, **172**,
 176–177
Egregia menziesii (feather boa kelp), **16–17**, 18–29,
 18–19, **20**, **24**, **27**, **28–29**, 32, 50, 56, 133,
 152, 170, 214, **254**
Elkhorn Slough, 173, 174
Enteromorpha, 158
Erythrophyllum delesserioides (feather weed), **viii**, 224,
 224, **254**
Estes, James, 97, 98
Estuary and Ocean Science Center (SFSU), 154, 174,
 175

feather boa kelp (*Egregia menziesii*), **16–17**, 18–29,
 18–19, **20**, **24**, **25**, **27**, **28–29**, 32, 50, 56,
 133, 152, 170, 214, **254**
feather weed (*Erythrophyllum delesseroides*), **viii**, 224,
 224, **254**
First Nations peoples. See indigenous peoples
Fisher, Edna, 40, 217, 228
Fuci (Turner), vi, 22, 23
Fucus agarum, 93, **94**
Fucus clathratus. See *Agarum clathratus*
Fucus clathrus. See *Agarum clathrus*
Fucus distichus (bladderwrack), 52, 230, **232–233**
Fucus fimbriatus. See *Agarum fimbriatum*
Fucus ligulata, **182**, 185. See also *Desmarestia ligulata*
Fucus menziesii. See *Egregia menziesii* (feather boa kelp)
Fucus osmundacea 56. See also *Stephanocystis osmundacea*
 (bladder chain wrack)
Fucus vesiculosus, 230, **232–233**

Gardner, Nathaniel, 25, 70, 109, 122, 225
Gatty, Margaret, 228
giant kelp (*Macrocystis pyrifera*), **vii**, 10, 32, 46,
 126–127, 128–137, **128**, **129**, **130**, **132**,
 133, **137**, 212, 218
Gigartina, 208, 225, **227**

Glantz, Dale, 135
Gmelin, Johann Georg, 92, 94, 96
Gmelin, Samuel Gottlieb, vi, 90, 92, 93, 96, 184
Grinnellia americana, **4**
Guiry, Michael and Wendy, 160

Haenke, Thaddeus, 58, 62
Halosaccion glandiforme (sea sacs), 117, **190**, 192–197,
 192, **194**, **195**, **197**
Harvey, William Henry, vi, 11, 25, 26, 27, 72, 143,
 154, 185, 225
Hereau, Clara, 176
Historia fucorum (Gmelin), vi, 92, 93, 96, 184
Hollenberg, George, 6, 53, 56, 206
Hopkins Marine Station, 200, 205

Illustrationes algarum (Postels and Ruprecht), vi, 39, 44,
 121
Index Nominum Algarum, 160
indigenous peoples, 6, 27, 44, 95, 108, 112, 113, 122,
 123, 124, 125, 136, 193, 212, 219, 220,
 212, 215, 219
Iridea, 70
Irish moss (*Chondrus crispus*), 134, **246–247**

Janish, Jeanne Russell, 205
Japan, 86, 108, 109, 111, 112
Jorgensen, Pablo, 176

Kamchatka Peninsula, 93, 94, 95, 96, 97, 192
Kelco Company, 134, 135, 136
Kelly, Isabel, 122, 123
Knowles, Larry, 116, 125, 212

Laminaria, 97, 98, 108, 217; *L. setchellii*, 117
Lamouroux, Jean Vincent Félix, 80, 185
Linnaeus, Carl, 80, 158, 185
Log from the Sea of Cortez, The (Steinbeck), 144, 145
Lütke, Friedrich Benjamin von, and expedition, 38, 70

MacMillan, Conway, 84, 86

Macrocystis pyrifera (giant kelp), **vii**, 10, 32, 46, **126–127**, 128–137, **128**, **129**, **130**, **132**, **133**, **137**, 212, 218

Malaspina, Alessandro, and expedition, 58, 59, 62

Manual of British Algae (Harvey), 72

Margulis, Lynn, 154, 156, 157, 158, 160, 228

Marian Koshland Bioscience and Natural Resources Library, vi, 93

Marine Algae of California (Abbott and Hollenberg), 6, 7, 53, 56, 144, 146, 193, 200, 205, 206, 208

Marine Algae of the Monterey Peninsula (Smith), vi, 6, 53, 204, 205

Marine Colloids, 134

Mastocarpus papillatus (cat's tongue), 108, 117, 164

Mazzaella, 53, 66–75; *M. flacida*, 67; *M. splendens* (rainbow leaf), **64–65**, 66–75, **66–67**, **68**, **71**, 117; *M. volans*, 67, **72–73**, 74

McPeak, Ronald, 135

Menzies, Archibald, 21, 22, 23, 26, 27, 38, 56, 58, 70, 184, 185

Merck, 135

Mertens, Henry, 39, 40, 70

Microcladia: *M. borealis*, 224; *M. coulteri*, **ix**, **222–223**, 225

Miller, Kathy Ann, 7, 122

Minnesota Seaside Station, 83, 86, 108, 169. See also Botanical Beach

Monterey Bay Area, 6, 53, 58, 62, 128, 173, 200, 201, 202, 204

Mumford, Tom, 224

Native Americans. See indigenous peoples

Nereis Boreali-Americana (Harvey), vi, 11, 25, 27, 185

Nereocystis luetkeana (bull kelp), **30–31**, 32–47, **33**, **35**, **38**, **41**, **42**, **43**, **46–47**, 50, 81, 98, 107, 108, **110**, 118, 124, 128, 131, 133, 212, 214, 217, 218, 229

Nielsen, Karina, 154, 228

nori. See *Pyropia*

Pacific Grove, 6, 53, 200, 202, 204, 205

Pallas, Peter Simon, 92, 96

Palmariales, 194

Papenfuss, George, 6, 143

Photographs of British Algae, Cyanotype Impressions (Atkins), 72

Phyllospadix scouleri (surfgrass), 53, 79, **162**, 164–177, **164**, **167**, **168**

Phyllospadix torreyi, **166**

Phyllospora menziesii, **20**, 25, 26. See also *Egregia menziesii*

Pikea californica, **74–75**

Porphyra, **102–103**, 104, 108, 109, 111, **112**. See also *Pyropia* (nori)

Postels, Alexander, vi, 39, 40, 70, 121, 230

Postelsia: The Year Book of the Minnesota Seaside Station (Tilden), 85, **114**, 169

Postelsia palmaeformis (sea palm), 84, 85 **114**, **115**, 116–125, **119**, **120**, **123**, **124**, 152

Prince of Wales (ship), 21, 22

Protoctista, 157, 158

Pterygophora californica (walking kelp), **15**, 98, 131, **210–211**, 212–221, **213**, **216**, **220–221**, 229

Pyropia (nori), 6, **102–103**, 104–113, **104–105**, **106**, **110**, 193; *P. abbottiae* (black seaweed), 112; *P. perforata*, **112–113**

rainbow leaf (*Mazzaella splendens*), **64–65**, 66–75, **66–67**, **68**, **71**, 117

red coralline algae (*Corallina vancouveriensis*), **76–77**, 78–87, **80**, **82**, **83**, **87**, 117, 140, 154, 169

Ricketts, Ed, 144, 145, 170, 176, 177, 204

Ruprecht, Franz Josef, vi, 25, 27, 39, 121, 122

Russian expeditions, 25, 93, 94, 95, 96. See also St. Petersburg

Russian Academy of Sciences, 92, 96, 121

Sagan, Dorion, 157

San Diego, 134, 136,

San Francisco Bay Area, 32, 128, 173, 174, 192

San Francisco State University, 40, 154, 174

Sargassum, 50, **60**, 62, 164

Schizymenia, **183**, 204, **208**

Scytosiphon lomentaria, **9**

sea grapes (*Botryocladia pseudodichotoma*), **191**, 192–197, **193**, **196**

sea lettuce (*Ulva*), 6, 22, 140, **150–151**, 152–161, **153**, **155**, **159**, **160–161**, 164, 185, 193

sea palm (*Postelsia palmaeformis*), 84, 85 **114**, **115**, 116–125, **119**, **120**, **123**, **124**, 152

sea sacs (*Halosaccion glandiforme*), 117, **190**, 192–197, **192**, **194**, **195**, **197**

sea sorrel, 184. See also *Desmarestia herbacea* (acid kelp)

Seniavin (ship), 38, 70

Setchell, William Albert, 6, 25, 70, 93, 109, 122, 143, 144, 146, 175, 201, 202, 204, 208, 225

Silva, Paul, 6, 25, 58, 62, 122, 143, 144, 146, 160, 206

Smith, Gilbert M., 6, 25, 53, 170, 204, 205, 206

Smith, Tom (Tomás Cometchal), 122

Smithora naiadum, **164**, **168**, 170, 171

Spain, 58, 59, 62

St. Petersburg, 25, 92, 94, 96, 121

Stackhouse, John, 185

Steinbeck, John, 144, 145, 157, 176, 177

Steinberg, Peter, 98

Steller, Georg, 90, 93, 94, 95, 96, 101, 121

Stephanocystis osmundacea (bladder chain wrack), **ii**, 32, **48–49**, 50–63, **50**, **51**, **52–53**, **54–55**, **57**, **61**, **63**, 214

surfgrass (*Phyllospadix scouleri*), 53, 79, **162**, 164–177, **164**, **167**, **168**

Symbiotic Planet (Margulis), 156, 157, 158

Talbot, Henry Fox, 73

Thalassiophyllum clathrus, 97, **100**. See also *Agarum clathrus*

Tilden, Josephine, 83, 84, 85, 86, 108, 169, 228

Turkish towel (*Chondracanthus exasperatus*), 164, 225, **225**, **226**, **235**

Turner, Dawson, vi, 22, 23, 25, 27, 56, 70, 184, 185, 228

Turner, Mary, 23, 228

Turner, Nancy, 112

Ulva (sea lettuce), 6, 22, 140, **150–151**, 152–161, **153**, **155**, **159**, **160–161**, 164, 185, 193

University Herbarium (UC Berkeley), vi, 8, 58, 201

University of California, Berkeley, vi, 6, 8, 58, 93, 109, 122, 125, 143, 144, 160, 201

University of Minnesota, 83, 84. See also Minnesota Seaside Station

Valero III (ship), 144, 145, 177

Vancouver, George, and expedition, 21, 56, 58, 184, 185

Vancouver Island. See Botanical Beach

Voznesensky, Ilya, 121, 122

walking kelp (*Pterygophora californica*), **15**, 98, 131, **210–211**, 212–221, **213**, **216**, **220–221**, 229

Watson, Jane, 215, 217, 218, 219, 220, 228

Webb, Sky Road, 122

Weeks, Jane M., 201, 202, 204, 205, 208, 228

Weeksia reticulata, **198–199**, 200–209, **201**, **203**, **207**, **209**

Western Flyer (ship), 145, 176

winged kelp (*Alaria marginata*), **231**

Yendo, Kichisaburo, 83, 84, 85, 86, 108

Zostera Experimental Network (ZEN), 175, 176

Zostera marina (eelgrass), **163**, 164–177, **171**, **172**, **176–177**

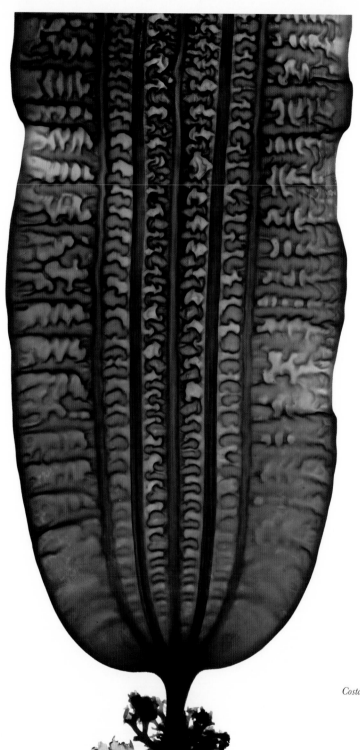

Costaria costata.

ABOUT THE AUTHOR

Josie Iselin is the photographer, author, and designer of many books exploring our coastal universe. *Beach Stones* was published in 2006; *Beach: A Book of Treasure* in 2010; and her visual primer on seaweed, *An Ocean Garden: The Secret Life of Seaweed*, was published in 2014. She uses her visual art practice as the stimulus for her scientific research and storytelling. You can often find her on various coasts at low tide exploring tide pools and investigating the intertidal realm.

Josie Iselin holds a BA in visual and environmental studies from Harvard and an MFA in photography from San Francisco State University. For over twenty-five years she has used her flatbed scanner and computer for generating her artwork. Iselin exhibits large-scale fine-art prints at galleries and museums, advocates for ocean health through education, and speaks widely on the confluence of art and science. She always has new projects in the works at her studio, Loving Blind Productions, located underneath her house on a steep hill in San Francisco.

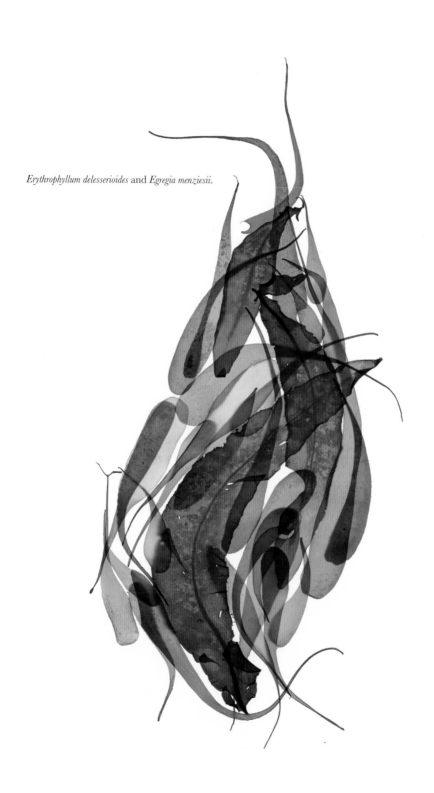

Erythrophyllum delesserioides and *Egregia menziesii*.

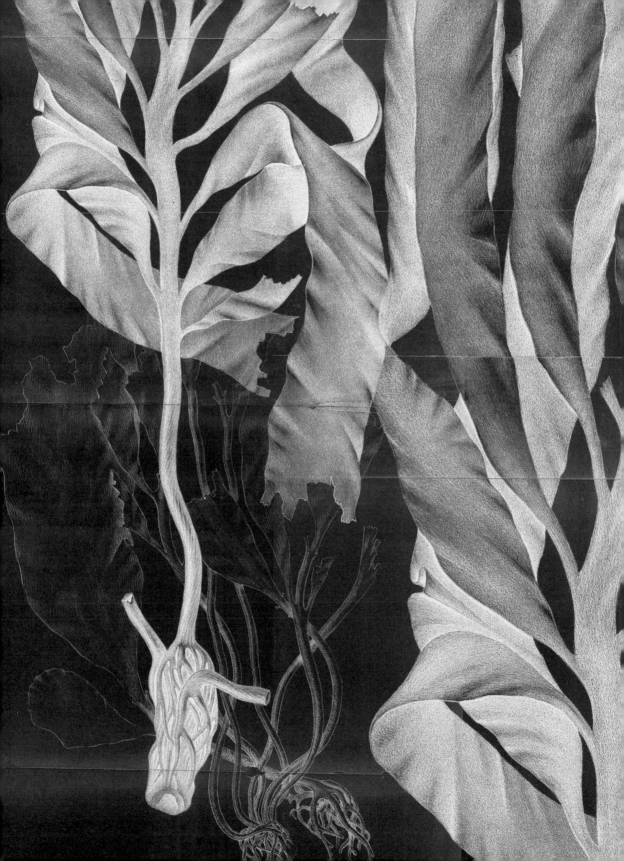